RICHARD WILSON

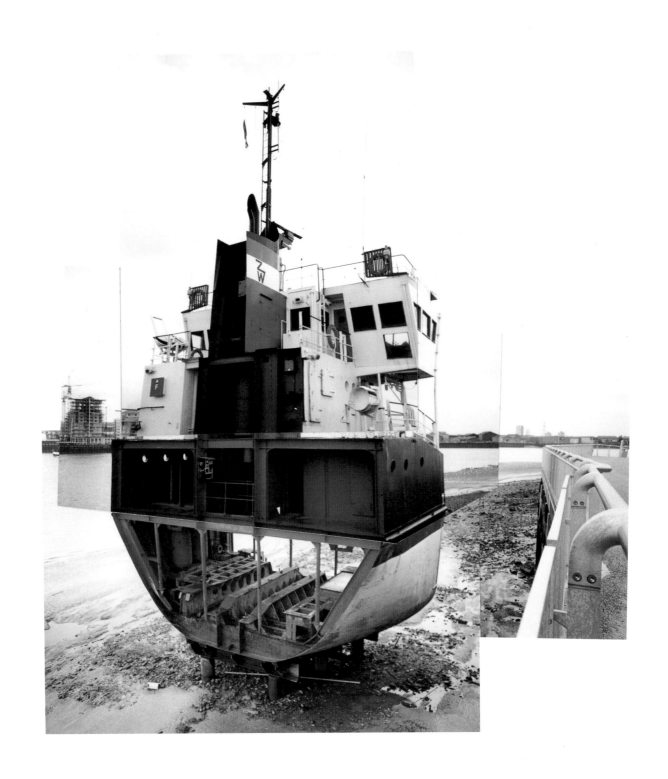

RICHARD WILSON

Michael Archer

Simon Morrissey

Harry Stocks

MERRELL

First published 2001 by Merrell Publishers Limited

Produced by
Merrell Publishers Limited
42 Southwark Street
London SE1 1UN
www.merrellpublishers.com

Distributed in the USA and Canada by Rizzoli International Publications, Inc.
through St Martin's Press, 175 Fifth Avenue, New York, New York 10010

British Library Cataloguing-in-Publication Data
Archer, Michael
Richard Wilson
1.Wilson, Richard – Criticism and interpretation 2.Installations (Art) –
Great Britain
I.Title II.Morrissey, Simon III.Stocks, Harry
709.2
ISBN 1 85894 155 5

Edited by Iain Ross
Designed by Karen Wilks

Special thanks are due to the following photographers for permission to
reproduce their work: David Allen; Shigeo Anzai; Jon Bewley; Steve Collins;
Sean Dower; Rose Garrard; Ken Gill; Hugo Glendinning; Jim Harold; Naoya
Hatakeyama; Ronnie Israel; Robin Klassnik; Jaroslaw Koslowski; Mark Lucas;
Roberto Marossi; Ohta; Anthony Oliver; Anne Painter; Paul Pederson; Steve
Percival; Martin García Perèz; Antonia Reeve; Sakomizu; Ed Sirrs; Kier Smith;
Morton Tholkilsden; Jane Thorburn; Rodney Todd-White & Son; Stephen White;
Richard Wilson; Tim Wilson; Edward Woodman; Bill Woodrow; Silvia Ziranek

Printed and bound in Italy

Front cover: the Kaichieh tragedy, Wufeng, Taiwan, 21 September 1999
(reproduced courtesy of Jin-Ming Tsai)
Back cover: *20:50*, 1987–96 (see pp. 40–47)
Frontispiece: *Slice of Reality*, 2000 (see pp. 180–87)

Artist's Acknowledgements

I should like to thank everyone at Merrell Publishers who has made this book possible, in particular Hugh Merrell and Julian Honer for giving me the opportunity to assemble the first truly comprehensive volume of my work.

A big thank you to Karen Wilks for her enthusiastic and sensitive collaboration on the design, and to all the people both near and far who helped fill in the gaps in my archive.

Thanks also to the writers: to Michael Archer for putting more than two decades of physical activity into words; to Harry Stocks for bringing his straight talk to bear; and to Simon Morrissey for finding the bits beneath the surface that motivate the work.

I should also like to thank all the people who have supported my work for the past twenty-five years, especially those with the space or opportunity to give me 'licence' to do my thing more than once: Valeria Belvedere, Ron Henocq, Fram Kitagawa and Robin Klassnik.

A special thank you must also go to The Henry Moore Foundation and to Price & Myers Consulting Engineers, who both continue to hold their doors open to make sure my grander schemes sit, stand, turn or float as much in the real world as in my imagination. And again to Simon Morrissey for sharing too small an office and outdated technology to help turn ideas into reality.

Finally, my thanks to Anne Bean and Paul Burwell for ten very special years of collaboration in the band, and for more than twenty-five years of great mental pyrotechnics.

And last but not least, my thanks to Silvia, Aldo and Yma.

CONTENTS

Richard Wilson

Michael Archer

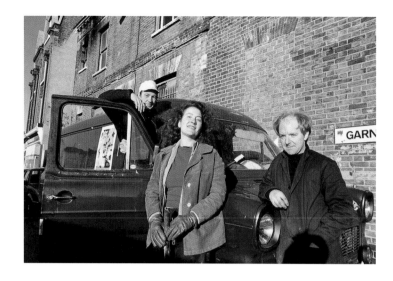

Bow Gamelan Ensemble
(left to right: Paul Burwell, Anne Bean,
Richard Wilson), 1985

Richard Wilson made what he describes as his first mature work, *Big Dipper*, at what is now London's Chisenhale Gallery in 1982. The building had recently been taken over for conversion into a studio block by a group of artists, many of whom, like him, had previously rented units at Butler's Wharf, a warehouse to the south of Tower Bridge. They had been forced to vacate those premises prior to their rehabilitation as luxury apartments and restaurants, and Chisenhale Works had been acquired as a more permanent new home for some of them. Before the ground floor was renovated for use as a gallery space, Wilson moved into it and constructed a large circular sand mould that looped around one of the supporting columns. The mould, along with the aluminium ring that was cast into it, was canted at an angle and supported on a simple wooden framework that took it from almost floor level at its lowest to well above head height at the diametrically opposite point. As the work's name implies, the formal qualities of this framework, together with the rise and plunge of the circular mould, brought vertiginous fairground rides to mind. This was especially so as the central pillar necessarily obscured part of the structure from view, requiring the spectator to wheel round the space in an attempt to catch a sense of the work in its entirety. Such popular cultural reference has been a characteristic of Wilson's work in the years since. Figures of speech and the titles of songs frequently occur in the names of his works, providing a tether to something known and familiar. While the physical experience of Wilson's art may well lead to the kind of bodily disorientation seen in *Big Dipper*, such disturbance can thus often be prevented from entirely confounding the observer's faculties through the lifeline offered by a familiar sliver of the everyday. There is, however, no reliance on bathos for effect, as the closeness and intimacy of the familiar reference is more often than not held in tension with a more general understanding of the work's implications. Of equal significance in the case of *Big Dipper*, for example, is the reference in the title to the constellation of Ursa Major and the rôle it has played historically in enabling us to orientate ourselves in the world. *Big Dipper* was not an object, a thing to be observed and visually absorbed from a particular vantage point. It was, in the literal sense of the term, a work of art, Wilson's own labour in constructing the piece being matched later by the work's own probing of space and the way in which our bodies deal with and appropriate it.

Several of the works made in the three or four years following *Big Dipper* developed various of its elements. *Viaduct*, *Sheer Fluke*, *Halo* and *Heatwave* all involved the use of cast metal. *Viaduct*, made for the Aspex Gallery in Portsmouth, consciously echoed the nearby railway architecture, building wooden piers constructed on the same principle as those in *Big Dipper* into a curved, ascending structure reminiscent of the viaduct of its title. Unlike *Big Dipper*, the shuttering of the casting mould was here dispensed with to leave just the curved 'rail' of cast aluminium resting atop the wooden framework.

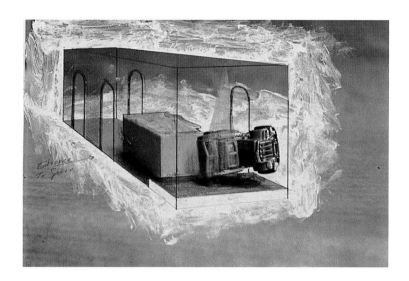

Echoing this three-dimensional construction, a drawing on the adjacent wall rendered the silhouette of a viaduct in soot. In subsequent, related works Wilson did away with the supporting wooden structure, and in both *Sheer Fluke* at Matt's Gallery, London, in 1985, and *Heatwave* at the Ikon Gallery, Birmingham, the following year, the cast-aluminium beam was suspended from the ceiling. *Heatwave's* beam spiralled out from the gallery's central, blackened pillar, while the one cast for *Sheer Fluke* arched diagonally across the entire showing space, from the entrance towards a large inverted whale's tail flukes marked out in soot. Part of the space was flooded with blue light, the combination of colour and form and the fact of the gallery's being in London bringing to mind the famous model of the blue whale in the Natural History Museum in South Kensington. The life-size model is so large that it could not be prefabricated and moved into the building, but had to be constructed on site. While it was being made the workers used its interior as their canteen, and when the body was finally completed and sealed up a number of things were left inside, making the creature a giant time capsule. This idea of the space within a space recurs in Wilson's work right up to the recent *Give me forty acres and I'll turn this rig around*, a large semi-truck and two trailers parked in a former church in Mexico City, filling the space so completely that almost any movement seems impossible.

The Chisenhale building had been vacated by its previous owners following a fire, and the blackening of the space remained as part of *Big Dipper*. Wilson, however, had already begun to use soot in his sculptures, both as a visually dense but physically ephemeral material in its own right, and as a signifier of fire as a living, transformative process. One of the artists who had had a studio in Butler's Wharf alongside Wilson was Stephen Cripps. Cripps's performances involving the use of scavenged materials and pyrotechnics found an echo in Wilson's own interest in these things. One clear outlet for this interest was Wilson's collaboration with performance artist Anne Bean and percussionist Paul Burwell in the Bow Gamelan Ensemble between 1983 and 1991. Assembling a range of percussion instruments, largely from industrial and household scrap found lying around, the three members of the group would score works for these that would involve playing them, both in the more or less conventional way by hitting and bashing, and in more spectacular fashion with fire. Wire wool heated and spun at high speed, for example, created a screen of flying sparks, while a battery of drainpipes might be blown with the hot air provided by a blowtorch, or a sheet of glass made to sound by cracking under intense heat. Asked to launch a book on Cripps published in 1993 to commemorate the tenth anniversary of his death, the ensemble did just that, firing the pages of the publication out of a cannon into the air. The explosiveness of the book launch was coupled with a slow event, the melting of several blocks of ice into which flowers had been frozen. No less significant than its appearance in his Bow Gamelan

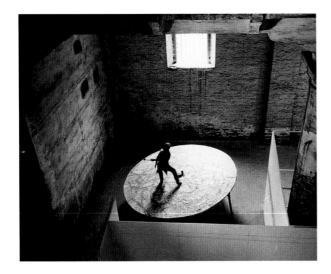

performances, however, was the place of fire – as both heat and light – in Wilson's own work. The
rough beams of aluminium in *Big Dipper*, *Viaduct*, *Heatwave* and *Sheer Fluke* are cast from successive
pourings from a ladle, and thus carry in their laboriously built-up form a sense of the heat and smell that
accompanied their making, as well as a record of the prolonged expenditure of energy that the process
required. Both a gas flame and the intense illumination of an arc-welder were used to trace Wilson's
body on to film and thermal paper in *Hot, Live, Still*, the resultant images showing traces of the activity
that produced them while the body that did so has become absent. Only the slight movement of the
suspended drawings in the draughts circulating in the gallery reintroduces the sense of that bodily
motion. Light is also one of the materials used in installations such as *Leading Lights* and *High-Tec*,
discussed below.

For *Halo*, made at the Venice Biennale in 1986, Wilson built a large, sloping, circular platform, the
surface of which he covered with heat-sensitive paper before standing on it to fling molten lead
from a ladle. The metal hit the paper and bounced off to splash on the walls of the space beyond.
Subsequently hung on the wall, the paper showed a blue tracery recording the lead's trajectory that
slowly faded over time, and which called to mind Pollock's drip paintings. Wilson's actions in casting
the molten lead against the limits of the space also called to mind Richard Serra's *Casting* (1969), a
work that, like process art in general, was influenced by Pollock. Serra threw lead into the angle
between wall and floor, easing successive casts away and leaving them on the floor of the space.
These references are not direct, and are not without complications. Serra emphasizes the architectural
features of the space within which he is working, inviting the viewer to view those particular certainties
in the context of the flux of social relations. Wilson, in *Halo* as elsewhere, allows us no such
certainties. *Halo*'s structure is angled, precarious. In this it is site-specific, reiterating the sinking of the
city that houses it, a city weighed down further by the hordes of visitors to its religious and artistic
treasures. In the light of these considerations, both Pollock and Serra can be seen to provide
something of the means through which Wilson wrests art from the most basic and elemental
of materials and the technologies that use them.

The belief that the earth under our feet will support us come what may, so plainly compromised in a
process-based installation such as *Halo*, has been challenged by Wilson in a series of works made
since. The treacherous promise held out by solid ground is also a feature of *Sea Level* (1989), two
further projects for Matt's Gallery, *20:50* (1987) and *Watertable* (1994), and *Deep End* (1994), as well as
of an unrealized project from the same period conceived for the Tate Gallery Liverpool. Wilson's wish for

Halo, 1986
20:50, 1987

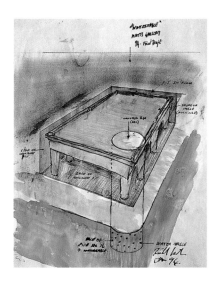

Watertable, 1994

the last of these was to drill down through the gallery to the bedrock beneath the Tate building and to fix into it a brass rod that would sit flush with the floor of the upper storey. Since the ground level of the entire docks area in which the Tate is situated sits on wooden piles, it is affected by the state of the tide; the rod would be flush only at high tide. As the water recedes, the piles shrink and so the building sinks, which would cause the rod to stand proud of the floor. *Deep End* flipped earth and sky, an off-the-peg swimming pool being held upside down in the Museum of Contemporary Art, Los Angeles, with a sixty-foot metal pipe extending from the plughole in its base up through the roof into the sky above. Standing under the imposing bulk of the pool and looking up towards its bottom, one could therefore see the natural and intense colour of the sky rather than the pale blue usually associated with this ersatz aquatic environment. *Sheer Fluke* was the first of a series of works that Wilson has made in Matt's Gallery. The second, *20:50,* achieved almost its exact opposite. Whereas the former had introduced the idea of a second space into the gallery, doubling its boundedness, the latter contrived to dissolve the space altogether. A shallow metal tray was built right across the gallery at waist height, rendering the space physically inaccessible but for a narrow walkway extending from the door a short distance into the room. Used sump oil poured into the tray formed a still, smooth, optically dense and perfectly reflective surface such that anyone looking into it would see only the upper parts of the gallery walls and the ceiling above their head reproduced below them. Because of the absolute blackness of the oil, it was impossible to gauge its depth, and so one was left to presume that perhaps it really did fill the room to waist height. A small tap low down on one of the plates lining the gangway into the middle of the room would also have implied that there was a substantial volume of oil, but for the fact that there were slight gaps between the plates. This gangway narrowed towards its terminus, and the slight constriction, combined with the upward-sloping floor, gave a sense of resistance to anyone walking in to view the work, as if they really were pushing against the weight of the oil. Thus the reality of physical resistance created the illusion of a substantial presence of material, and what material there was present created the opposite effect of dissolving one's visual grasp of the spatial characteristics of the gallery. Looking down into the oil was to look into light and space, the dense blackness of the oil becoming invisible.

Although the effect created by the oil in *20:50* was a serene and delicate one, it was the dirt suspended in it, an equivalent of the soot used in Wilson's earlier installations, that provided it. His interest in the material, as he said at the time, derived more from the fact that it was the kind of stuff he found himself dealing with anyway in his everyday life. Oil featured again in 1993 in a work made for the Fernsehturm telecommunications tower in Berlin, *GMS Frieden*. The work presented in text form a story told to Wilson

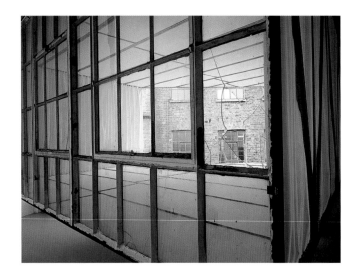

by the captain of a Rhine barge. On one trip the engine of his boat had cut out. After clearing what he thought to be the air-line blockage, he continued his journey, only for the engine to malfunction again after a short while. Further investigation led to the discovery that the blockage was in fact in the outlet from one of the fuel tanks. Concluding that the only way he would be able to clear this was from inside the tank itself, the captain stripped off, covered himself in grease, blocked up his ears and nose, and dived into the tank of fuel oil to retrieve what turned out to be a duffel coat that had got lodged in the outlet pipe.

For *Sea Level* at the Arnolfini, Bristol, Wilson installed a floor made from a metal grille that rose from ground level at the gallery entrance to the height of the window sill on the far side of the space. This large window looked out on to the water of Bristol docks, and the unobstructed view that the extra height now afforded the viewer led to the feeling that the gallery had somehow shifted from land to sea, and that the floor had become transformed into the pitching deck of an ocean-going vessel. An industrial heater placed under the false floor blew hot air up through the grating, causing the atmosphere in the room to shimmer and adding another layer of uncertainty to the experience. *Sea Level* was one of a trio of works staged concurrently in Bristol, Oxford and London. All, in their different ways, involved a play on the exchange between inside and outside. *High-Tec*, at the Museum of Modern Art in Oxford, was a concrete column reaching at a slight angle from the floor up to and through the roof of the museum's upper gallery. A solidified beam of the light pouring in from above, it overpowered the artificial illumination of the gallery, pulling lengths of lighting track into itself and bending them to its will as it plunged to the ground.

She came in through the bathroom window was the third of Wilson's installations for Matt's Gallery. A section of the window that ran the length of one wall was removed, pulled into the middle of the room and placed at an angle to its original orientation. Boarded in above and below, the sides of the displaced frame were attached to the opening in the wall by lengths of concertinaed white PVC, so that the whole thing formed a kind of lens, or bellows, turning the space into an inverted camera. Where outside ended and inside began was now called into question, and in what way the window acted to facilitate exchange between the two environments was equally uncertain. The effect was as if the outside, normally the place that would passively receive the gaze, directed from within, of those standing at the window, had become active and had begun to push its way into the gallery. In a related work made a couple of years later, a window frame in Calais's Galerie de l'Ancienne Poste and the radiator immediately underneath it were pulled out into the centre of the room. As in the case of *She came in through the bathroom window*, *Return to Sender* undermined any chance of the viewer being able to

establish a clearly ordered sense of inside and outside, of occupying an interior space while being able to look beyond that to an exterior that could be seen but not otherwise experienced. Before either of these works, however, Wilson had already addressed the theme in slightly different ways. In 1987 several white sticks connected to motors were attached to the external wall of an opulently decorated Baroque building in Graz, Austria. Those who entered the building to 'see' *Up a Blind Alley* were left instead experiencing the visually rich features of the palace itself to the auditory accompaniment of the unseen blind person's sticks tapping from outside. For *Leading Lights*, made the year before *She came in through the bathroom window*, Wilson blocked up all but one of the windows of a light-industrial space in Denmark. The Kunsthallen Brandts Klaederfabrik in Odense had formerly been a textile factory, and the space, the ceiling of which was supported on regularly spaced, slim circular pillars, was lit by a regular grid of lights. Running cable from each lighting point in the ceiling grid allowed Wilson to cluster all of the bulbs used to illuminate the space in the remaining unobscured window. Installed during the predominantly dark winter months, *Leading Lights* turned the gallery from a well-lit haven from the long night-time hours into a beacon trying in vain to brighten the sunless world.

The long association that had developed between Wilson and Matt's Gallery through the installations *Sheer Fluke*, *20:50* and *She came in through the bathroom window* was continued when the gallery moved to new premises in a light-industrial building next to a canal in east London. Cutting into the concrete floor of the gallery – altering it before it had even opened to the public for the first time – Wilson excavated a pit large enough to accommodate a full-size billiard table. A circular hole cut into this table allowed a large section of concrete pipe to be inserted and sunk down further into the earth below. Because the water table is so near ground level in the area, the pipe, although not very long, still reached it. Although it could not be seen, one could tell that there was water at the bottom of the pipe because of the occasional sounds of it sloshing about. One could believe that there was a fish or some other aquatic creature down there looking for a way out, although in fact the water was being agitated by a small motorized device. In addition to these features, the rhythm of falling and rising set up by the rounded pockets of the billiard table and the circular concrete pipe was echoed by the cluster of gasometers that could be seen on the far bank of the canal. It is, one understands, the uncertainties arising out of the characteristics of this particular location that are being tested, rather than a more abstract idea of disorientation.

Across the variety of Wilson's sculptural installations and larger public works there has been an abiding concern with this issue of place. The question of exactly where it is that the spectators can understand

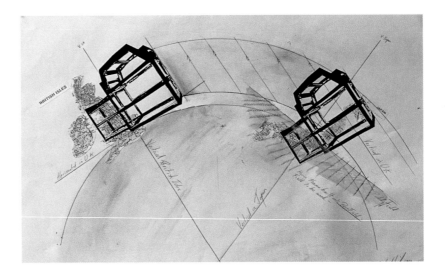

Set North for Japan (74° 33' 2"), 2000

themselves to be, both in themselves and in relation to the things around them, arises again and again. As far back as *Big Dipper*, this question is always asked in such a way that it can be answered fully only by acknowledging both its physical and intellectual implications, and by recognizing that the strength of Wilson's art lies in its complex play of the real, the artificial, the illusory and the spectacular. A public project in Tokyo in 1994 to provide an entrance to a utility tunnel led Wilson, in the face of stringent safety restrictions, to devise an access structure that incorporated features more usually found on a domestic staircase. *Pleasure Trip* brought together the arid Negev desert in Israel, close to which he had been invited to exhibit, and the River Thames. On to a screen constructed using two postcard images of the desert, Wilson projected a slide of Tower Bridge while playing a recording of the commentary on a Thames river cruise. The place of exhibition and Wilson's own, proper place, his home, were thereby brought into relation.

Most recently, *Set North for Japan (74° 33′ 2″)* accomplished the conceptually simple but practically demanding task of transferring Wilson's London home to a new site in Japan. Rather than transporting the fabric of the actual building, a metal frame mirroring its exact shape and size was constructed on location. Positioned in precisely the same spatial orientation as the London original, the new structure sits at a crazy angle to the ground, its roof half buried and its foundations up in the air as if it had plummeted to earth after a bizarre flight. What appeared at first sight to be a simple idea – let's move from here to there – thus brings about an apparent spatial dislocation that demands considerable mental effort to rationalize. That *Set North for Japan* is both spectacular and enjoyable does not detract from our need to address those cultural, political, linguistic and emotional issues that reveal themselves in the startling and disjunctive form of the work. Both in its use of the framework as a volumetric sketch of a specific place, and in its questioning of what it means to establish a relationship between one place and another, *Set North for Japan* extends the enquiry begun by Wilson in a group of works based on hotel rooms.

Any artist with an established career now spends a considerable portion of his or her time staying away from home. For someone whose work deals so centrally with place and with the orientation of the body in space, this lifestyle presents a particular set of problems. The three works of 1996 *Hotel: Zimmer 27, Central Hotel*, *Hotel: Room 6, Channel View Hotel* and *Hotel: Room 921, Empress Hotel* involved the exhibiting of a framework reconstruction of the hotel room in which Wilson was staying while installing the exhibition. Attached to appropriate parts of *Hotel: Zimmer 27, Central Hotel* were Polaroids taken in the room itself, showing its furnishings, layout and so on, a record of what might be taken back home

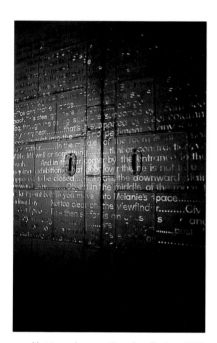

Not too clear on the viewfinder, 1992

to show others, while stuck on to *Hotel: Room 6, Channel View Hotel* were similar photographs mocked up as seaside postcards, used to keep in touch and maintain a connection while away. Set on castors, the skeletal room could perhaps be moved to wherever it is needed next time, but for the fact that its size in relation to the gallery means that it has become entangled with the lighting track and is therefore unable to escape without either destroying its present home or being dismantled altogether.

Touching on, as it were, the other side of the coin, *Not too clear on the viewfinder*, made for the 1992 Sydney Biennale, developed from Wilson's inability to see for himself the space that had been allocated to him for the exhibition. Living at that time in Berlin, he thought the easiest solution would be to ask the curator to make a record of the gallery on video and to send him the tape. When it arrived, the tape, shot as it had been in a fairly dark space that had to be entered through a set of heavy metal doors, proved to be largely indistinct and of little help in getting to know the gallery. What it lacked in visual information, however, was made up for by the apologetic commentary from the curator on the soundtrack, through which he attempted to make up for his technical shortcomings. The work as Wilson finally realized it made use of this soundtrack, etching the curator's words into the metal doors and lifting them into the space as the things to be exhibited. In shifting the doors out of their frame, the physical separation that normally existed between the different zones of the building was removed. In particular, the distinction between areas used for exhibiting and others dedicated to support services such as storage, cleaning, workshops, administration and so on became blurred. Once again, Wilson's engagement with perceptual activity and the psychosomatic parameters of spatial awareness – matters that could very easily be thought of as proper to art – is truly approachable only through reference to the larger world of real work. Similarly, the 1989 São Paulo Biennale installation *High Rise* forced a rapprochement between the realms of aesthetics and labour. A greenhouse sat some way off the floor, having apparently been rammed through the wall from the gallery into the storage area beyond. That part of the greenhouse that projected into the gallery had all its glass removed, leaving only the metal framework, while on the reverse side of the wall it remained fully glazed. Insectocutors inside the greenhouse suggested a wish to keep its interior pure and clean, a desire that would inevitably be frustrated by the fact of its being porous and open to the vagaries of the real world. This aspect of Wilson's art, leading those who encounter it to acknowledge its place both within and in relation to broader social and economic realities, lies close to concerns in the work of the American artist Michael Asher. For Wilson, as for Asher, it is impossible to maintain the illusion that the gallery exists as some detached and isolated environment solely for the purposes of aesthetic contemplation. Robert Smithson's distinction between a geographically specific 'site' – a place in the real world – and the

Jamming Gears, 1996

abstract 'non-site' of the gallery's white cube breaks down as Wilson continually folds the two back upon each other. Time and again, and usually with considerable humour, he outrages decorum and frustrates assumptions. *Lodger* involved the construction of an upside-down summer house in the small Galleria Valeria Belvedere, Milan. Cuckoo-like, it hogged the limited amount of room available, spilling out of the showing space into the corridor and other parts of the gallery. Another installation for the same gallery three years later gently tested the perfection of the space. *Cutting Corners* required nothing more than the pushing of two filing cabinets into opposite corners of the room, although given that neither corner was perfectly square it turned out not to be as straightforward as that. In order to make both cabinets fit snugly, a wedge had to be removed from one of them and inserted into the other. Contracted and expanded thus, they were now able to sit tight in corners that were slightly less and slightly more than square, their conformity to the demands of the space having been bought through the sacrifice of their usability.

In such works as *Elbow Room* at the Museet for Samtidskunst, Oslo, in 1993, and *Doner* at the newly opened Museu d'Art Contemporani, Barcelona, in 1996, Wilson can be seen to be taking on not merely the physical, but also the institutional requirements of the art world. Unable to make any alteration to the fabric of the Oslo museum, his solution was to construct a piece that included a simulacrum of the gallery. Thus, a reproduction of a section of the floor and wall of the showing space is cantilevered up off the real floor and jammed into the back of a small garden chalet. As in the case of *High Rise*'s greenhouse and *Lodger*'s summer house, the chalet invokes ways of being in, acting on and responding to nature and reality that provide an alternative to the respectful contemplation of illusion associated with the gallery. Neither of these alternative 'ways of seeing' is privileged over the other. Instead, the two engage in a tense struggle, battling it out while the viewer circles, trying to make sense of it all. The museum in Barcelona was built on ground cleared of the tenement buildings that had previously occupied it. Almost before it was completed, Wilson cut a hole in the external wall in order to pass an L-beam from an organically shaped gallery housed in a separate tower back into the main body of the museum. The beam, set next to another one that passed in a more orthodox manner down the passageway connecting the two spaces, provided a platform on which rested a brand-new Portakabin of the kind used as an office on building sites. *Doner* was completed in the same year as Wilson's project *Jamming Gears*, made to mark the closing of the Serpentine Gallery in London prior to a major renovation programme. Since the building was about to undergo large-scale structural alterations, Wilson was able to take liberties that might otherwise have been impossible. Cores drilled through several parts of the gallery – the tiled floor through to the ground beneath, the bookshop shelves

complete with stock through to the wall behind and so on – were inserted into the walls of Portakabins, whose presence in its spaces acted as a precursor to the work that was about to begin. The relationship of the cabins to the existing gallery architecture provided, as the title suggests, a set of playful improvisations that incorporated many features from Wilson's previous works. One, like *Elbow Room* and *All Mod Cons*, was jacked up at an angle. A second was left in the middle of being lowered into a pit by a forklift truck, somewhat akin to the billiard table let into the floor of Matt's Gallery in *Watertable*. The third protruded through a window, the section that had been removed to allow this being reinserted in the back of it rather as the window was shunted forward in *She came in through the bathroom window*.

With *Jamming Gears*, Wilson's treatment of the Serpentine Gallery uses techniques that can also be seen in the work of Gordon Matta-Clark. Whereas Matta-Clark was concerned through his work with laying open the relations of power built into the contemporary urban landscape, it has not, on the whole, been part of Wilson's aim to provide a social critique, let alone a critique of the institution of architecture.

It is true that throughout the past twenty years he has used materials in his art that have industrial overtones, and the way in which these materials have been manipulated has sometimes required considerable mechanical assistance. For other artists during this period, it has been important for such materials and processes to be seen in relation to an industrial past. The German sculptors Meuser and Reinhard Mucha, for example, can be understood to have made works that directly acknowledged their country's steel-making industry and railway system. In contrast, Wilson has made no such claims for his own work. In 1987, for example, shortly after completing *20:50*, he made *One Piece at a Time* in Newcastle upon Tyne. The piece was installed in one of the support towers of the Tyne Bridge and was designed to last for the duration of the festival of public art of which it was a part. Twelve hundred car parts were suspended from a false ceiling built high up in the tower. The wires from which each part hung passed through the ceiling before being tied off on a frame. A cutting mechanism on this platform would slice at random through about forty of these wires each day until, by the end of the exhibition, all the car parts had fallen to the floor below. To the rumble and thud of cars passing over the bridge above, the visitor would stand in anticipation of the next part crashing to the ground. A recording was made of the work each day, to be played back in the space the following day. Thus, over the course of the work's life, the acoustic element became more and more dense, culminating in a final day on which all 1200 pieces could be heard to fall, either recorded or live. Conversely, the thick cloud of suspended, silver-painted parts became increasingly sparse until, by the end, it had vanished

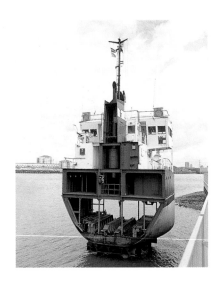

Slice of Reality, 2000

altogether, leaving the evidence of its former existence strewn all over the floor. It was primarily, as Wilson suggests, a work that transformed itself over time from a largely visual to an overwhelmingly auditory experience.

Slice of Reality, his contribution to the group of public sculptures commissioned for the riverside around the Millennium Dome in Greenwich, London, is a section of an old sand dredger set in the mud at the river's edge. Resting on an increasingly outmoded past, the functionally useless fragment of ship sits in the present as the portent of a possible leisure-oriented and non-purposive future. With *Turbine Hall Swimming Pool*, also made in 2000, Wilson drew the art world into his critique. The work was installed in the Clare College Mission Church on the south side of Southwark Park, London. Very close to Wilson's home, the park has played host to his work on more than one occasion. In 1985 *Hopperhead* marked the closure of the park's swimming pool and the poolside building's change of use from café to gallery. Where drinks had been passed through the serving hatch to customers outside, Wilson reversed the flow of liquid, draining the pool by pumping its 21,000 gallons of water through a hose and firing it as a jet of liquid into the café, where it splashed noisily into a hopperhead at the far end of the room before emptying down a drain. Film of a burst water main beneath a lawn was incorporated into 1997's *Ricochet (Going in/off)*, wherein the white ball on a billiard table acted as a screen on which the loop was projected in reverse, and for *Turbine Hall Swimming Pool* Wilson returned to the now empty and overgrown pool. A short distance upriver from the park, the new Tate Modern gallery was opening in a converted power station on Bankside. As in the case of the Dome, built on the reclaimed land of Greenwich peninsula, Wilson saw Tate Modern as embodying the transformation of an industrial past into a future in thrall to spectacle, leisure and excessive consumption. Using the swimming pool as the derelict venue for a rejected form of communal relaxation and enjoyment, he instigated his own counter-model of the turbine, one that would offer a stubborn alternative to the fate of the Bankside building. Paul Burwell was invited to spend a day providing percussive accompaniment to the sound of a small diesel generator. Sitting at his kit on a wheeled platform, Burwell was moved around the pool as he played, his body growing progressively more tired as the day wore on. A film of his performance was subsequently screened in the chapel, the projector powered by the same generator. Thus, in counterpoint to the cavernous former power station nearby, emptied of its machinery to make way for art, Wilson offered the activation of a place through an event. Playful and serious, productive and enjoyable, it was, above all, a human event.

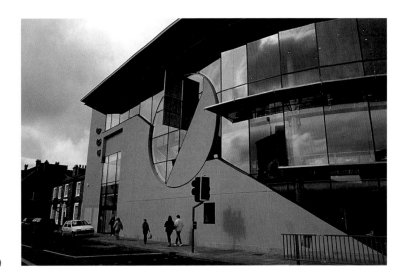

Over Easy, 1999

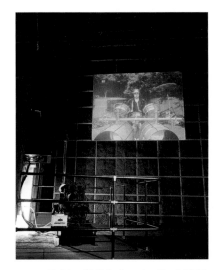

Turbine Hall Swimming Pool, 2000

It is, of course, true that Wilson's employment over the years of industrial materials and processes invites one to explore issues of de-industrialization and the end of modernity through his work. It is also true that his provocative spatial dislocations have consistently spoken to the themes of social, cultural and political exclusion. Yet it is only more recently, with *Slice of Reality* and *Turbine Hall Swimming Pool*, that he has actively sought to engage in an overt manner with such issues. In the light of those two, however, we might wish to think further about other recent works, as diverse as the public commission *Over Easy* and the smaller piece *Hung, Drawn and Quartered*. A large disc set into the façade of the Arc performing-arts centre, Stockton-on-Tees, *Over Easy* oscillates with the rhythm of the day. Light years removed from the notion of public sculpture as a diminished form of the monument, an object to decorate bleak open spaces or bland architectural forms, its swinging to and fro ties it to the lives of those who pass, enter and circulate within the centre. Their sense of the flow of time and of changes in season and atmosphere become bound up with the shifting visage of the building itself. To make *Hung, Drawn and Quartered* Wilson took pairs of shelves, cabinets and wardrobes purchased from IKEA, and intercut each pair to make three hybrid objects. While they continue to be recognizable as close relations of the items of furniture from which they have been constructed, they steadfastly refuse functionality. It is a refusal that is felt all the more strongly owing to the general amenability and user-friendliness that is habitually associated with such things. In this frustration of the consumer's orthodox expectations, Wilson's evident enjoyment of dismantling and reassembling, of formal play and physical manipulation, is revealed to have a darker, more urgent and disturbing side. That this dimension to his work has, in reality, always been there, we should not doubt.

London's Lost Riverscape
rewritten in the style of
Engineering Wonders of the World, vol. III

(or Between Contexts in the Work of Richard Wilson)

Simon Morrissey

10.30 on an overcast Wednesday morning, November 2000. Passing through the bright-yellow metal gates of the Millennium Experience site in south-east London, I head for the main entrance of the Dome to get out of the persistent drizzle. The interior itself is deserted at this time despite its being open for business. A towering map of the British Isles flashes with a rash of random red lights highlighting where the Millennium Commission has spent money, though without telling you on what. Turning the corner past the Work Zone, I take Mast Way, the main thoroughfare, through the pervading smell of fast-food-restaurant extractor fans, past the Money Zone and the Millennium Jewels ("closed until further notice" after the botched heist), towards the exit that will lead me outside again, to the Meridian Quarter.

I re-emerge into the now-strengthening rain and pass Tony Cragg's carbon-kevlar sculptures, replete with photo-opportunity bollard helpfully supplied by Official Supplier Kodak. Beyond the reed beds and the river wall, the bridge of a large ship can be seen. The industrial presence of the ship is incongruous not only within the context of the Dome's funfair-meets-supermarket attempt at celebration, but equally on the Thames itself, as working ships are now rarely ever seen on the river.

Drawing nearer to the ship, it becomes evident that there is something amiss. By the time you have reached the river walkway and can see beyond the railings, the fact that the ship has been brutally but precisely reduced in size is obvious, the expanse of what must have been her fore and aft shorn off, leaving only the powerhouse of the vessel – from the bridge down to the section of hull below that housed the engine-room – sitting on the foreshore of Blackwall Point. Her name is clearly visible on her lifebelts: *Slice of Reality*.

Richard Wilson's contribution to the Millennium Experience site, completed in 1999, is very much an object (if on a monumental scale), and in being so is precisely the inverse of what many would expect him to create. The prevailing discussions around Wilson's work, synonymous as it is with the term 'installation', have focused on his tendency to treat the architectural container in which his work is shown as material from which the work can be created, rather than an inviolate frame within which to place an object. This preoccupation is unsurprising as many of the artist's most notable works, from his classic intervention at Matt's Gallery in 1989, *She came in through the bathroom window* – where he pulled the gallery window into the space to form a physical volume that dominated the viewer – to recent interventions on an architectural scale such as *Over Easy* – where he inserted an 8-metre-diameter bearing into the Arc, Stockton-on-Tees, enabling a section of the building's façade to slowly rotate – seem to be almost entirely concerned with radically altering the viewer's expectations and experience of space.

Wilson's work has therefore come to be primarily read in relation to the physical properties of its site. But although this physical reading is crucial to understanding the artist's production, it appears

increasingly inadequate as a sole explanation for a number of his most recent projects, including *Slice of Reality*.

Go through the motions of the discussion: the work is a response to the physical properties of the site; the site of the work is the Thames; the Thames is a river; rivers are water; rivers have ships on them – so that's why it's made from a ship. But why is it cut up? What other information is there about this site? The Meridian Line passes through it; the line slices the peninsula into sections – therefore the artist slices the boat. Framed within this purely physical discussion, *Slice of Reality* does not necessarily seem a particularly engaging work. Once the implied machismo of the operation to remove the bulk of the ship has been dispensed with, the sculpture does not physically transform its site in any particularly unexpected way. It is simply a large section of ship on a river foreshore.

Standing before the *Slice*, however, this physical vocabulary and its ensuing explanation seem academic, unsatisfactory. The work has a distinct presence. It is a forlorn object, stripped of its function and purpose. A year after the work was installed she has started to deteriorate. Rust bleeds under the paintwork, streaking the truncated vessel with corrosion. Algae colonizes the bilge where the river trespasses inside. Windows are too dull to navigate by, sullied by London's dirty rain. Her tattered flags announce 'I am aground and require no assistance'. There is no illusion that she will be rescued, reanimated. And there is no sign of the sense of dynamism, of implied or overt movement, we expect from the artist's transformations either. Instead, *Slice of Reality* is leaden, inert. In place of the expected transformation we are presented with an emasculation – a once-proud workhorse reduced to an impotent shell.

The reason for this fundamentally different manifestation of Wilson's practice in *Slice of Reality* is that the physical interpretation of the site is distinctly secondary. If we approach the Thames as a site, we must acknowledge that, unlike the deliberately neutral space of most galleries, its physical context is only one part of its inherent conditions. The site's conditions are as much, if not more, determined by its social and historical contexts as by its physical parameters. Surprisingly for an artist so identified with the self-reflexive vocabulary of installation, *Slice of Reality* is not a physical response to its site but an expression of social context through sculptural form.

Except for the odd pleasure-cruiser and police launch, the Thames is now empty. It is hard to imagine that as little as forty years ago the view of the river would have been one of constant industrial traffic, the Thames being, first and foremost, the country's most important working river. In the guidebook to the Dome, *Slice of Reality* is insipidly described in the language of feel-good public relations as a "celebration" of merchant shipping on the Thames. But the tenor of the work is obviously not this simplistically positive. Her forlorn nature, her inert status, are the keys to her expression. Framed within a social context, *Slice of Reality* becomes a lament for the loss of skills and communities that worked the river. The reinstatement of this industrial remnant is an attempt to acknowledge that it was merchant ships not unlike the *Arco Trent* – the redundant 600-ton sand dredger from which *Slice of Reality* was cut – and the sailors and dockers who worked them, that played a central role in building and defining the London we have inherited.

For Bob Gibson, Director of River Tees Engineering and Welding, the company that cut the *Slice*, the meaning of the work is not in doubt: *Slice of Reality* is a metaphor for the decimated condition of merchant shipping in Britain: "sunk, shrunk and the heart torn from it".[1]

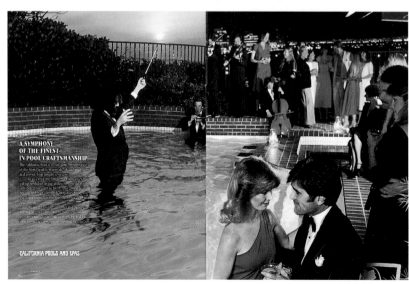

Office bookshelf (top): *Engineering Wonders of the World,* vols. I and III; *Myth and Magic,* vols. I–IV; *The Modern Plumber and Sanitary Engineer; The Amateur Mechanic; The Book of Electrical Installations; Plumbing in Building; The Second Year of War in Pictures; The First Year of War in Pictures; The Modern Painter and Decorator; Speed: The Authentic Life of Sir Malcolm Campbell; The Shark: Splendid Savage of the Sea; The Whale: Mighty Monarch of the Sea; Vauxhall Opel: Diesel Engine; Glass Houses; London's Lost Riverscape; Dockland's Life: A Pictorial History of London's Docks, 1860–1970; Disaster!; Fitting Out Ferrocement Hulls; Riverside Walks for Londoners; Old Father Thames; Conceptual Blockbusting; The Knot Book; Small Boatbuilding; Complete Amateur Boatbuilding; The Oxford Companion of Boats and the Sea; Nicholl's Seamanship and Nautical Knowledge; The Boatswain's Manual; Applied Mechanics for Beginners; Nettlefold's Screws; Rewiring a House; Safe Load Tables; Mechanical World Year Book, 1940; Theory of Machines; Packings; How to Choose and Use Car Tools; A Picture History of the Brooklyn Bridge; Breakthrough: Tunnelling the Channel; Stokers Manual, 1927; The Repair of Car Bodies; Geometrical and Technical Drawing; Structural Steelwork; Reader's Digest Repair Manual; Workshop Technology; How Things Work: The Universal Encyclopaedia of Machines 2; Round the World the Ridgeway; Ten Thousand Wonderful Things; The Oilwell Engineering Co. Ltd Catalogue, No. 26; The Tigris Expedition; Sheet and Plate Metalwork; Motorcycle Care and Maintenance; Modern Autocycles; Motor and Gas Power Pocketbook; Lessons in Heat and Light; Sir Thomas Lipton Wins; Your Book of Industrial Archaeology; Ordinary Level Physics; Tuning for Speed; Berlitz Guide to Japan.*

*

Wilson's tendency to take things apart started early. When the artist was a child, he would welcome each new present his parents gave him for birthdays or Christmas with the same response. Once he had unwrapped the present – a gleaming yellow metal dumper truck, for example – he would systematically take the toy apart.[2] Wilson's desire was not to push the new toy truck along the floor and see it run, but to take the thing to pieces to find out *how* it ran.

Although the story of the artist's precocious engineering offers an insight in itself, what is perhaps more revealing is the question it begs: if Wilson applies this form of mental and physical deconstruction to a site to fuel his work, from what references does he create the instructions to put it back together again?

The artist's eclectic library not only highlights that this fascination with how things work has persisted into adulthood, but also demonstrates that it has grown to encompass an interest in displacements of the received order of our environment. These events – from tunnelling to earthquakes, oil wells to archaeology – present new and strangely acceptable logics that we quickly assimilate. Wilson's work calls on the creation of these unfamiliar, yet somehow plausible and coherent, systems for its success, and it would be easy to ascribe the motivation for the artist's work to his interest in these disruptive physical theatres alone.

But Wilson's bookshelves also reveal that he has long been absorbed in the history of the Thames and of shipping. Indeed, as early as 1985 he cited the impermanence of the Thames as a major metaphorical inspiration in the creation of his work.[3] Importantly, the coexistence of such diverse influences is not limited to the artist's library. In fact, it is this that is precisely the key to understanding the diversity and sometimes divergent forms of Wilson's work.

Although virtually all of Wilson's works have an explicit dialogue with the space in which they are experienced, it is not the consideration of the site in isolation that gives birth to them. Any stimulus

could spark an idea: the life story of a chance acquaintance, a discarded film found in a car-boot sale, a fragment of local history. But greater than any of these single influences is the fusion of any number of them within the coincidental time frame of the artist's consideration of a site.

Wilson hinted at this in an interview given in 1995. When asked if he referred to past examples, such as previous artists' work, when making a work, he replied that "it is an amalgamation of all sorts of things: it's that point before getting on a plane; it's that point of turning some pages in a book on Walter de Maria; and then it's also picking up a manual on how to wire your house, and there is a photograph of floorboards pulled up There is a moment where they align themselves and are digested mentally into becoming the nucleus of a possible idea."[4]

Each response, each work, is one such fusion of different influences and information into a specific, hybrid manifestation. What all Wilson's works have in common is that they are all functions of his own experience. As is the case with all of us, the artist's mental landscape is made up of the things he has seen, the things he has read, the things he has done. When Wilson encounters a new site it is through the filter of these influences and experiences that he begins to read its context. The engine that starts the idea is the confluence of context – not physical context alone, not purely social context, not even only the artist's own, but the intersection between his personal framework and that of the site in its widest interpretation. And the different resonances sites provoke create the apparently radically different sets of instructions through which the work is created.

Take two divergent examples: *20:50*, 1987, and *Set North for Japan (74° 33' 2")*, 2000. The works are separated by time, geography and location. *20:50* has become Richard Wilson's 'masterpiece'. A piece whose economy of means allows a plethora of poetic interpretations, the artist's flooding of a gallery with used sump oil so that it makes a perfect and impenetrable mirror has been adopted by many critics as one of the works that defined the idea of 'installation'. It apparently refers explicitly to the gallery it inhabits, mirroring the space perfectly in its reflective surface and defined by its physical boundaries. Yet the origin of the first incarnation of *20:50* at Matt's Gallery, London, had less to do with the physical properties of the gallery than with its fusion of coincidental fragments of the artist's experience.

On holiday in the Algarve in the run-up to the exhibition, Wilson found himself struggling for an idea. He had made a work for the gallery before and did not want to repeat himself. Staring at the apartment's swimming pool, he realized he was interpreting the volume of water primarily as a surface. In his previous exhibition, *Sheer Fluke*, 1985, he had performed a large-scale metal casting. Taking the way that liquid defines space as it becomes solid in the casting process, the artist hit on the idea of treating the gallery itself as a cast that would define a volume of liquid poured into it. He remembered he had a tank of oil that he had once used for annealing steel. Because of the difficulty in disposing of the liquid, its reflective quality had become a stubborn and suggestive presence in his studio. What had been a nuisance was suddenly reinterpreted as a sculptural solution, and the work was born.

Set North for Japan (74° 33' 2") sits in an unused corner of the grounds of the junior high school in the village of Nakasato, Niigata Prefecture, Japan. Niigata is a predominantly rural province, dominated by the natural splendour of the landscape. Invited to make a permanently sited work as part of the Echigo-Tsumari Art Triennial, the artist found himself culturally adrift and acutely aware of wanting not to 'parachute' into the area, dump his work and leave.

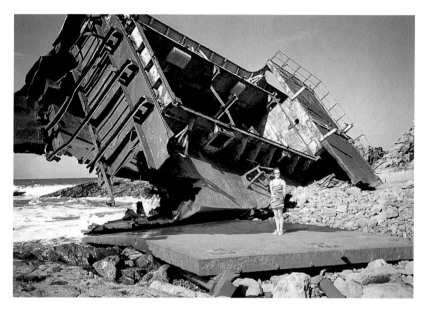

In response to this feeling of dislocation, Wilson found himself focusing almost exclusively on its mechanics in an attempt to trigger a response. The essential ingredients of the situation were that the artist, who is normally in Bermondsey, South London, was now in Nakasato, Niiagata, Japan. What is normally on one side of the world was now on the other. The situation was essentially the same as when Wilson was invited to create a public work to disguise a set of subterranean maintenance steps in Tachikawa, a suburb of Tokyo, in 1994. In *Entrance to the Utility Tunnel*, he placed an outsized aluminium-and-steel version of a typically English staircase over the workers' entrance. In Nakasato he adopted a similar tactic, again mixing contexts, colliding the Japanese with the English. But rather than transport an emblematic or stereotypical object, for *Set North for Japan (74° 33' 2")* Wilson transported that which is closest to him: his home.

The sculpture is a near-full-scale reconstruction of the artist's London terraced house reduced to a steel frame. The structure is upside down, however, its roof embedded in the ground and rising up at a displaced angle. It is as if the house has been literally torn free of its foundations in London, as Dorothy's house was torn from Kansas by the tornado in *The Wizard of Oz*. Crashing back to earth in Japan, the house tries to maintain its original identity and function, but it has been displaced by 74 degrees 33 minutes and 2 seconds from true north, and therefore it is exactly its attempt to maintain its relation to England's perpendicular and horizontal that subverts it so totally: its attempt at colonization overpowered by its new context and abandoned.

Despite their radically different manifestations – one installation, one object; one gallery-based, one publicly sited – *20:50* and *Set North for Japan (74° 33' 2")* both arise from the same methodology. Both owe their physical manifestation to the artist's processing of context through the filter of his own experience.

The method is the same but the pattern is different every time.

*

Office bookshelf (middle): *Contemporary Drummer; Percussion Instruments and their History; Jazz Jamboree 1958; The Big Beat; Traps: The Drum Wonder; The Music of Man; The Rolling Stones Chronicle; Gamelan en andere gong-spel ensembles van Zuidost-Azie; The Who in their Own Words; A Guide to the Gamelan; Up and Down with the Rolling Stones; Crossfire: The Plot That Killed Kennedy; Train Wrecks for Fun and Profit; Sacred Elephant; Whale Nation; Mexico: A Travel Survival Kit; Petter Diesel Engines; Pool; A–Z of London; Atmosphere, Weather and Climate; Geometry; Teach Yourself Quick and Easy German; California; The Oxford Dictionary of First Names; A Book of Nonsense; Future Shock; The Story of Rotherhithe; Brunel's Tunnel ... and Where it Led; Firing Days: Reminiscences of a Great Western Fireman; Amazing Architecture from Japan; The Boys' Book of Science and Invention; Great Events of the Royal Year 1953; Sunset Swimming Pools; Maritime Greenwich; Southwark, Bermondsey and Rotherhithe in Old Photographs; Know How 2; Desert Poetry; Milestones in Light Engineering; Improve Your Snooker; The Modern World Book of Machinery; Fire!; An Introduction to Islamic Arms; Chessmen; Damon Hill's Grand Prix Year; Racers; Sailing Round the World; The Book of Heroic Failures; Myford ML7 Lathe; The World's Greatest Cranks and Crackpots; India: Land and Peoples; 1000 Extraordinary Objects; The Modern Encyclopaedia for Children; Butterflies and Moths in Britain; Modern Garden Craft, vol. 1; Isambard Kingdom Brunel; The Ladybird Book of Motorcars; Tales of Power; Heidegger; Riding the Iron Rooster: By Train through China; 1955 Gadgets Manual; The Electric Kool-Aid Acid Test; Jack the Ripper: The Final Solution; Understanding Media; Self Help House*

Repairs Manual; The Book of Bubblecars; The Scientific Study of Scenery; Diary of a Century; The Fireguard's Handbook; The Railway Navvies; Modern Magic; World Understanding on Two Wheels; Renderings; Zen and the Art of Motorcycle Maintenance; 921 Earthquake.

*

In referencing some of the artist's most recent works, what is noticeable about both *Slice of Reality* and *Set North for Japan*, apart from their divergence from more strictly defined ideas of 'installation', is that they are both publicly sited. Although this factor has had an inevitable influence on their manifestation, it is not so much a case of Wilson adopting different methods for this arena but rather of each individual circumstance providing more or less resonance for the artist.

This is demonstrated by the purely spatial concerns of other publicly sited works, such as *Over Easy*, or, inversely, by Wilson's gallery-based works that have commented on the wider social context. In 1994, for example, the artist was invited to exhibit *20:50* and create a new work for the Museum of Contemporary Art in Los Angeles as part of the UK/LA Festival. This work, *Deep End*, took the form of a holed and inverted fibre-glass swimming pool, its Bahamas-blue interior connected by a 60-foot steel pipe to the skylight of the subterranean gallery, allowing it to function as a huge ear, funnelling down the sounds of the street above.

In interview Wilson makes the social questioning inherent in the installation self-evident. The artist describes how it struck him, when flying over the Los Angeles hills to visit the museum, that there was a "peculiar" lifestyle being played out below him in the conspicuous consumption of mansions and private swimming pools. Ironically, *20:50* was made from the product that made California rich. In its new context the work gained a new social relevance. He decided he would use the swimming pool as a complementary metaphor. Oil and luxury swimming pools could represent money and leisure – the backbone of the Californian dream.[5] "The swimming pool ... symbolises this strange lifestyle centred upon the idea of the perfect dream. My pool is a shell that has been inverted so that one sees its rather grotesque, ugly, exterior surface, which ordinarily one would never see. Analogously, we have the 'paradise' of California. But if you go swimming in the Santa Monica Bay, you need an injection when you come out."[6] Despite being located in the neutral environment of the modern museum, physical intervention again hosted social comment. *20:50* and *Deep End* became California: grandeur built from a pollutant, and a lifestyle shot full of holes.

Pick a few books from the office shelf. First: *Southwark, Bermondsey and Rotherhithe in Old Photographs*. Choose again: *Petter Diesel Engines*. Last one: *Contemporary Drummer*. Where the intersection of Wilson's own context and that of the site is at its most involved, it has produced some of his most challenging works since the classic gallery interventions of the late 1980s. *Turbine Hall Swimming Pool* (2000) presented the artist with a unique confluence of extremely local factors, its site being only a few minutes' walk from the house he has lived in for twenty-five years.

Asked to make a work for the deconsecrated Clare College Mission Church on the edge of Southwark Park, London, by the Café Gallery, Wilson began to consider how he would animate the vast and near-derelict space of the concrete church. Only a few miles away Tate Modern was about to open, and the coincidence of this once-derelict cathedral for generating power being turned into an art gallery drew the dereliction both of the church and other prominent community features in the local area – such as the open-air swimming pool the artist had used in his previous work for the Café Gallery, *Hopperhead*

(1985) – into sharp contrast for him. He decided he would turn the church into a generating station, inverting the process at Tate Modern, to question the decay of the church and the swimming pool.

Calling on his knowledge of engines and his past activity as a member of the percussion performance collective the Bow Gamelan Ensemble, Wilson created a form of symbiosis – part duel, part duet – between man and machine, swimming pool and church. Dividing the body of the church with a vast wall of acoustic insulation, he installed a fully functioning Lister Petter diesel engine in the space. Passing behind the insulation, the viewer found the engine noisily sustaining a video projection of Paul Burwell, one of Wilson's collaborators in the Bow Gamelan Ensemble, drumming a frenetic response to the engine's relentless rhythmic drone from inside the derelict swimming pool.

Predicated on a supply of mechanical energy that would eventually be turned off and an unsustainable human effort, *Turbine Hall Swimming Pool* was a meditation on transformation, sustenance and endurance, and, in turn, a complex metaphor for the interrelation between the physical decay of community buildings and the effect this has on the communal and creative expression they fostered.

Turbine Hall Swimming Pool highlights the fact that Wilson's works represent an attempt to take a place apart, then reassemble it to allow the ordinary stuff of the world to say something more about where we are and what we see than it did before. Neither purely internal dialogues, nor responses derived solely from the physical conditions of the site, his works are essentially a fusion of two contextual destinations: the intersection of the artist's personal context and the external context of the site.

As I finish writing, I notice the lyrics of the song drifting out of the radio:

It's not where you're from,
It's not where you're at,
It's not where you've been,

It's where you're between ...

It's not what you've been,
It's not what you've seen,

It's where you're between,

It's where you're between ...

Notes:

1. Recounted in conversation with Richard Wilson, 2001.
2. Recounted in conversation with Richard Wilson 2001.
3. Richard Wilson interviewed by Lynne Cooke in *Heatwave*, exhib. cat., Ikon Gallery, Birmingham, 1985.
4. Richard Wilson interviewed by Jeremy Till in *Artifice*, no. 2, 1995.
5. Recounted in conversation with Richard Wilson, 2001.
6. Richard Wilson interviewed by Paul Schimmel, *Deep End*, exhib. cat., British Council and the Museum of Contemporary Art, Los Angeles, 1994.

Big Dipper, 1982
Chisenhale Works, London

A circular wooden structure supporting a sand mould was constructed around a central support column on the ground floor of a fire-damaged former industrial space. Over a period of days, molten aluminium was poured in to form a complete cast ring around the column, effectively locking the sculpture, its manufacturing structure and the building together. The sculpture had to be destroyed to be removed.

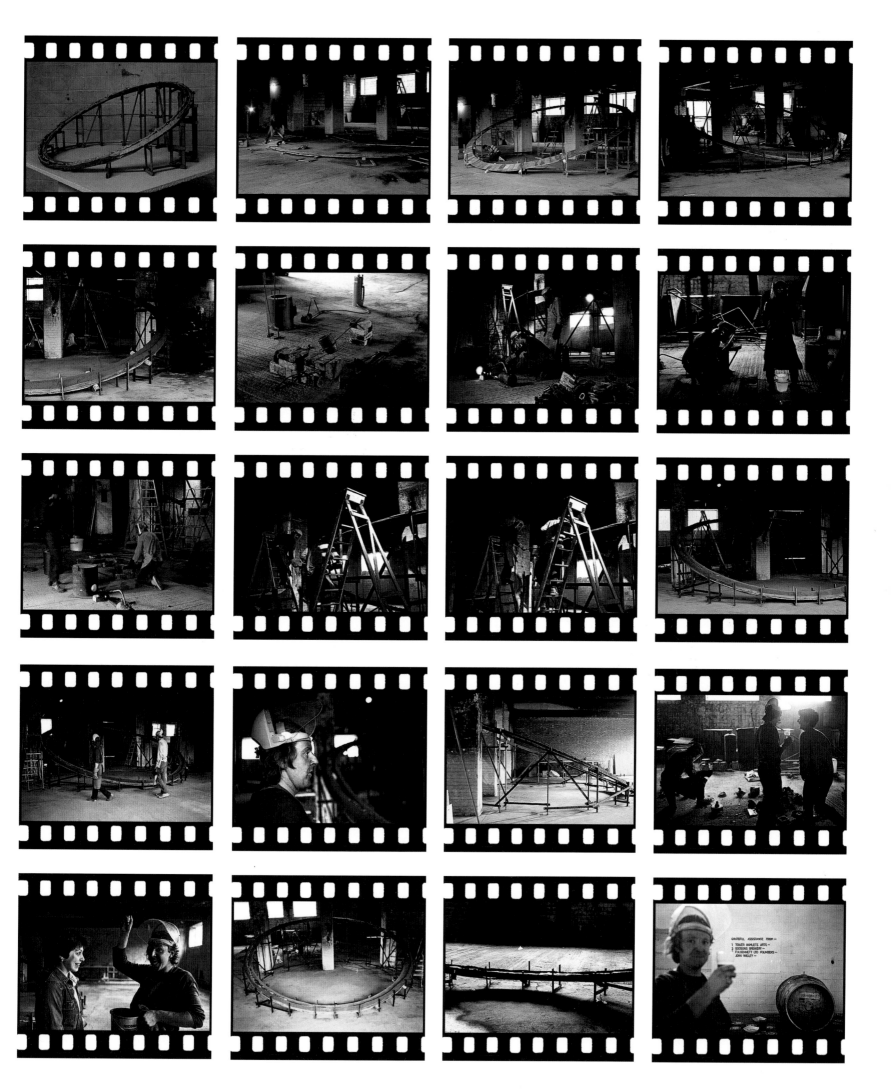

Hopperhead, 1985
Café Gallery, London

Over the duration of the exhibition, 21,000 gallons of water were
pumped from the outdoor swimming pool adjacent to the gallery
and fired as a jet, over a 33-foot trajectory, through a hole in a
window into a specially manufactured metal hopper. The water
was then channelled away to a drain outside.

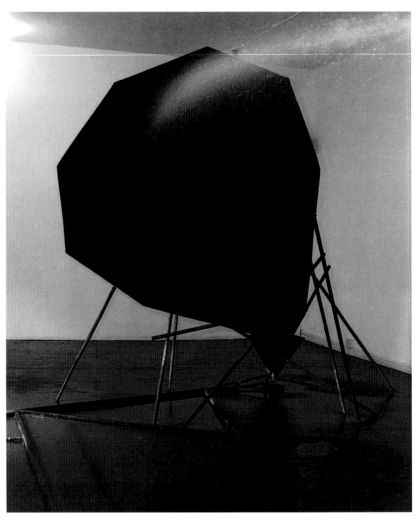

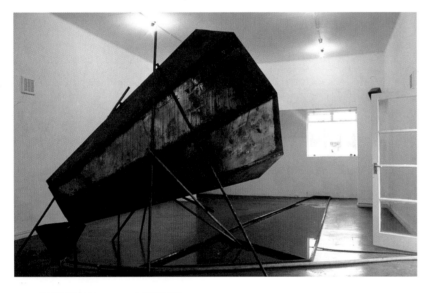

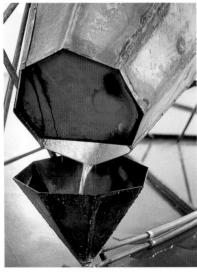

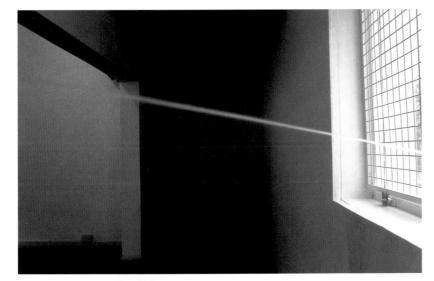

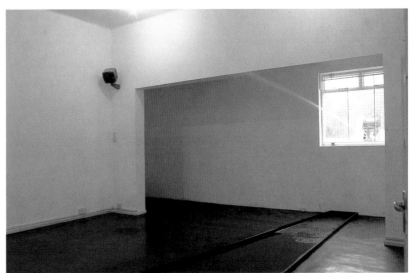

Sheer Fluke, 1985
Matt's Gallery, London

An aluminium beam was cast in the space and subsequently
suspended from the ceiling in the same position in which it was
cast. The beam arched from the entrance to the room to the far
corner, where it met the inverted flukes of a whale, drawn on the
wall in soot from an acetylene torch. A single tungsten light was
mounted on the floor, illuminating the drawing. A short text about
the manufacture in 1927 of the plaster blue whale at the Natural
History Museum hung in the entrance to the exhibition, which
was bathed in blue light.

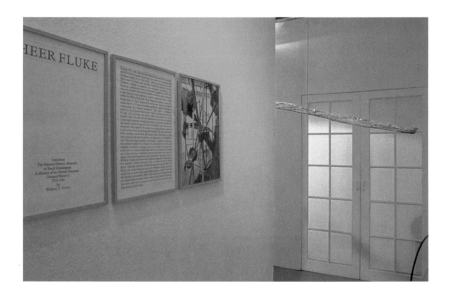

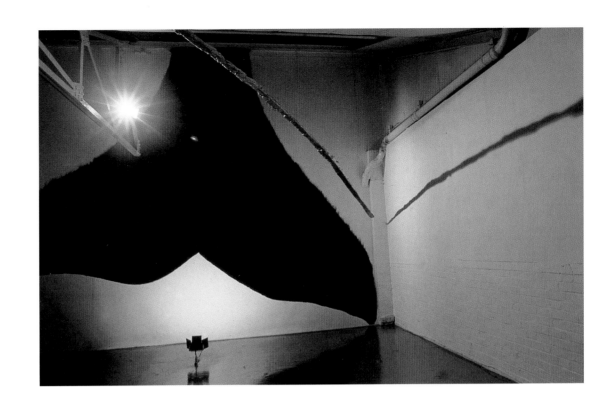

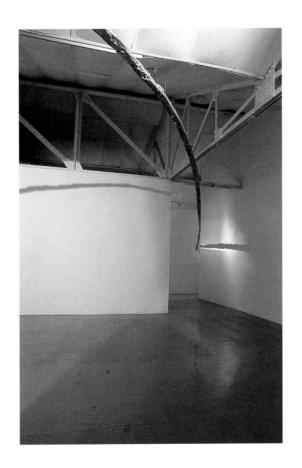

Heatwave, 1986
Ikon Gallery, Birmingham

The work consisted of an ever-expanding curve that wound itself out
into the basement gallery from a starting point near one of the
building's supporting columns. The column at the hub of the curve
was blackened with soot, intimating the casting of the curve from
molten aluminium in the space.

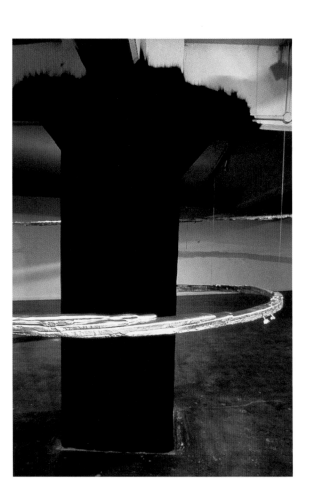

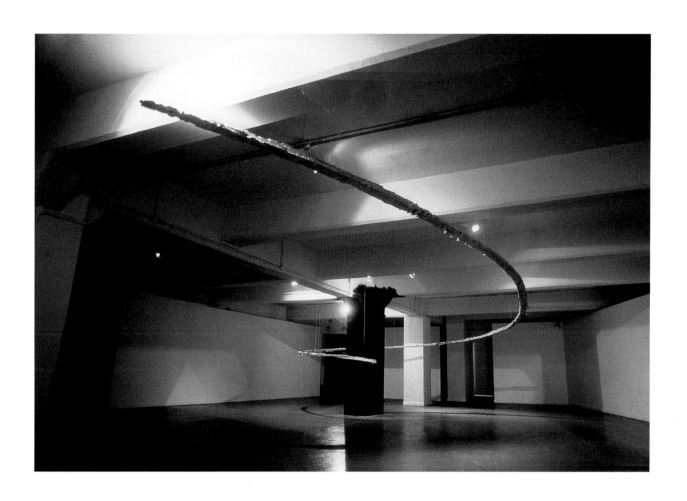

Halo, 1986
Aperto, Venice Biennale, Venice

On a titled wooden platform, the artist threw molten lead from a
ladle on to a sheet of heat-sensitive paper cut to fit the platform's
surface. On contact with the paper, the molten metal created blue
marks that arrested the moment of contact. The resulting drawing
was removed and suspended on the wall, and the activity was then
repeated by the artist, with the lead allowed to cool on the surface
of the platform.

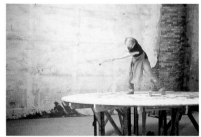
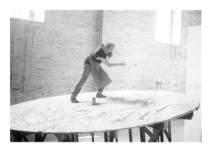
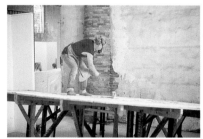
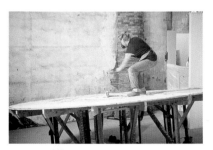

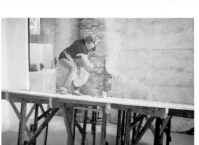
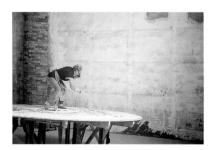
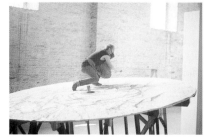
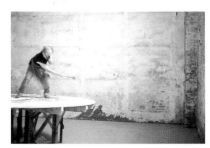

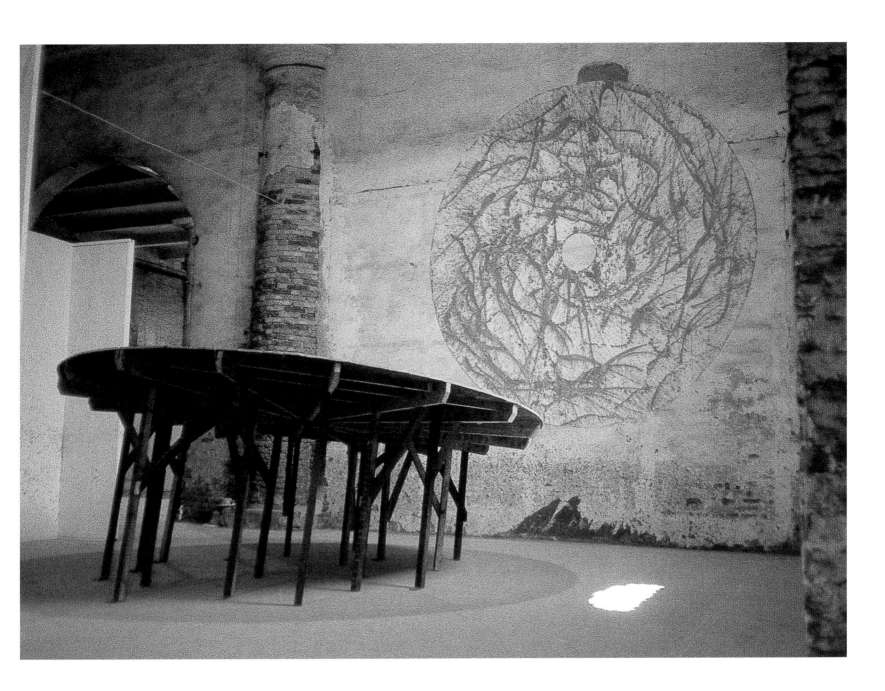

20:50, 1987–96
Originally installed Matt's Gallery, London, 1987, and subsequent
venues 1987–96

The gallery is filled to waist height with recycled engine oil, from
which the piece takes its name. A walkway leads from a single
entrance, taking the viewer into the space until he or she is
surrounded by oil on all sides. The impenetrable, reflective surface
of the oil mirrors the architecture of the room exactly, placing the
viewer at the mid-point of a symmetrical visual plane.

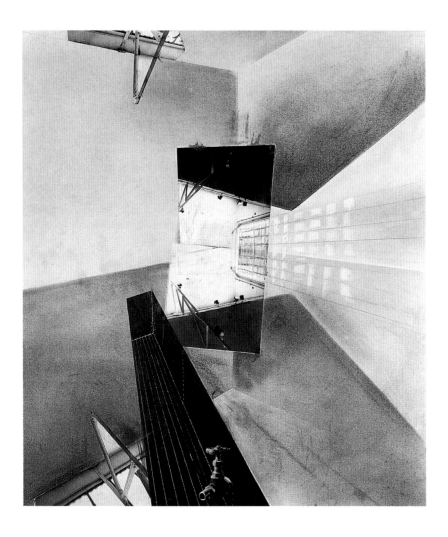

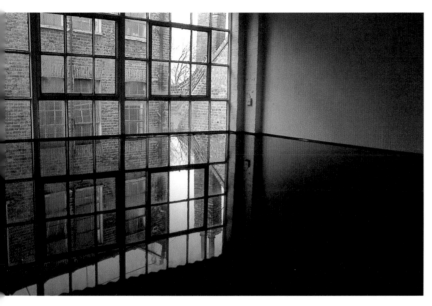 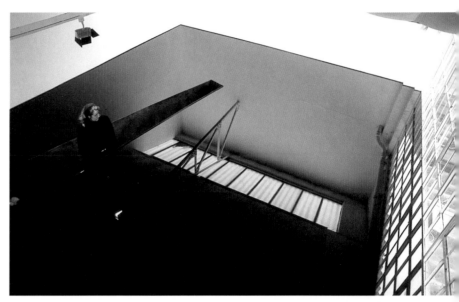

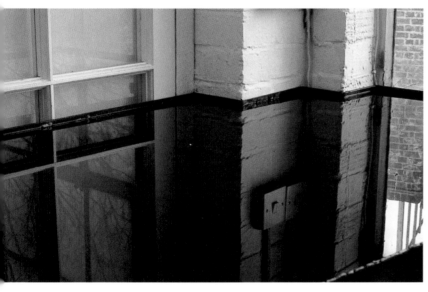 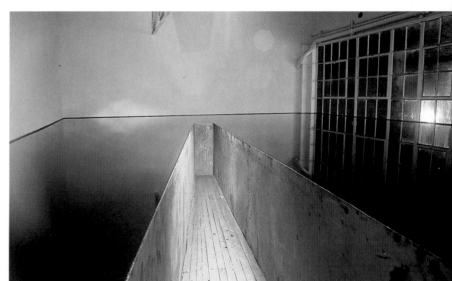

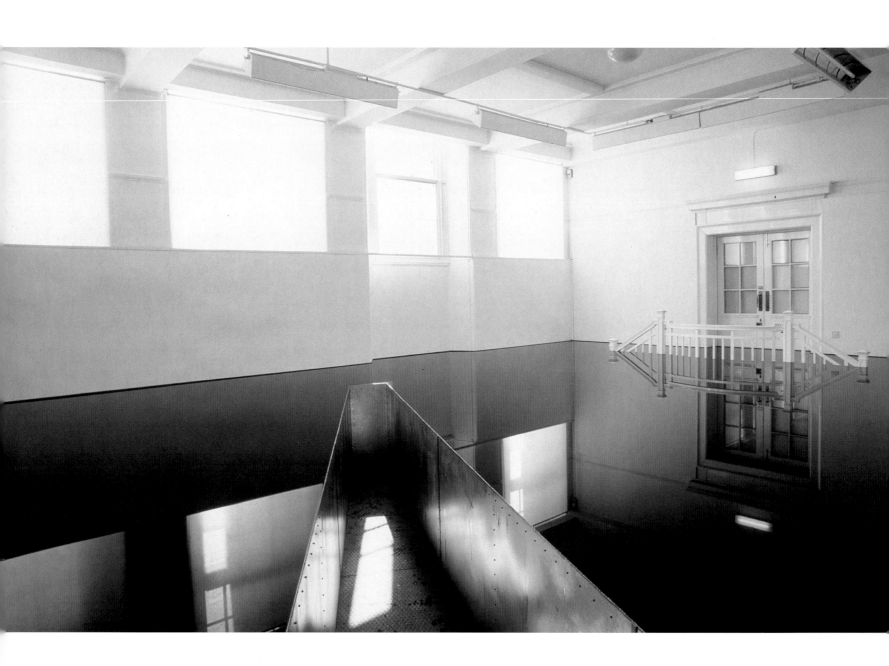

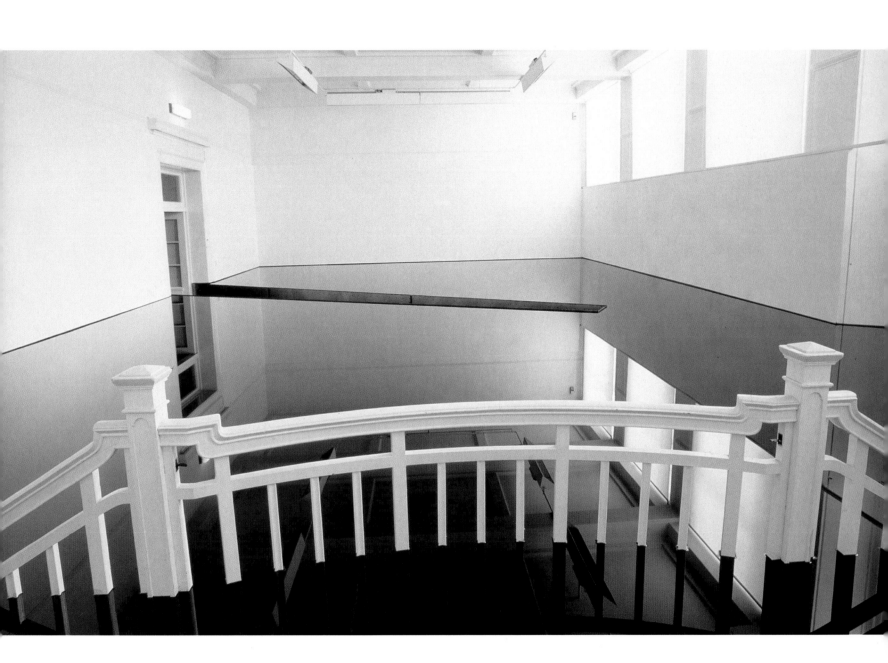

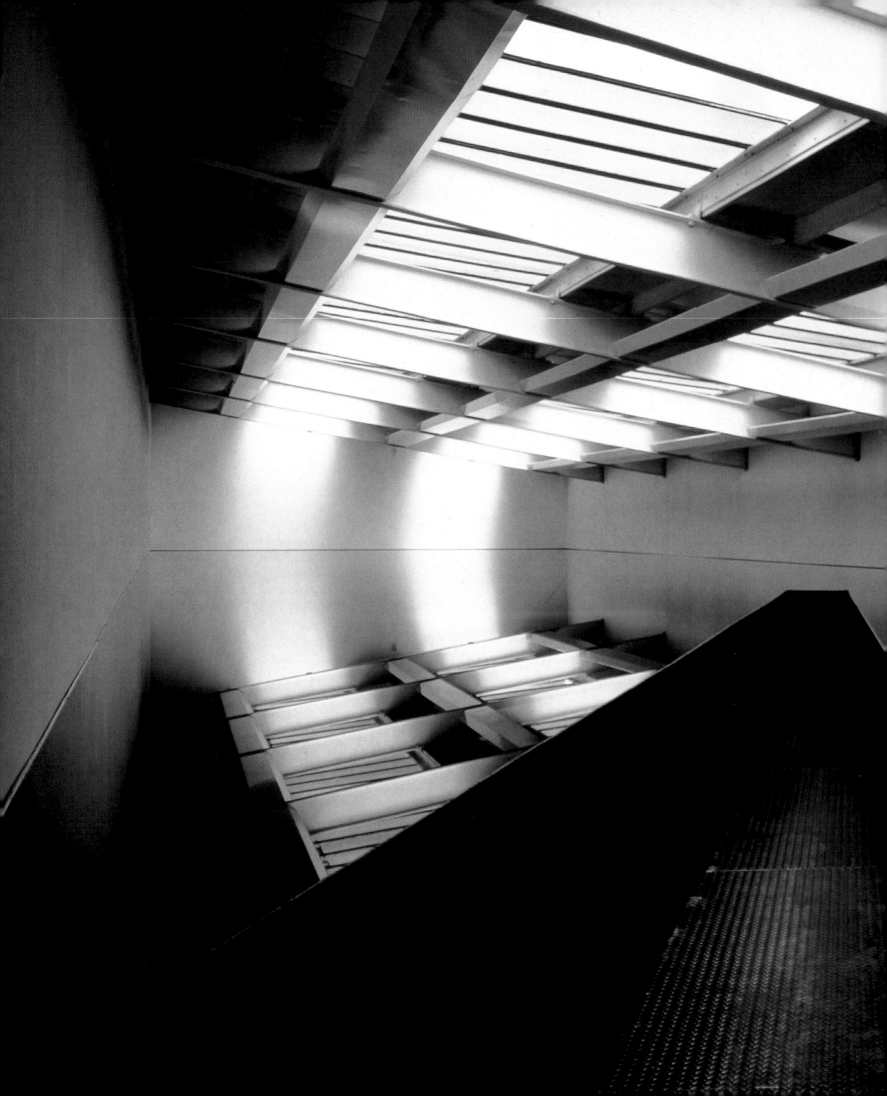

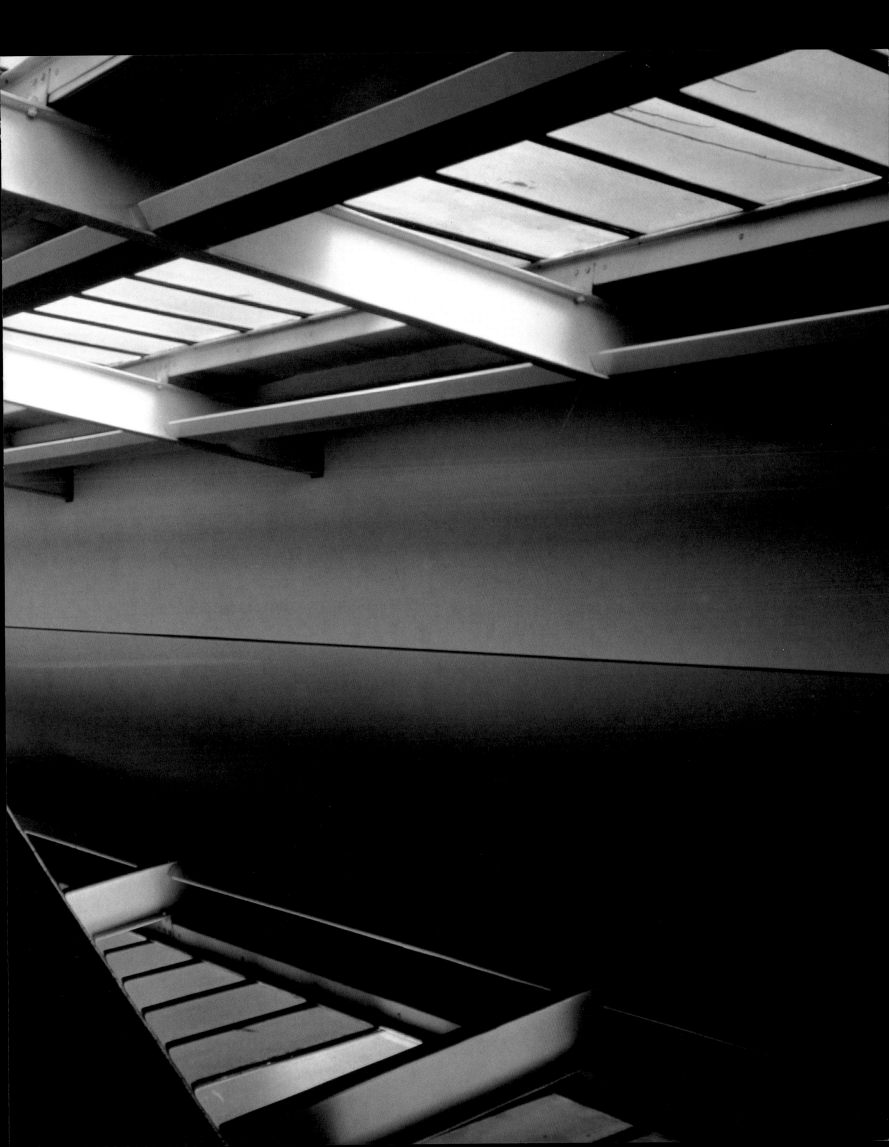

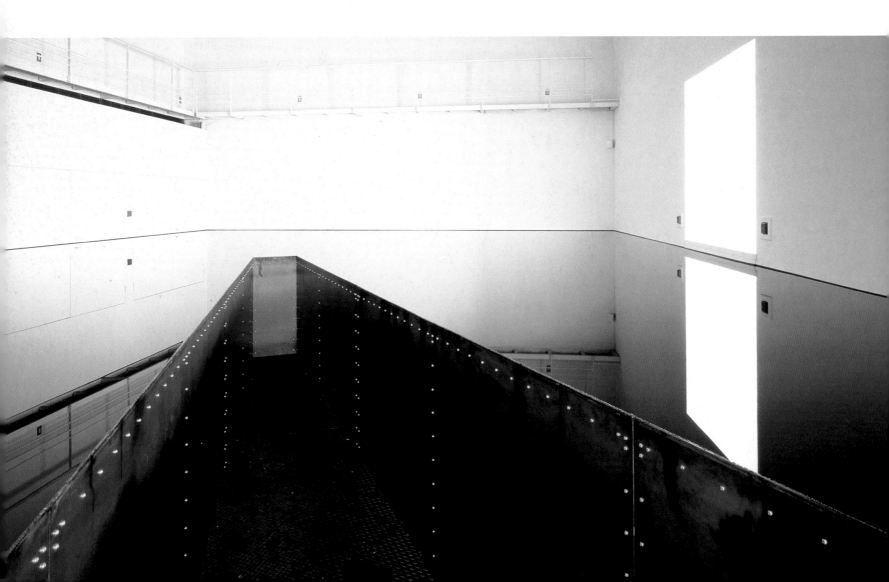

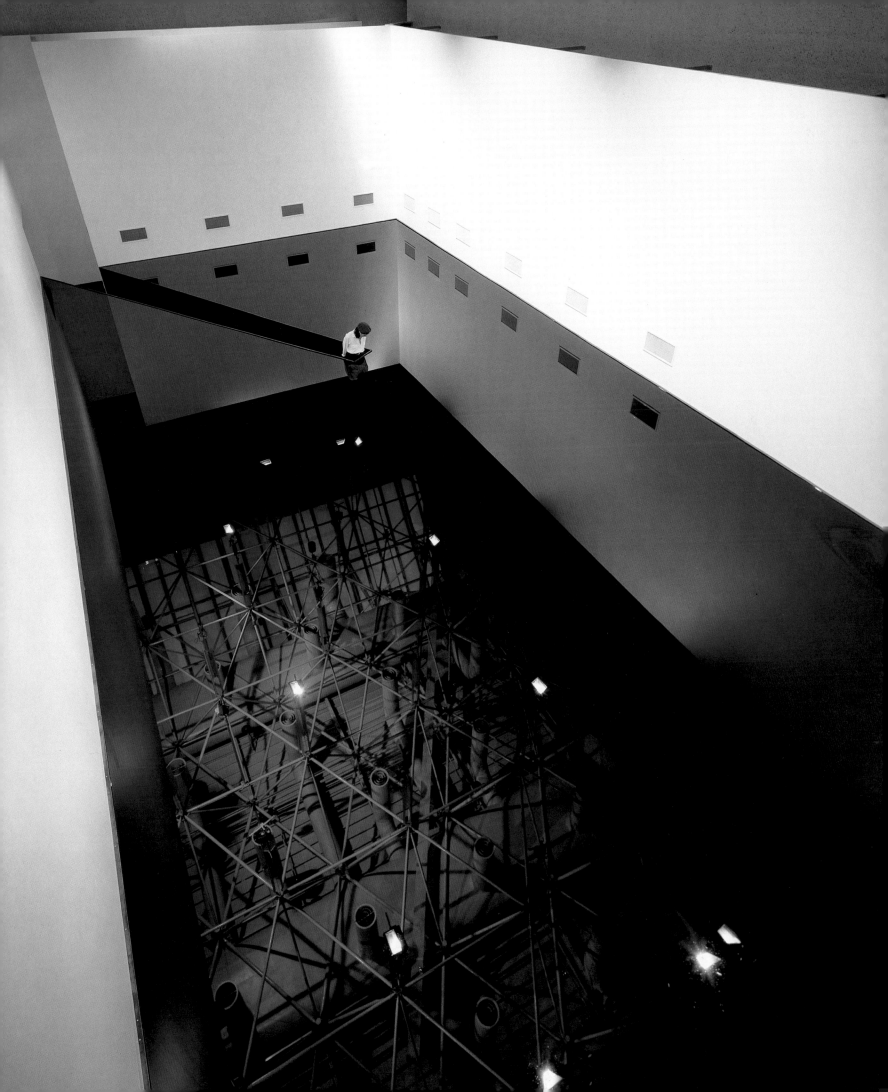

One Piece at a Time, 1987
South Tower, Tyne Bridge, Gateshead

Twelve hundred second-hand car parts were suspended by wires from a platform mounted in the roof of the tower. Over a period of five weeks a motorized cutting mechanism cut approximately forty wires per day, causing the car components to crash to the floor. The sound of the falling metal was recorded, layering actual sounds of falling material with previously recorded noise. At the end of the exhibition all of the car parts had fallen to the ground, leaving only the accumulated sound of the 1200 components falling.

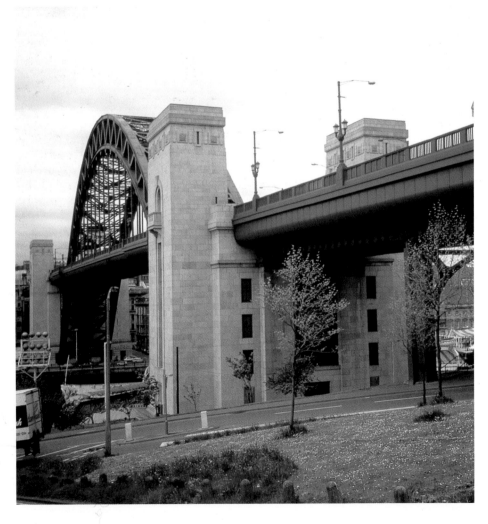

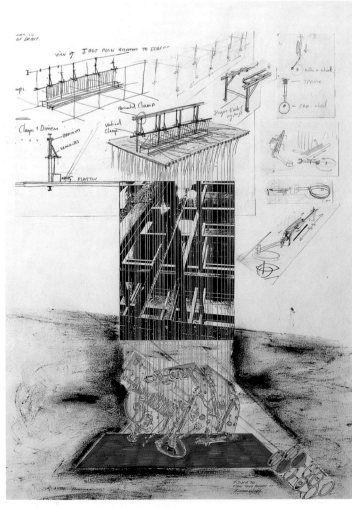

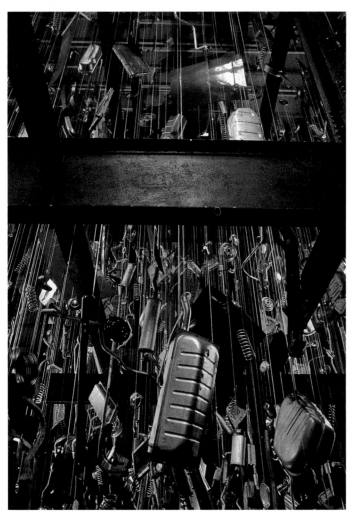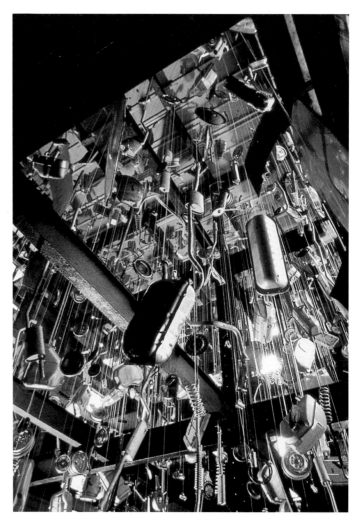
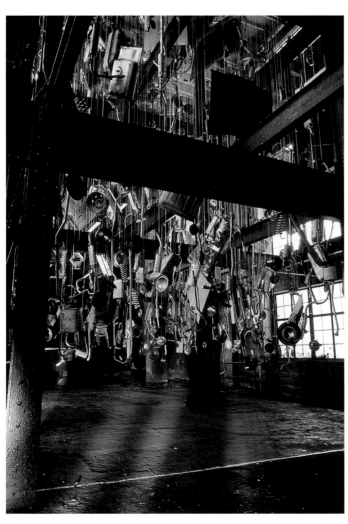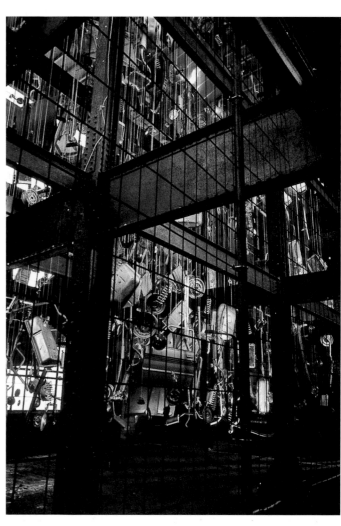

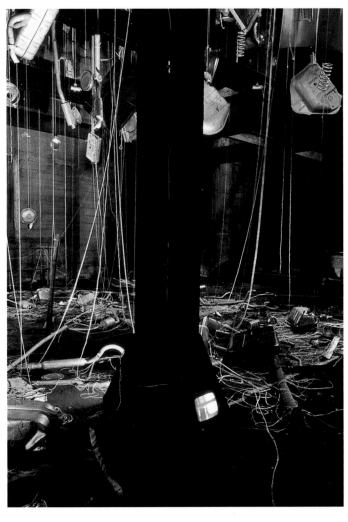
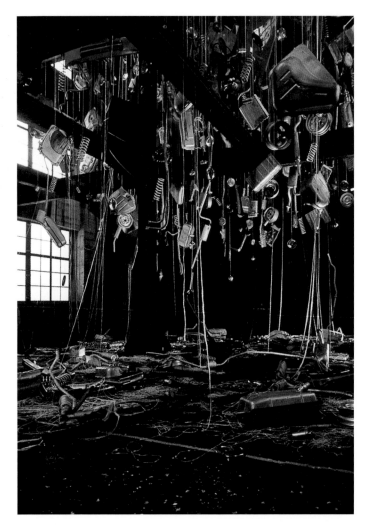
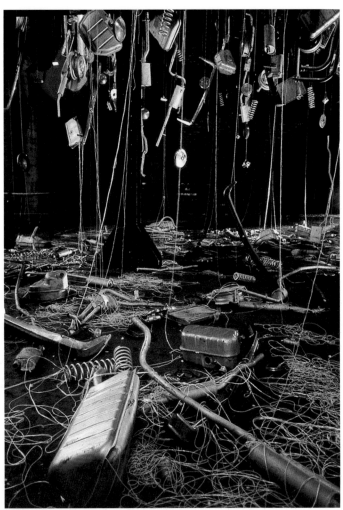
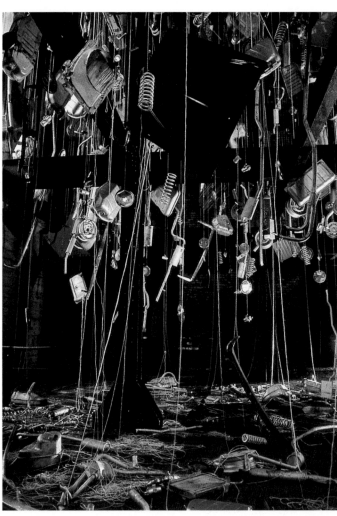

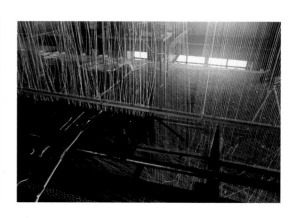

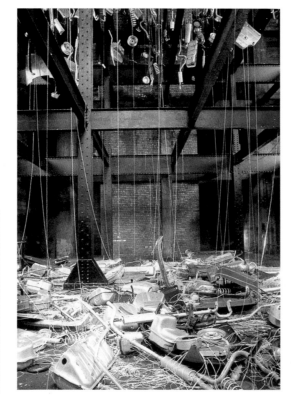

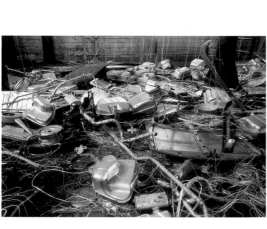
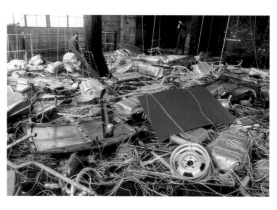

Up a Blind Alley, 1987
Trigon Biennale, Graz, Austria

The work consisted of seven motorized, gilded, blind person's
sticks, tapping the exterior wall and window of the room in which
the artist was invited to exhibit. The artist left this room untouched.

Up a Blind Alley, 1987
Trigon Biennale, Graz, Austria

Hot, Live, Still, 1987
Plymouth Art Centre, Plymouth

The work was made within the framework of an exhibition on the
theme of self-portraiture. Inspired by the presence of a functioning
gas tap within the gallery space, the artist conceived of two
portraits, one the result of the heat from fire and the other the result
of the light from fire. The two pieces comprised a photograph of
the artist's body outlined in flame and another image generated by
tracing the outline of his body with an arc-welder on to thermal
paper. A continuous gas flame burnt in the gallery.

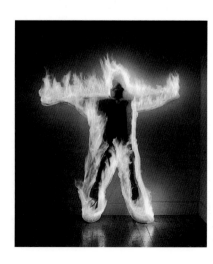
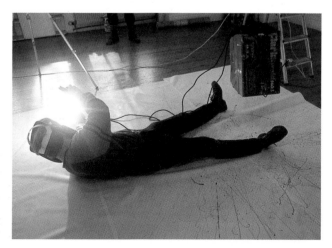

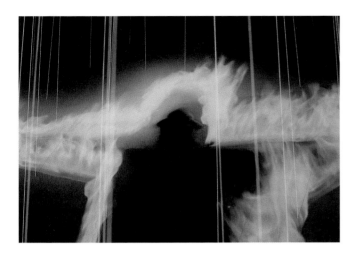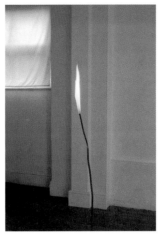

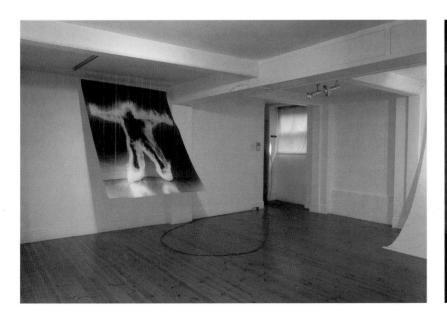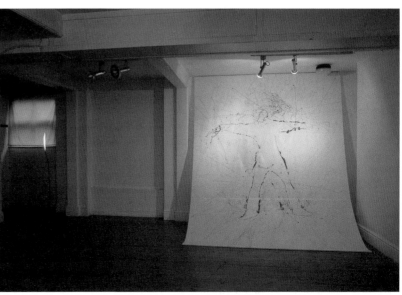

Luma Light Factory, 1988
Unrealized proposal for Luma Light Factory, Glasgow

Before World War II, the 84-foot glazed tower of the derelict light factory was a prominent beacon on the Glasgow skyscape, intensely illuminated throughout the night. The artist proposed to reanimate the redundant tower with a series of unpredictable light effects between 8 pm and 2 am that would combine to produce an effect not unlike fireworks exploding within the building.

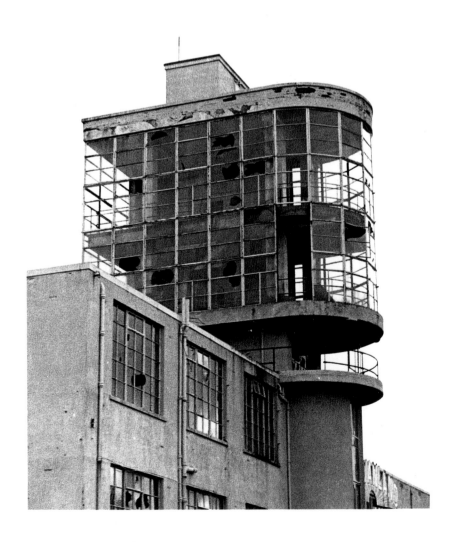

WAR DAYS·-----BLACKOUT

IM GOING TO GET LIT UP WHEN THE LIGHTS GO UP IN LONDON
IM COING TO GET LIT UP AS IVE NEVER BEEN BEFORE
YOU WILL FIND ME ON THE TILES-YOU WILL FIND ME WREATHED
IN SMILES
IM GOING TO GET SO LIT UP ILL BE VISABLE FOR MILES

Lyric of popular song(1943)

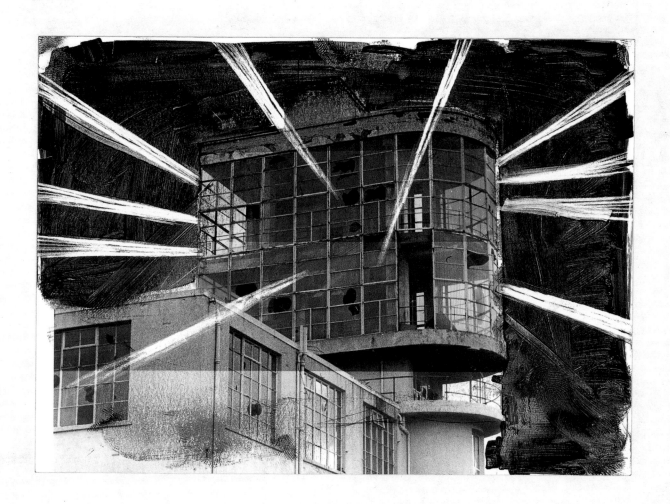

Chroronzon, 1984
Covent Garden, London

At the invitation of Paul Burwell, the artist collaborated with the
drummer on a 'hit-and-run' musical performance. The pair drove a
transit van into Covent Garden and swiftly unloaded an array of
industrial components. They then carried out a fifteen-minute
percussion piece accompanied by pyrotechnics. At the close of the
piece, the instruments were quickly disassembled and returned to
the van, and the area swept clean. The artists then drove off at high
speed, dragging some of the instruments behind them.

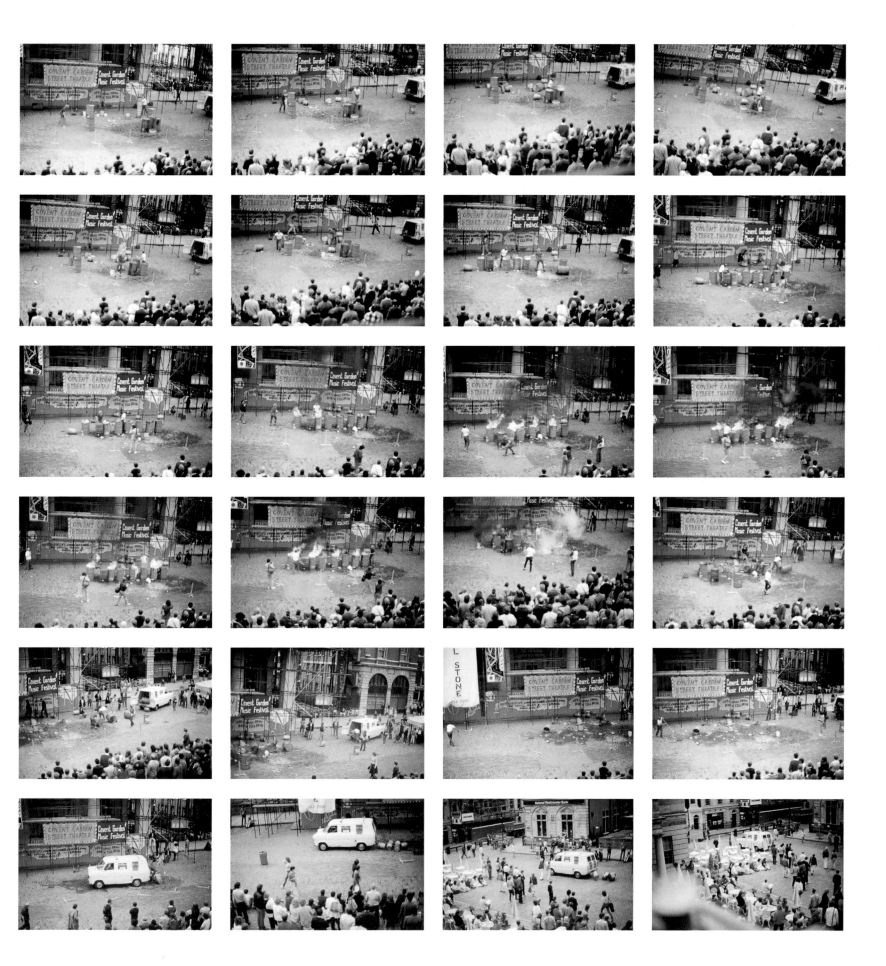

Leading Lights, 1989
Kunsthallen Brandts Klaederfabrik, Odense

The eighty lights originally set into the ceiling of the space were
removed, extended using electrical cable and relocated in the cavity
between the double glazing of one of the gallery's windows. The
amassed bulbs were illuminated all day, creating an intense heat
and unbearable light in the confined space that made them very
difficult to approach or look at.

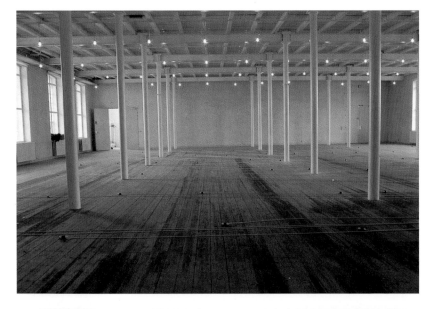

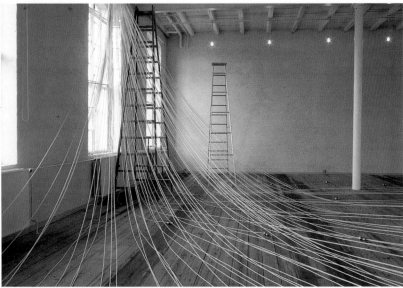

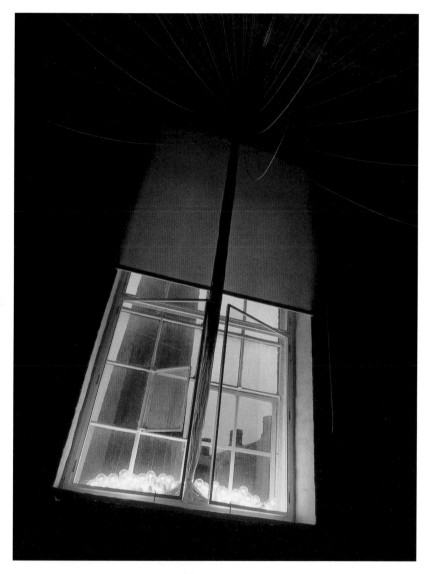

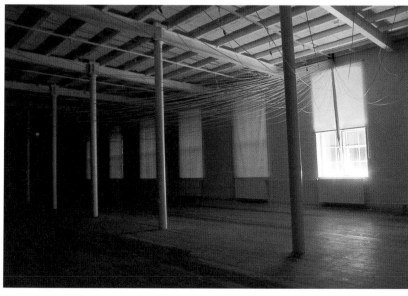

Sea Level, 1989
Arnolfini, Bristol

A galvanized open-grille flooring was installed within the gallery space, rising on a gentle incline from the entrance to the far-corner window, resulting in the floor level being flush with the base of the window. An industrial gas heater was placed under the grille, adjacent to the window, causing the temperature of the room to intensify with the incline of the floor.

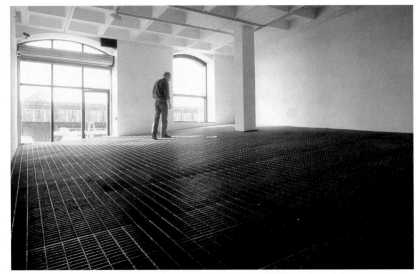
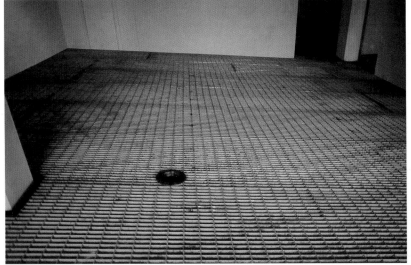
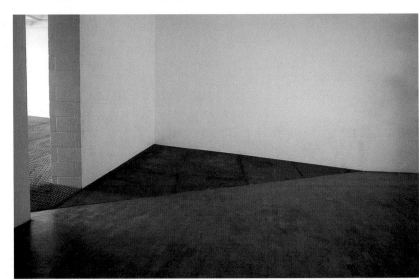

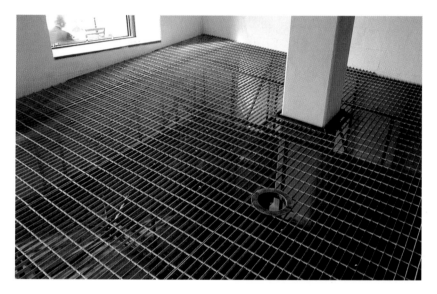

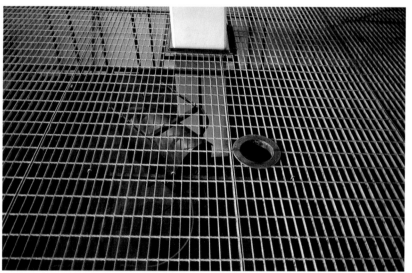

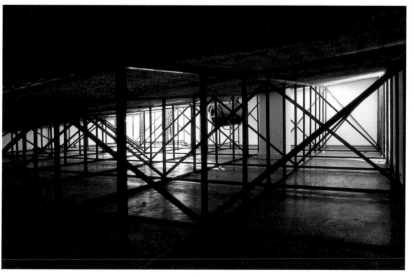

High-Tec, 1989
Museum of Modern Art, Oxford

An inclined concrete column rose from the gallery floor as if to
support the roof structure. The column, however, terminated in
the open space of a skylight, therefore performing no structural
function. Instead, it served only to interfere with the gallery's
standard features, displacing two lighting tracks from their
normal positions.

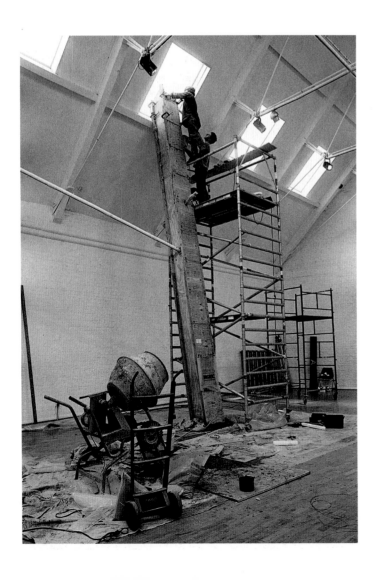

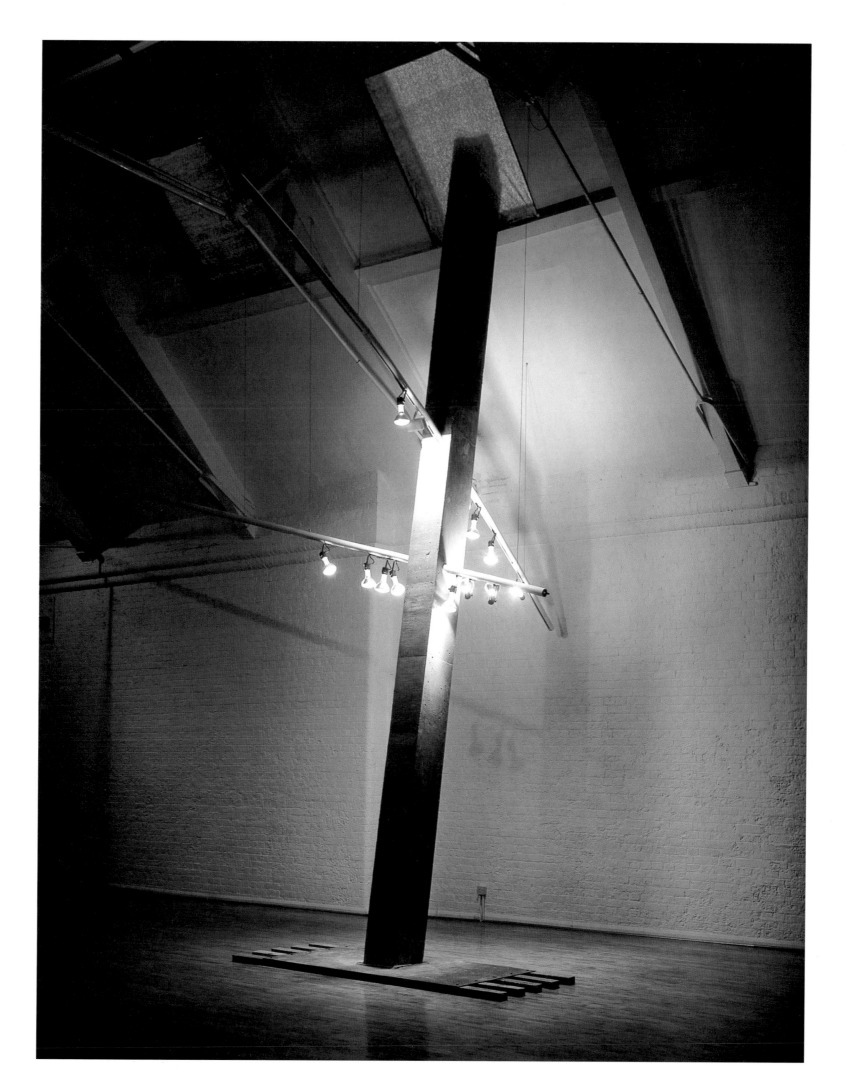

She came in through the bathroom window, 1989
Matt's Gallery, London

A section of gallery window was removed from its housing and brought into the gallery space. The displaced window was joined to a metal armature, clothed in folded, rubberized fabric, which protruded into the space beyond the building. The space the sculpture now delineated was positioned so as to occupy the greater part of the interior of the gallery.

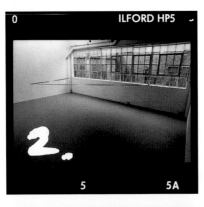
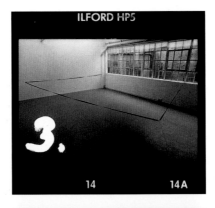
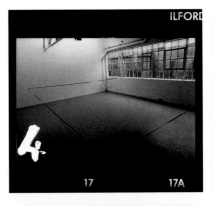
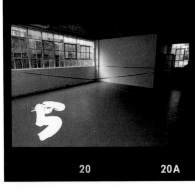
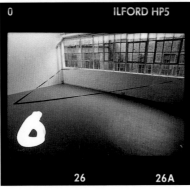
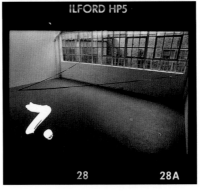
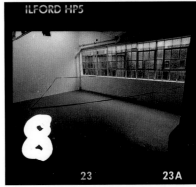

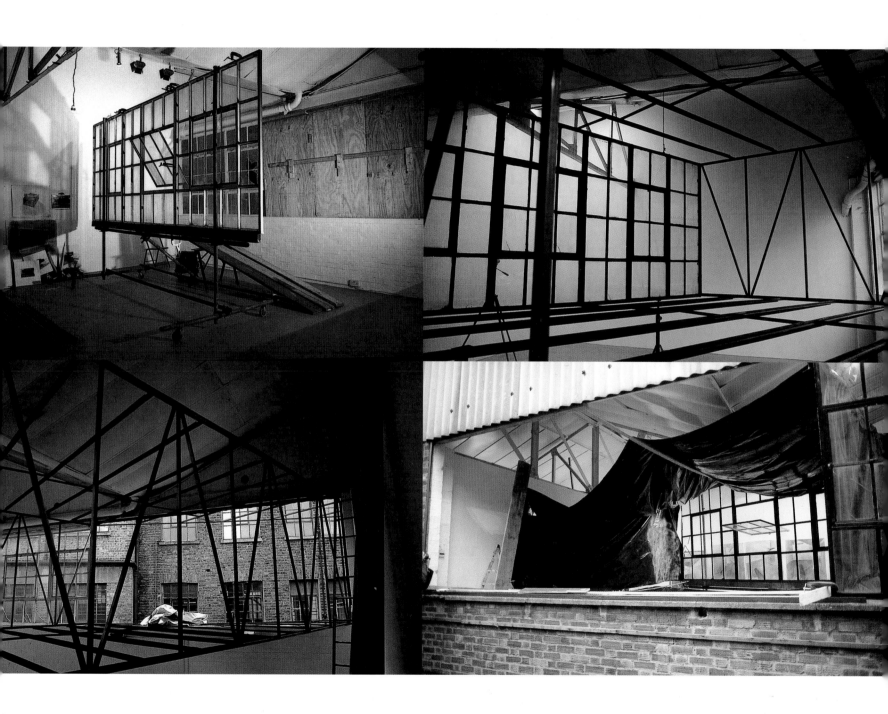

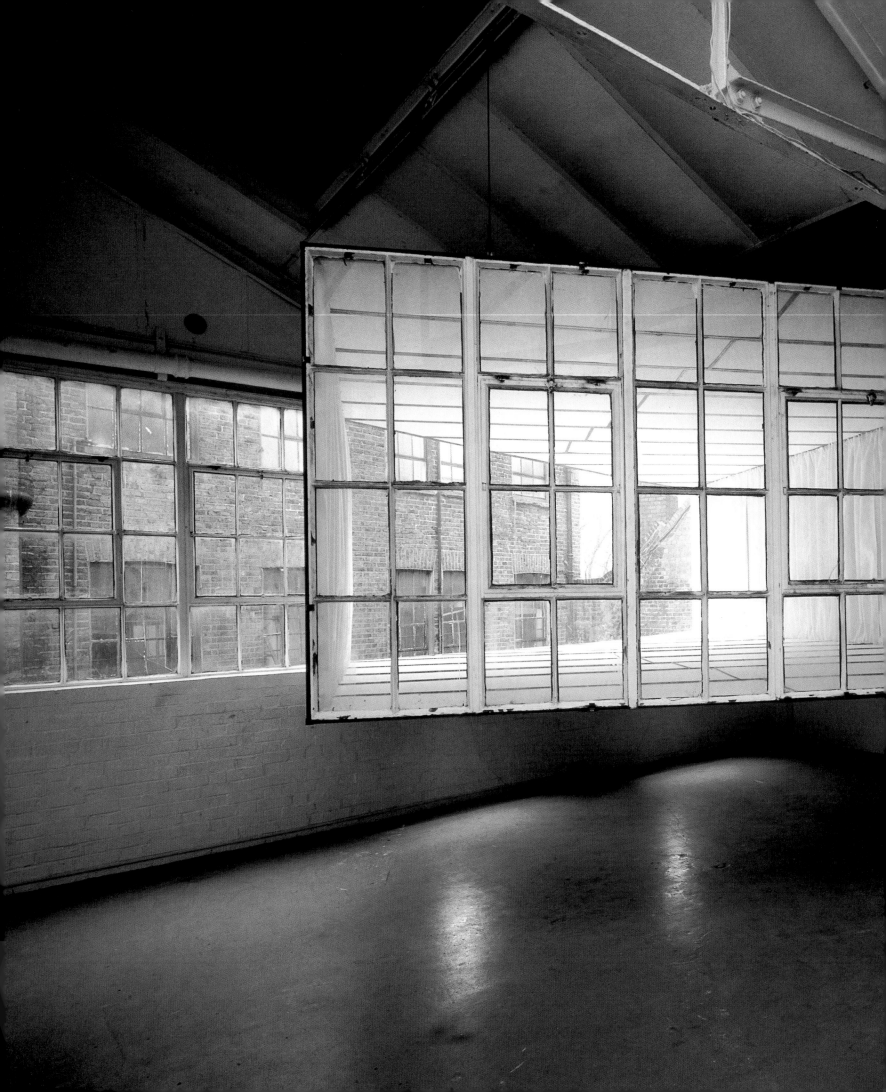

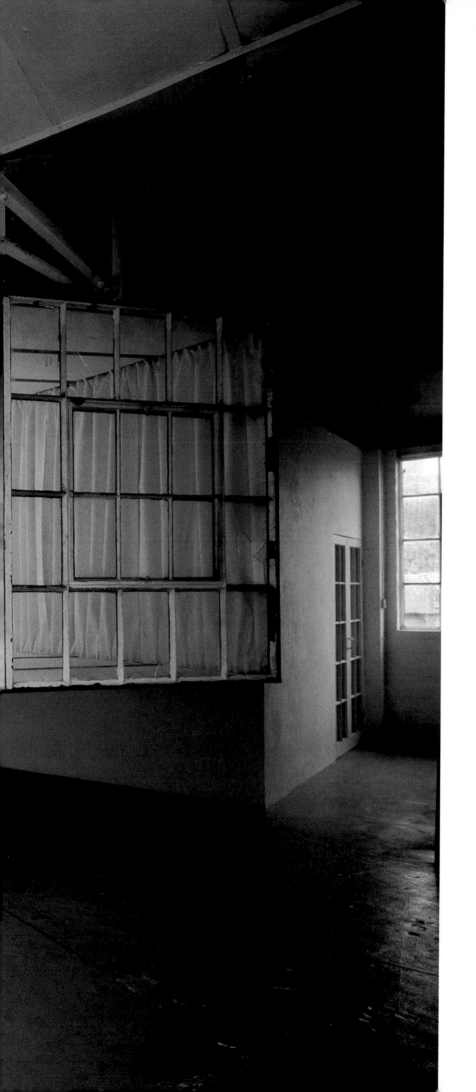

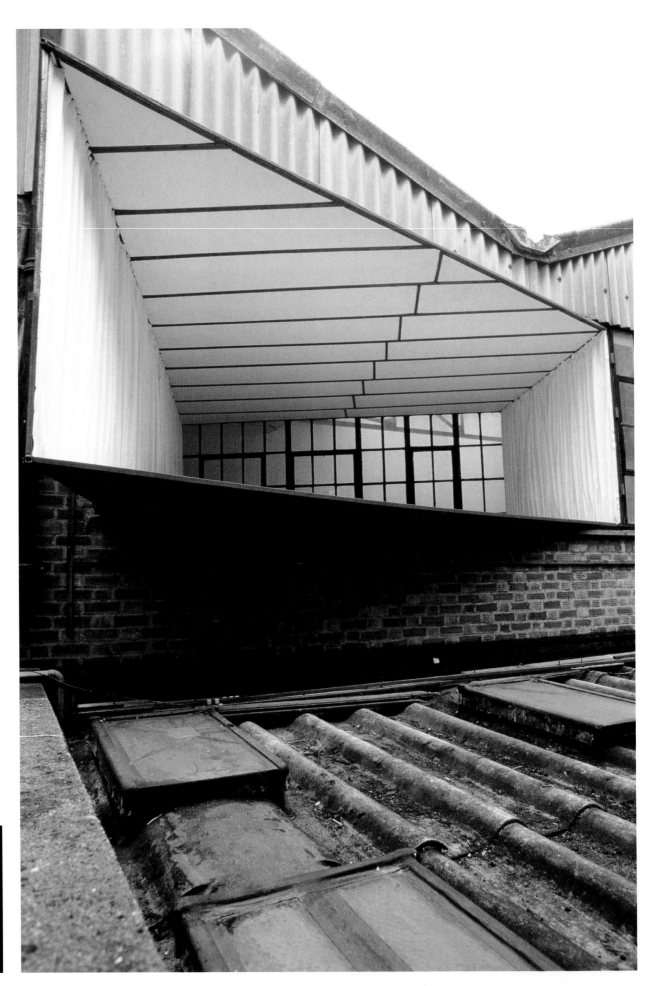

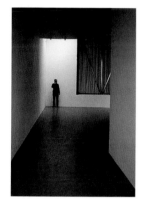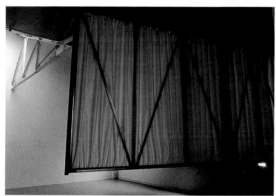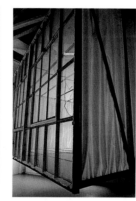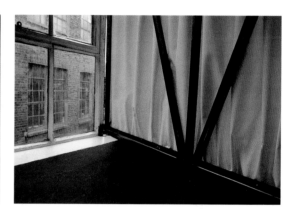

Bow Gamelan Ensemble, 1983–91

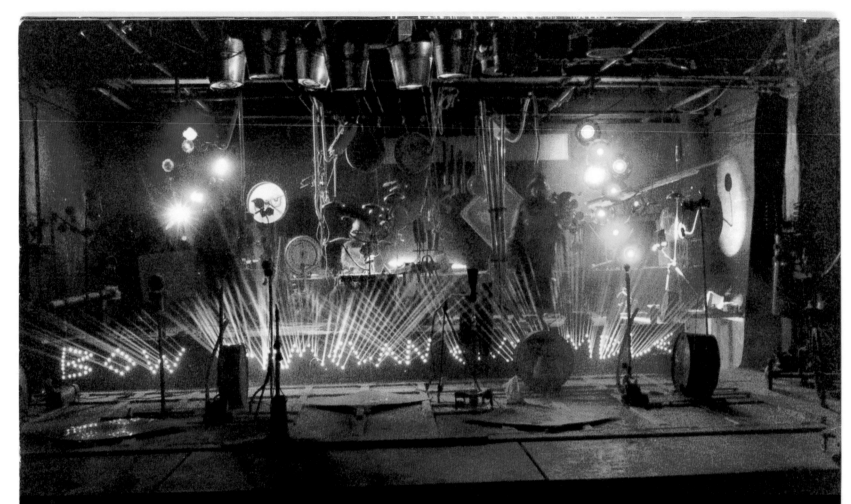

"The English excell in dancing and music, for they are active and lively: they are vastly fond of great noises that fill the air, such as the firing of cannon, drums and the ringing of bells, so that it is common for a number of them, when drunk, to go up into some belfrey and ring the bells for hours together."

Paul Henzer, in a guide to Gt. Britain, written in 1605.

THE BOW GAMELAN ENSEMBLE

Founded in 1983 by PD Burwell, with Anne Bean and Richard Wilson during a boat trip up Bow Creek.

Since their first performance at the London Musicians Collective they have made dozens of performances, events and specially commissioned works in the British Isles, Europe and America, a selection of which are represented on this Album.

The name derives from the area of East London where they live and work, and from the Indonesian metallophone ensembles (a resemblance in name only). the instruments have all been specially constructed, mostly from scrap metal, electric motors and glass, and produce a wide variety of unusual sounds. The musical structures generated are also unusual. This is in part due to the physical relationship between the ways the instruments work, and how they have to be played.

The unique combined sensibilities of the members, with their long individual experience in the areas of performance Art, Drumming, Sculpture, Environmental and Multi Media work have made the collaboration remarkably creatively fruitful.

Recordings by: Nettlefold, Laurence Casserley. Nottingham, Ronnie Fowler. Bretton Hall, Ray Beckett. Offshore Rig, Nichole Ogrodnik. Rotterdam, unknown.Master tape by Mike Skeet, Studio 44, Milton Keynes. Record mastering by Arun Chakraverty. the Master Room, London.

Cover Photo: Ed Sirrs. Back cover Photo: Jim Harold.

"GREAT NOISES THAT FILL THE AIR"
BOW GAMELAN ENSEMBLE
SIDE 1.

1.	Two "Marimbas".	Nettlefold.	2.39
2.	Snappits/Hooter.	Nettlefold.	4.28
3.	Horse/Bells/Hubcaps.	Rotterdam.	3.49
4.	Take III.	Bretton Hall.	4.43
5.	Saws.	Bretton Hall.	1.04
6.	Whistles.	'Offshore Rig' Watermans Arts Centre	5.32

SIDE 2.

1.	Thundersheets/Sirens/Baths.	Nettlefold.	4.40
2.	Pyrophones.	Nottingham.	5.20
3.	Massed Percussion.	Bretton Hall.	3.48
4.	Glass Chimes.	Nottingham.	2.30
5.	Caps/Percussion Tubes.	Rotterdam.	1.39
6.	Black Betty/Pyrotechnics	'Offshore Rig'	5.07

All compositions by Anne Bean, Richard Wilson and PD Burwell. All tracks performed by the Bow Gamelan, apart from side one, track 5, joined by NicolaKate Heys. Side 1, track 6, joined by Z'ev, and the Thames Steam Launch Co. Side 2, track 3, joined by students from Bretton Hall, track 6, joined by Z'ev, the Thames Steam Launch Co. and Eel Pie Marine.

KLINKER ZOUNDZ

KZ8804

144 Tottenham Road
London N1 4DY
Telephone

(also available on cassette) 01-249 2510

The Bow Gamelan Ensemble 147 Knapp Road.
Bow, London E3, 4BP. 01-515 4279.

Published by New River Music / PULP MUSIC ©℗ 1988 (PRS)

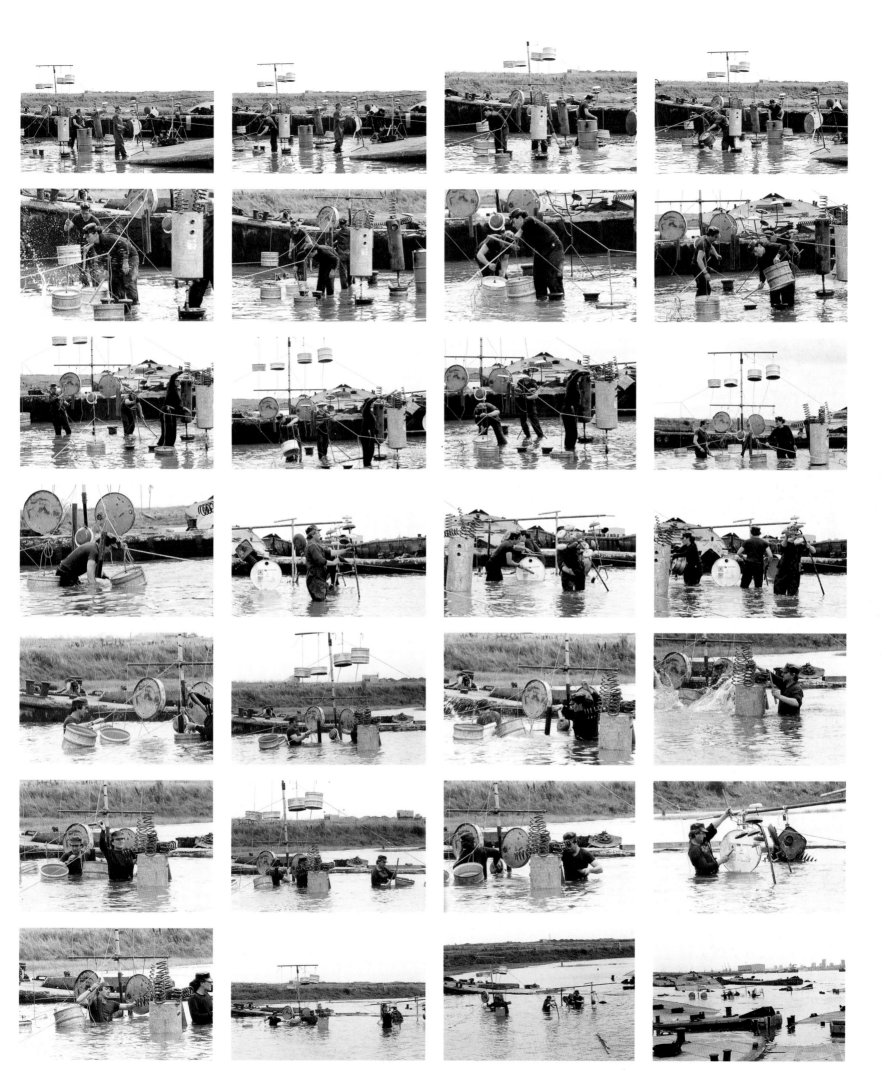

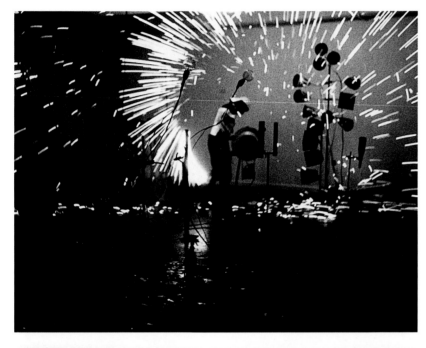

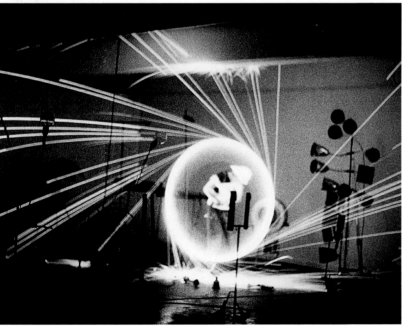

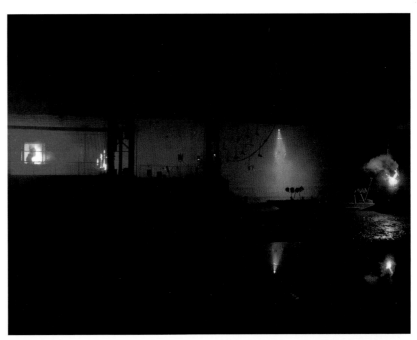

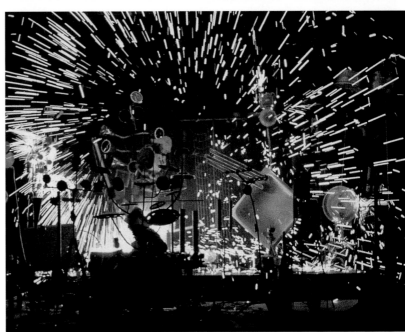

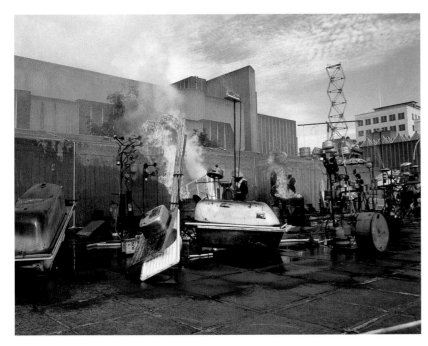

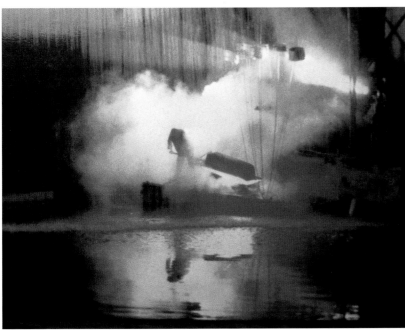

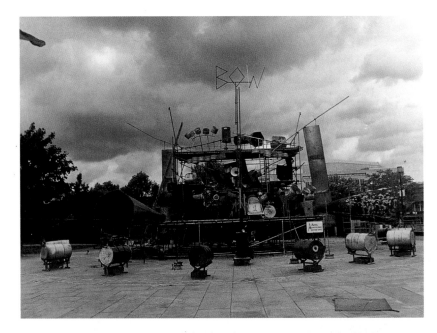

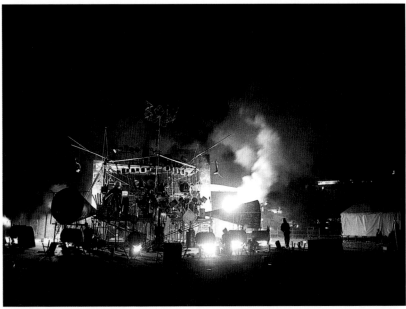

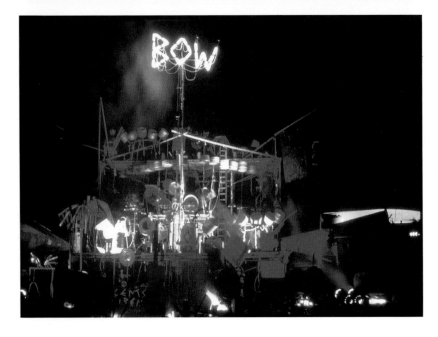

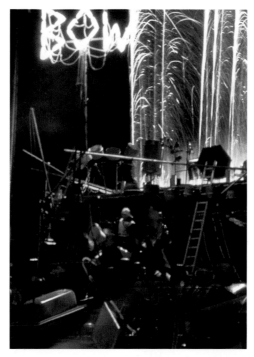

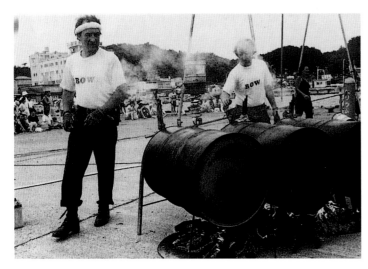
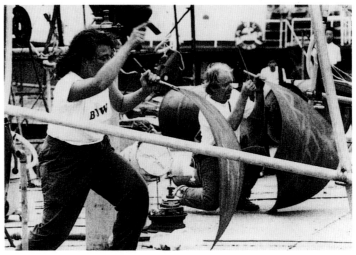
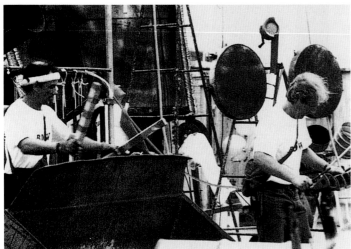
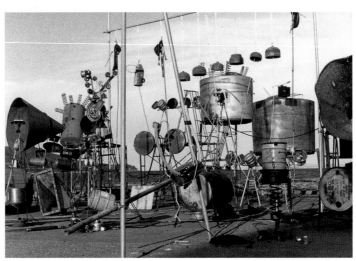

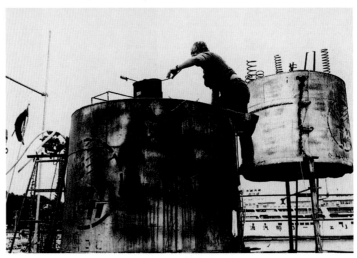

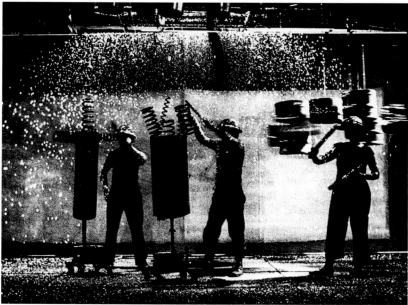

High Rise, 1989
XXth São Paulo Biennale, São Paulo, and subsequent venues
1990–91

Mistakenly allocated a wall space with which to work, the artist
created a window looking on to the service area behind the gallery
space by inserting a prefabricated greenhouse through the partition
wall. The work functioned as a sculpture supported by the wall,
rather than an object placed on it. Insectocutors were positioned
within the greenhouse, one within the gallery space and one in the
service area, encouraging visitors to leave the gallery and venture
into the normally unseen area beyond.

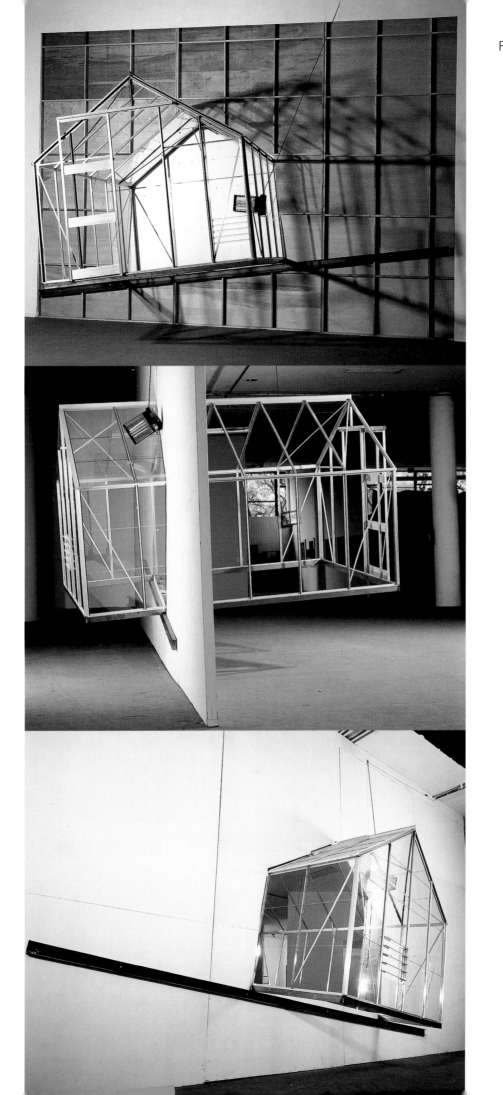

Takeaway, 1990
Centre for Contemporary Art, Warsaw

The artist suspended 999 Chinese takeaway carrier bags by wires
from their string handles throughout the then-derelict art centre. The
bags contained builders' rubble removed from the room when it
was cleared for the installation. One extra bag was ripped open to
form a screen on to which a slide of Galeria Wielka 19, Poznan, was
projected. Although the artist was originally invited to exhibit in
Poznan, the gallery was converted into the city's first Chinese
takeaway restaurant immediately before his arrival.

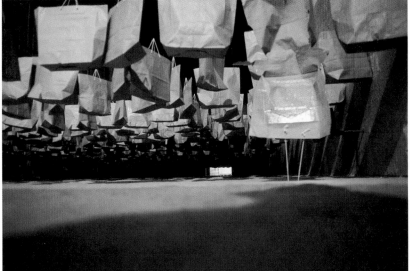

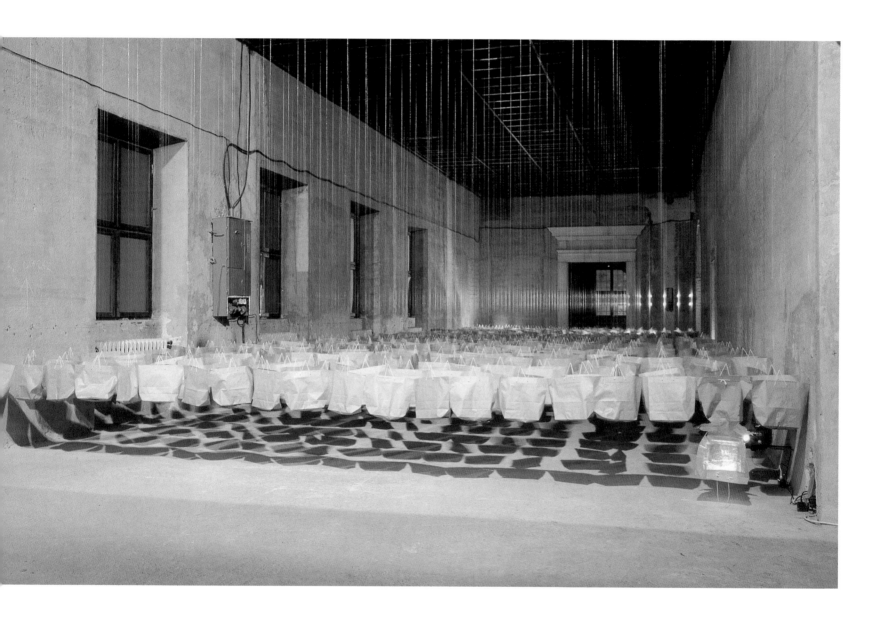

All Mod Cons, 1990
Edge 90, Edge, Newcastle upon Tyne

On the top floor of a derelict warehouse building scheduled for
conversion into flats, the artist removed a section of floorboards in
front of the entrance to the loading gantry. A new floor was then
hung, following the topology of the existing joists, rising to its
highest point outside the building. The view from the newly created
balcony looked out over a piece of industrial waste ground.

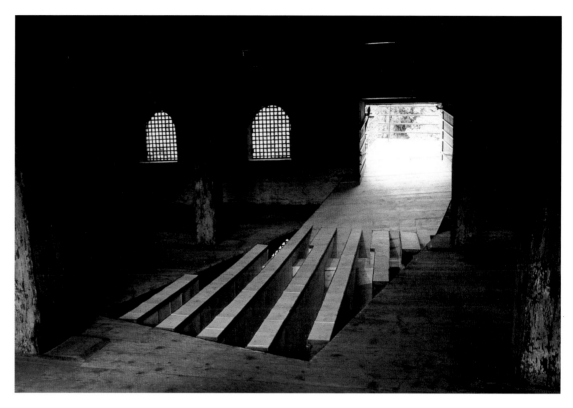

Face Lift, 1991
Saatchi Gallery, London

A dilapidated, typical English caravan was purchased second-hand. The exterior side panels were then removed and an exact replica of the caravan's form fabricated in steel, plywood and aluminium sheeting. The exterior side panels were then fixed to the newly built form, suggesting it to be a reconfigured existing object. The resultant hybrid was then split in two and one half rotated 90 degrees so that it lay on the floor. The two halves were then rejoined to make a new, twisted form.

Face Lift, 1991

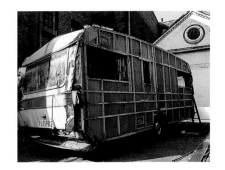

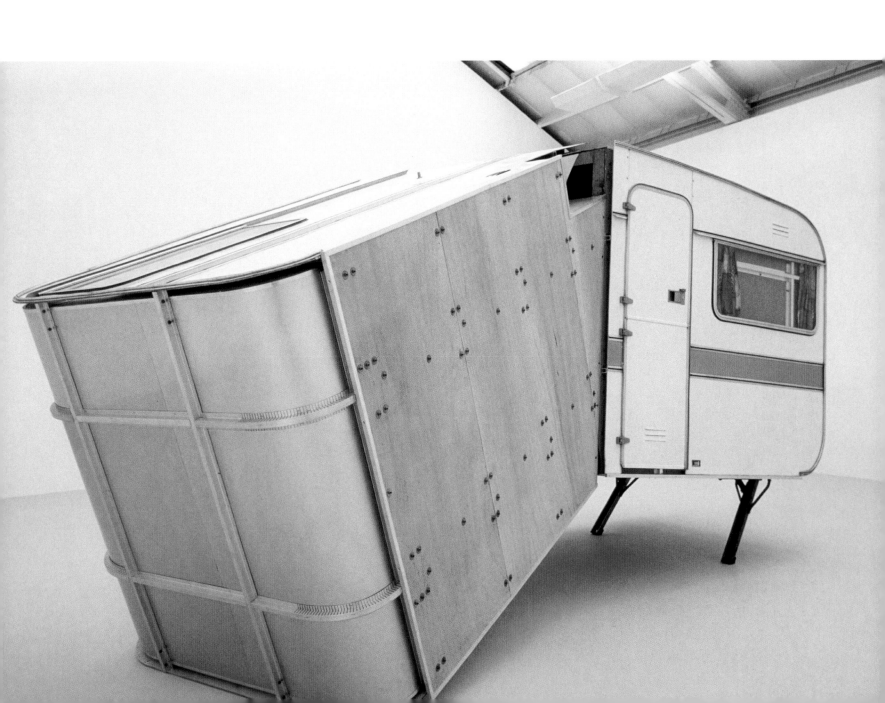

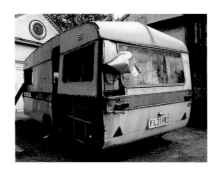

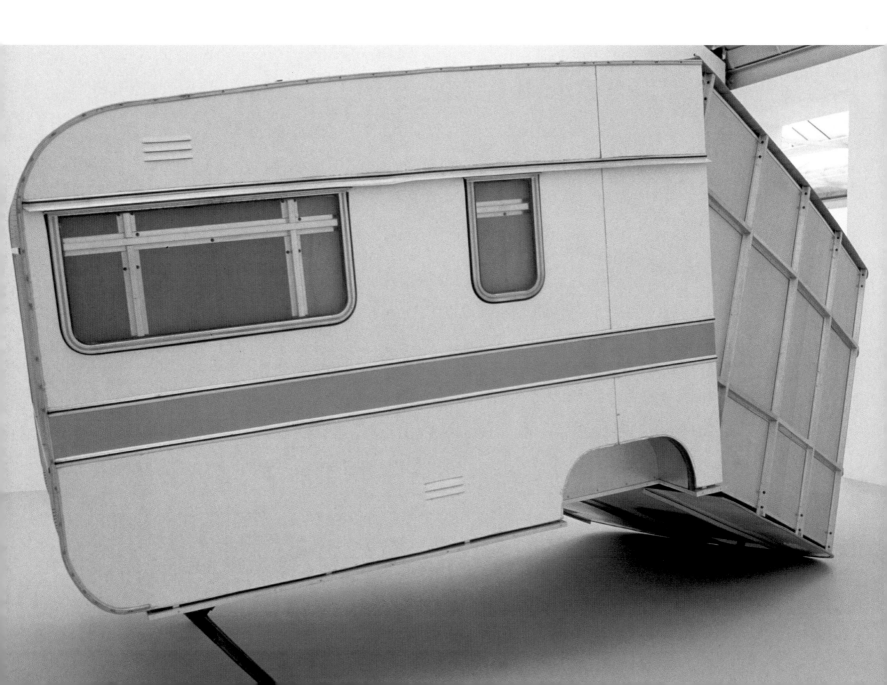

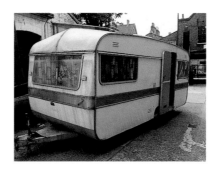

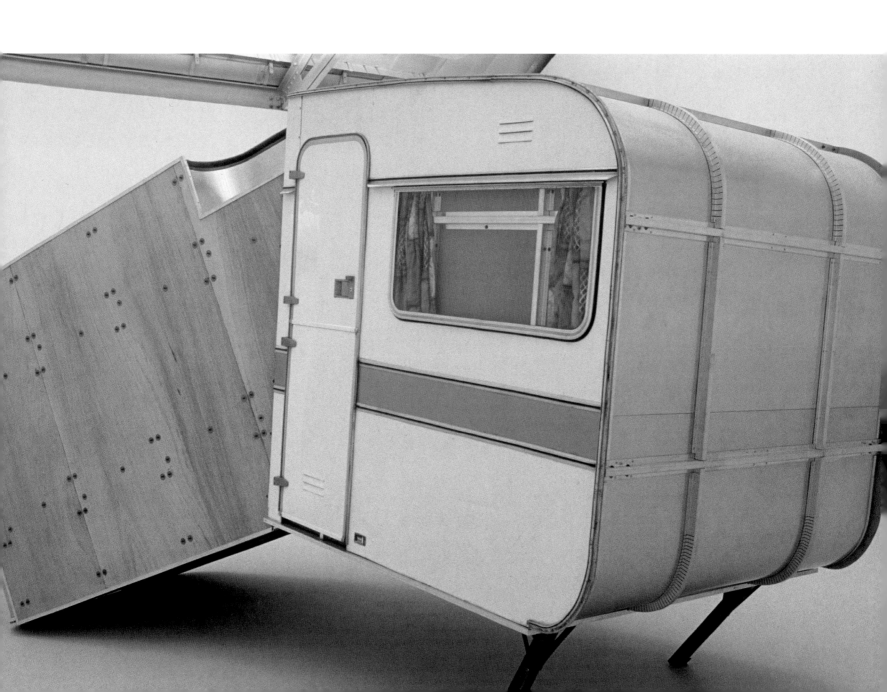

Lodger, 1991
Galleria Valeria Belvedere, Milan

A self-assembly wooden summer house was inverted to sit on one
of its gables; it was then cut to follow the architecture of the rooms,
creating an impenetrable, negative, third space wedged between
the gallery's corridor and its main space.

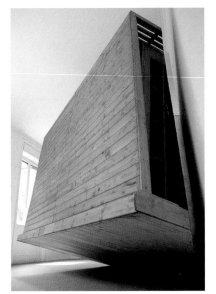

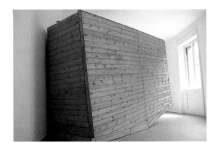

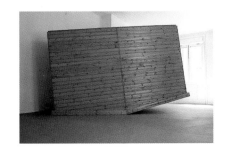

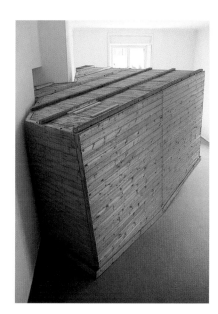

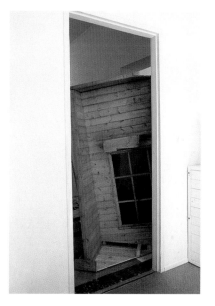

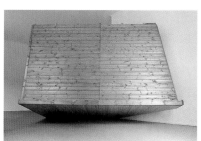

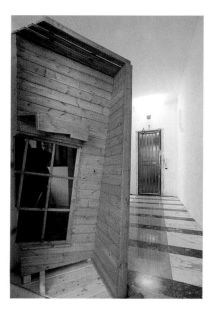

Swift Half, 1992
Galerie de l'Ancienne Poste, Calais

A semi-circular form constructed from polystyrene and corrugated
yellow plastic over a metal frame descended from the ceiling to
enclose one of the four central support columns in the middle of the
gallery space. The structure worked as a sight-screen to an adjacent
column, forming an optical illusion that appeared to cause it to bend.

 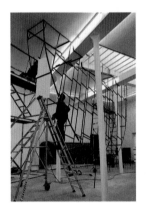 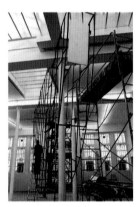 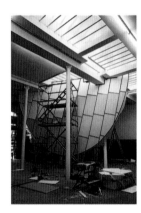 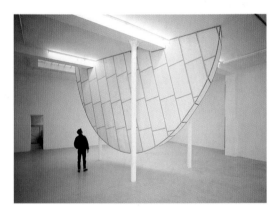

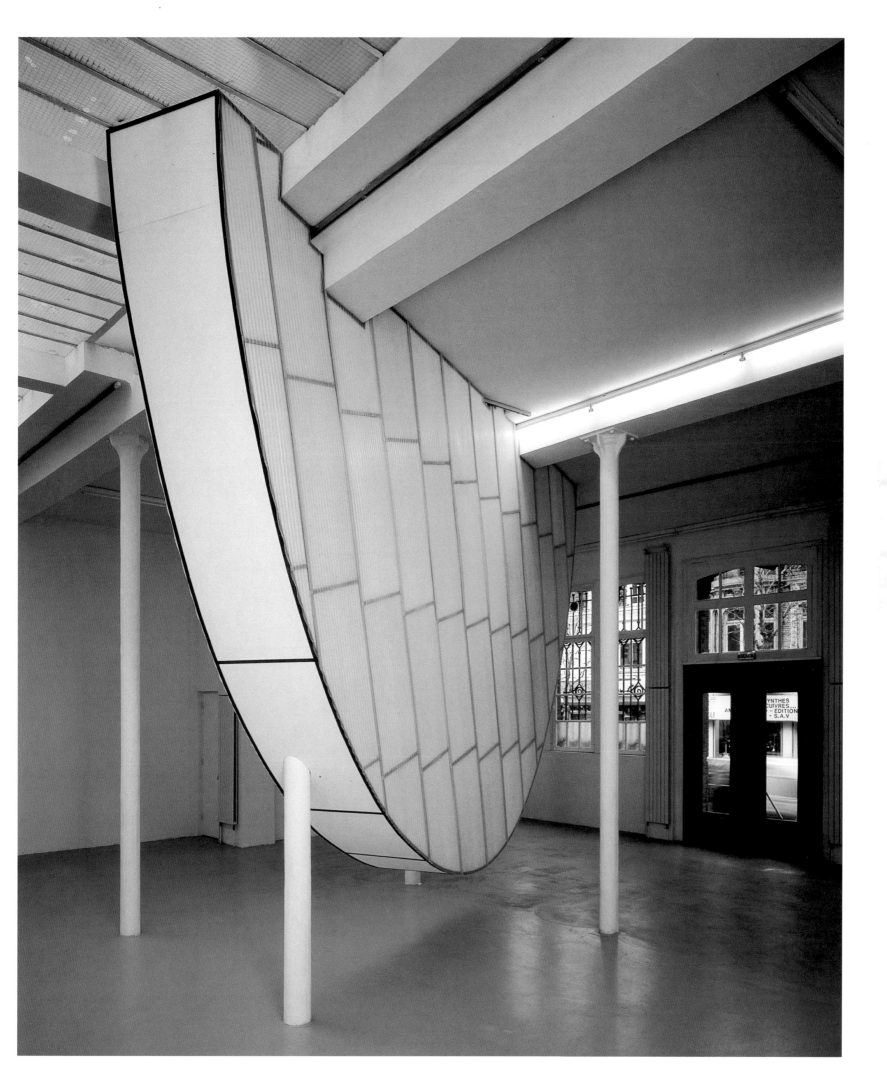

Return to Sender, 1992
Galerie de l'Ancienne Poste, Calais

A radiator and the mullions from a window, normally forming part of
the boundary of the space, were removed, cleaned and relocated to
the centre of the room. The newly located object was then visually
joined to its original location with copper pipes and plastic twin-wall
sheeting, thus allowing them still to perform their original functions
of heating the room and supporting the glass in the window. The
work was a companion piece to *Swift Half*.

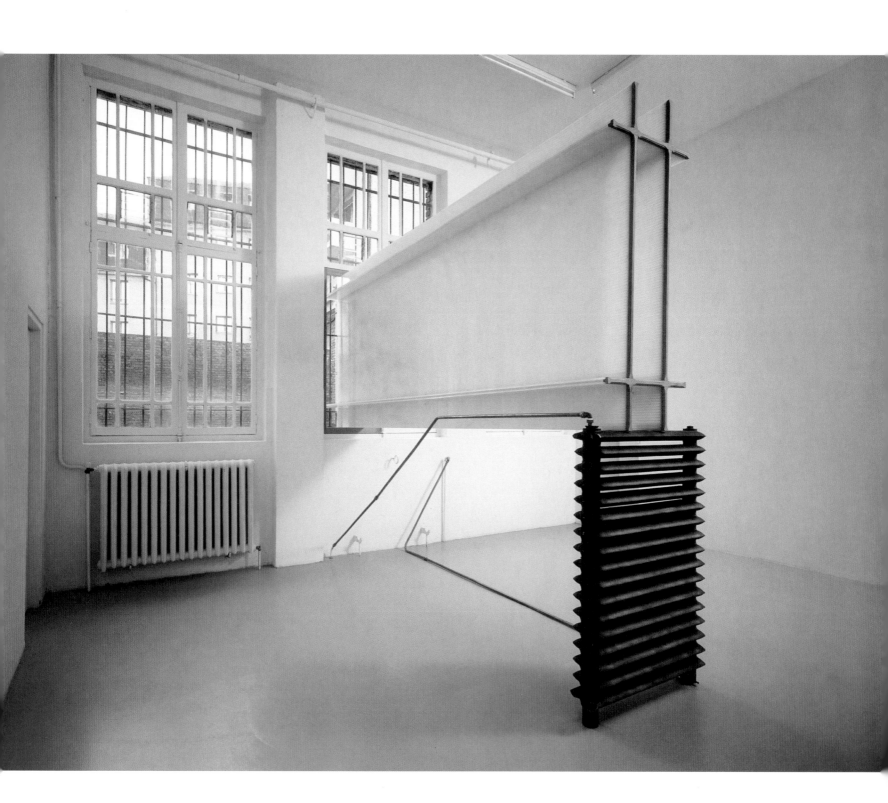

I've Started So I'll Finish, 1992
Galleria Mazzocchi, Parma

The work was made within the framework of an exhibition on the theme of furniture. The artist removed a radiator from its original position in the corner of the gallery and relocated it to the opposing side of the gallery. The radiator was connected to the hot-water system with extended copper piping so that it remained functional. Referencing Parma's reputation as a leading manufacturing district for ceramic tiles, the artist then constructed a chair from locally made tiles, which was balanced on top of the working radiator. The heat from the radiator was conducted through the ceramic tiles, heating up the form of the chair.

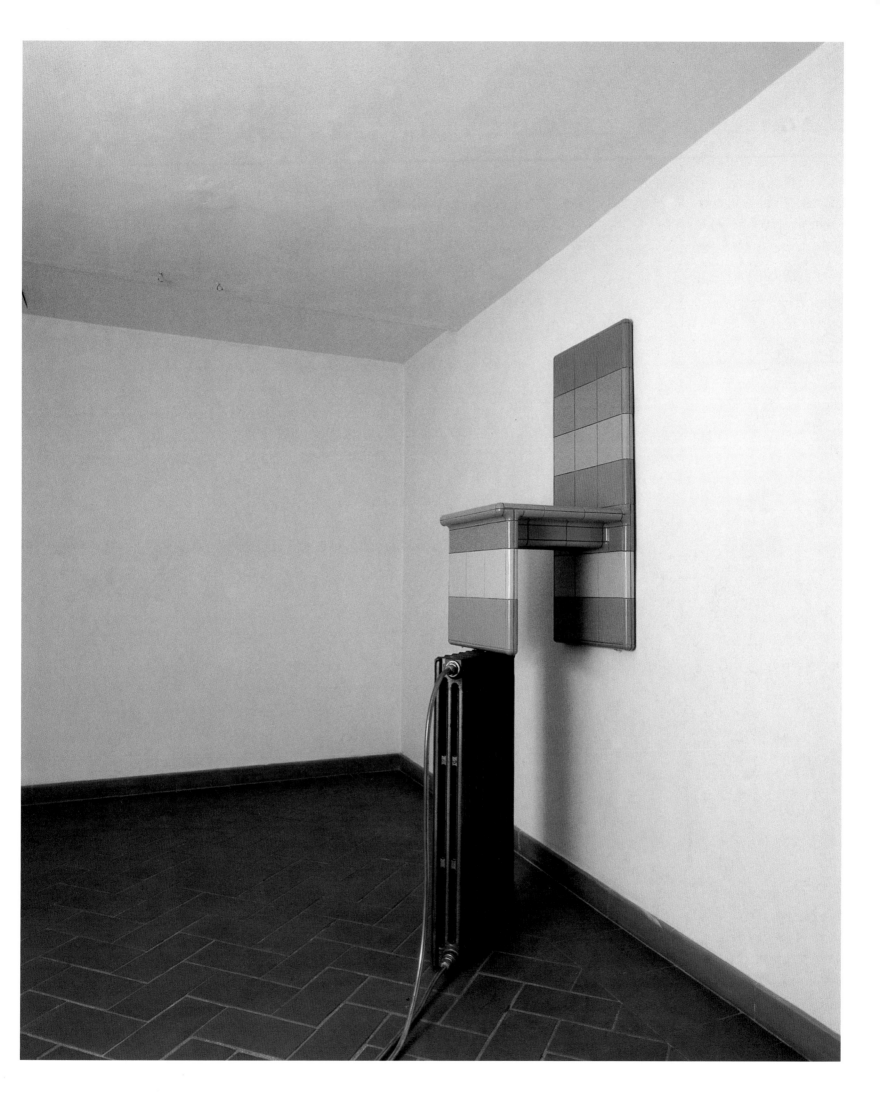

Elbow Room, 1993
On Siat, Museet for Samtidskunst, Oslo

A Scandinavian wooden chalet had the majority of its form replaced by a precise replica of the gallery interior it inhabited. The replica interior was inserted at an exaggerated angle to create a false perspective that obscured the presence of the chalet on first encounter.

 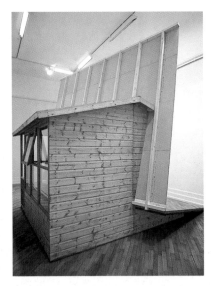

Not too clear on the viewfinder, 1992
IXth Sydney Biennale, Sydney

The work consisted of a text etched into the steel fire doors that
normally separated the space from the rest of the building. The
doors were removed from their original position and suspended
from the ceiling in the centre of the space. The text was the
transcribed soundtrack of a video recording of the space allocated
to the artist, on which the picture was too dark to be decipherable.

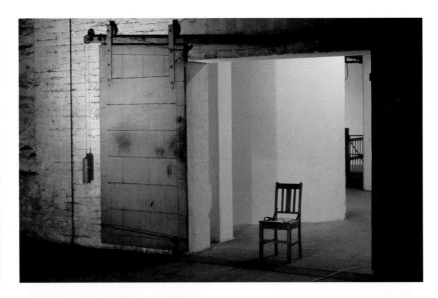

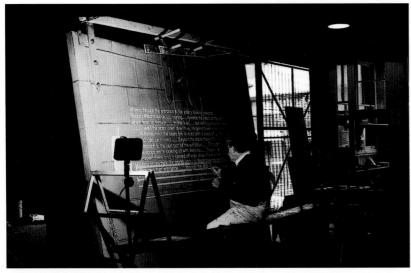

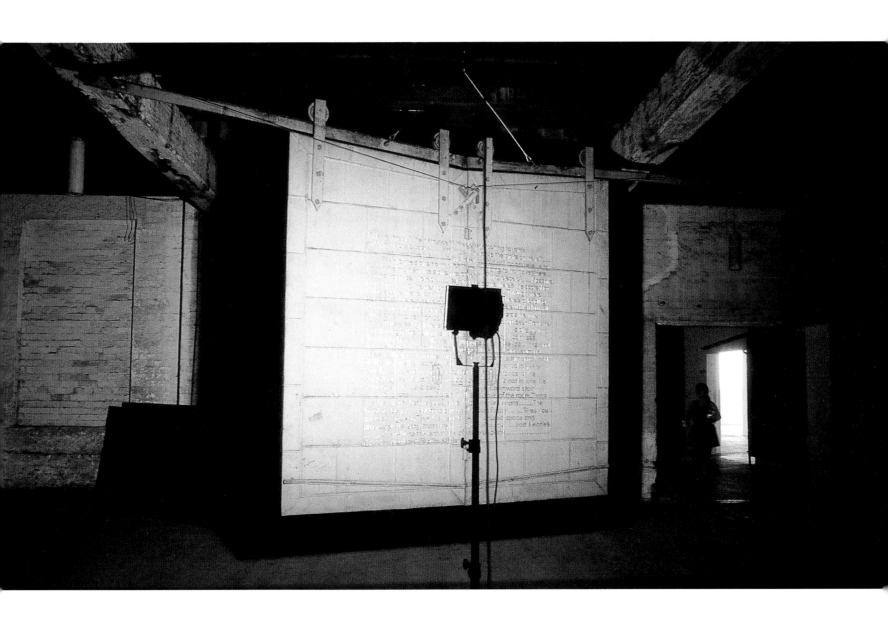

A Fresh Bunch of Flowers, 1992
Serpentine Gallery, London

The work was made in collaboration with Anne Bean and Paul Burwell to commemorate the death of sculptor Stephen Cripps.

Twenty-nine blocks of ice were laid on a wooden platform on the lawn in front of the Serpentine Gallery to form a wall-like structure. Each block had had actual flowers, or sculptural objects resembling flowers, placed within it prior to freezing. Over the duration of a full day, the ice gradually melted, causing the structure to collapse while simultaneously revealing the encased objects.

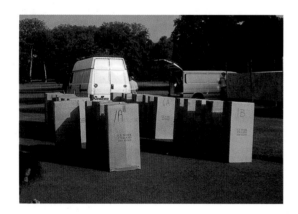

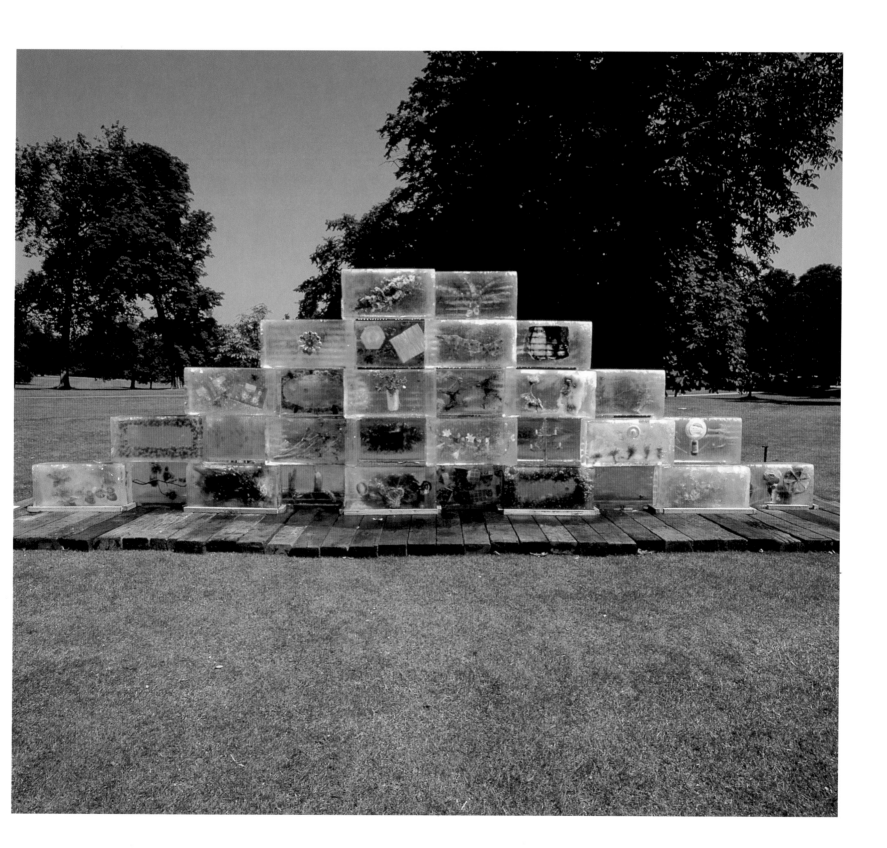

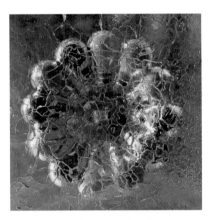

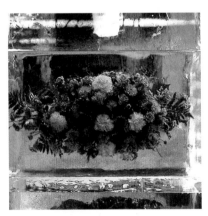

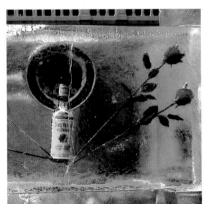

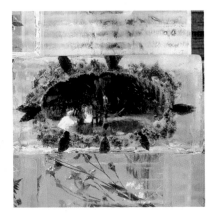

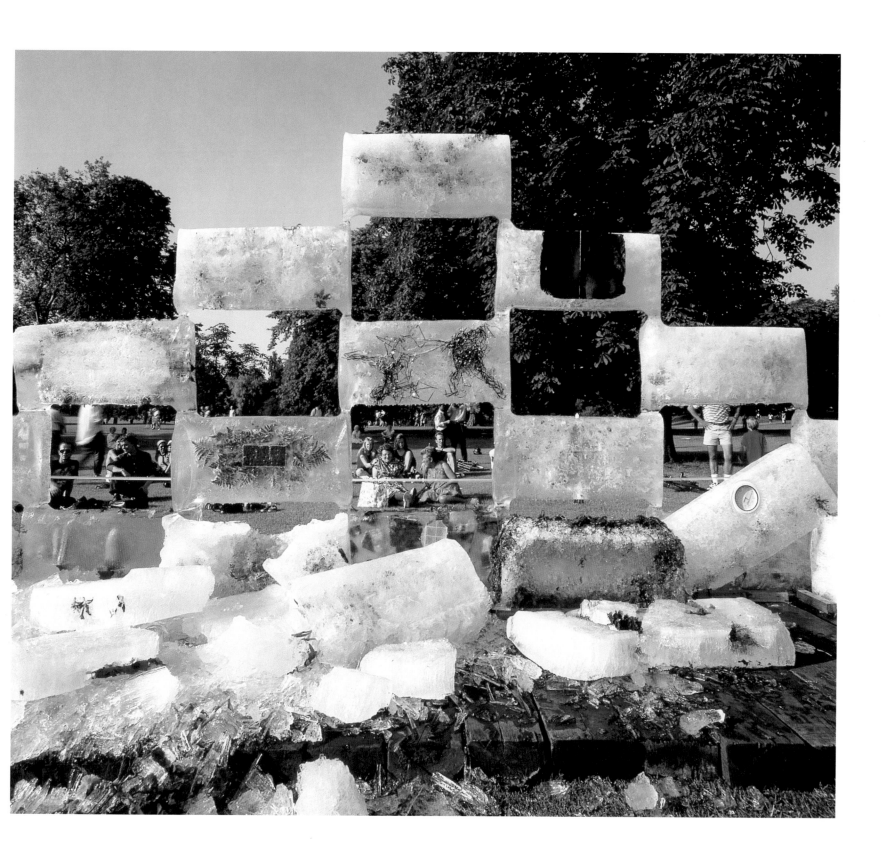

GMS Frieden, 1993
Inkjet print

Printed in white text on a black background, the work recounts a
true story told to the artist by Captain Siegfried Schauder of the
Rhine barge GMS *Frieden*.

"and now here's what happened next. When I bought the stern in 1975 for DM 230,000 I bought this at the shipyard and added it on. Underneath the stern cabins is the machine room. There are two fuel tanks there, port and starboard with the engine laying central. The starboard tank was 5,500 litres capacity and the port 6,000 litres capacity. When all that construction was finished, I went to the station and bought 10,000 litres of fuel.....and here's what happened...■ I started of with my ship from the shipyard to Duisburg on the Rhine and I loaded up with 600 tons of coal for Berlin. And now on the way we were at Minden in Westphalia, the halfway point of the trip. Here the Mittellandkanal crosses the Weser and is called the Weserkreuz. ■ After Minden on the way to Hannover my engine did not want to draw air anymore – the speed kept going down and up and I could not get her up to a regular speed. I couldn't figure out why the motor would run sometimes 350 R.P.M. and sometimes 500 R.P.M. When you start up the engine her slowest speed is 80 R.P.M. and the maximum capacity is 500 R.P.M. full speed. You have of course these pipes that run to the engine through filters directly from the fuel tanks. I stopped and moored the ship and then went down into the machine room and the first thing I did was to figure out what was going on... then I saw that there was air in the filters. But then I realised that I still had 7,000 litres of fuel in the tanks so it couldn't be a lack of fuel. I cleaned up the filters and started off again. And we went along for about an hour and the same thing started happening again, slow – fast. And then I had to moor to some trees as there was no mooring place. I picked out some big trees to moor to because, if the engine suddenly stops, I have no control anymore. So I stayed tied up to the trees for six hours and spent my whole time down in the engine room looking till I found out the idea. Suddenly I realised that in front of the 6,000 litre tank is a flange on the fuel line. So I opened up the flange because I wanted to look in there and see if the fuel was flowing through it, as it ought to be. I put a big bucket under it and at the beginning about five or six litres of fuel came out in one big rush. So I knew something was in the fuel tank but what? So then I replaced the flange. Now, there is a wall between the tank and the motor and the tank wall was two metres high. The tank's outer wall curved to the curve of the ship's stern quarter. I couldn't continue... I had to go into the tank itself. The tank was two metres deep and at the front was a man hole cover made for a man to go through but this cover was oval shaped. This cover was 125 centimetres up from the floor. Now, in order to be able to open this cover, I had to pump some of the fuel from the stopped up tank into the other tank. Now all of that with a handpump. So I pumped it down until there was only 125 centimetres of fuel in the tank and then I had to take off the cover. I remember there were 58 bolts and of course with seals. So I took off the lid but there was fuel up to that level. Now, down on the near right corner as I faced into the tank was where the fuel pipe left the tank. So from outside I tried to reach that outlet with a piece of wire. I fished around there because I had the feeling there may be a piece of rag or handkerchief down there but this didn't work so I now had to take off all my clothes and go into the dark tank. 125 centimetres was roughly up to my chest level and I don't have such a long arm that I could reach all the way to the bottom. Before I went in I covered my whole body in propshaft grease and then I went in. First I felt around the bottom with my foot and I could feel some sort of rag and a few pieces of metal and for a few seconds I had to immerse myself in the dark diesel diving to the fuel outlet. ■ It was September 1975, in comparison to today let's just say I was a young man then. Now I'm in my sixty second year – it was 18 years ago. First using handfuls of grease I closed up my eyes, ears, nose and finally I took a big gulp of air and closed my mouth with grease. And then I plunged into the diesel. I reached down and grabbed the rag. This rag was part of a coat – a big chunk of coat. Now there are three theories how this piece of fabric got into this spot. The first theory was they were once cleaning the tank and left it in there. The second theory was when they were putting the tanks together they had been doing some welding work and somebody had been cooling the welds with this sodden rag. Or the third version was that, being a company ship, one of the sailors who had been doing the work had, after filling the tank, thrown the piece of cloth into the tank because he was unhappy with something and this was his form of a boycott. ■ When I came out of the tank my wife Hildegard gave me an old pair of trousers and a jacket and I wore these to soak up all the grease and diesel. I – as captain – had to ensure everything was in order before I could continue and it wasn't until evening that we headed off to a proper mooring with piers. So we set off, 6 or 8 kilometres to the mooring site, and I wore these clothes for that period. In the meantime, the engine was producing hot water again so that when we moored up I filled up the bath with hot water from the machine room and took a long bath and washed everything off. Diesel itself doesn't smell that bad particularly – I mean the machine room always smells of diesel and I'm used to the smell. It's the taste I remember. I had diesel in my mouth and it took a long time to get rid of the taste. It seemed to always be there and now when I'm working with an engine and I get diesel on my lips that intense taste comes back...

When we began to scrap the ship I stood there and tried to record everything with video and still camera. And as I stood there all eighteen years of my experience with this ship began to pass in front of my eyes, all the most serious and intense moments came back to me including this experience and I stood there and did not want to cry but I was being shaken and the tears just ran down my cheeks. I could not help myself and in the course of eight days I lost seven kilos of weight and by February 11th 1993 the ship was no longer."

– This true account was told to me by
Kapitän Siegfried Schauder of the ship FRIEDEN

Richard Wilson
Berlin 1993

14:20:18 Aug 11th 1993 Looking North: Right, 1993
Various sites, *Time Out* billboard commission, London
Photographer Stephen White

The work took the form of a photographic billboard image depicting
the explosion of a modified star-shell firework within a room
undergoing construction work. The firework would normally explode
spherically, sending out flares of multicoloured light in all directions,
but the artist's modification meant it exploded on one plane only,
the sparks describing the perimeter of the architecture. The
detonation of the firework was triggered by the shutter-release of
the camera, creating the image at the precise moment of explosion.

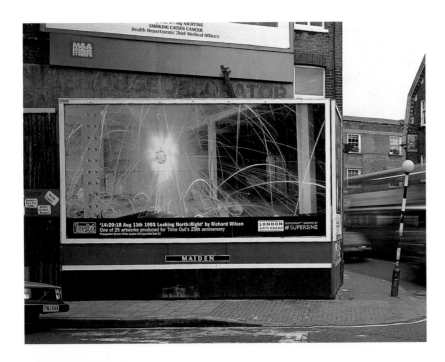

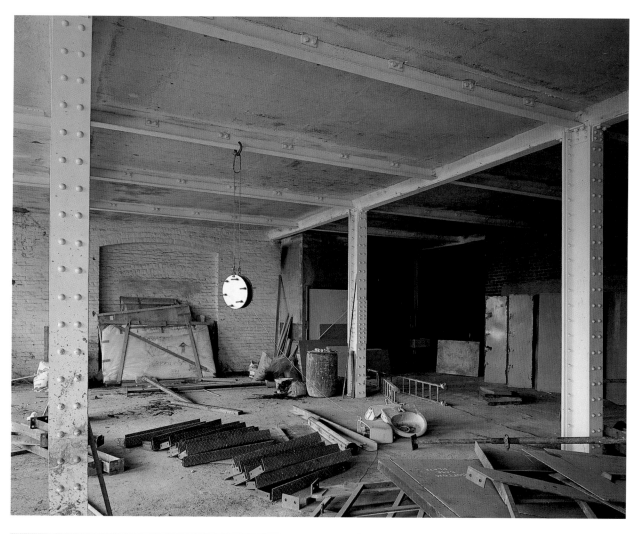

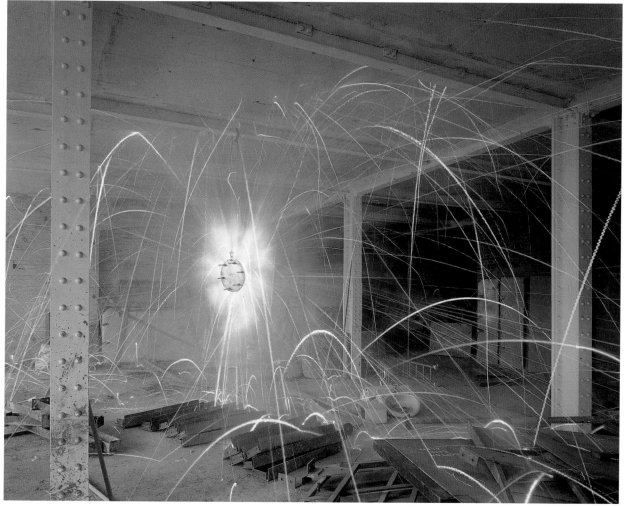

Bronze Column, 1992–93
Unrealized proposal for the Henry Moore Sculpture Studio, Dean
Clough Gallery, Halifax, West Yorkshire

The work related to the iron columns that ran down the centre of
the space. The artist proposed to remove one column and replace it
with an inverted version cast in bronze. The temporary displacement
would have included the flags of York stone from around the base,
and the supporting hard core, which would also have been cast to
form the capital of the column. The inverted brass column would
have been completely functional as it would have been supported
internally by a steel armature.

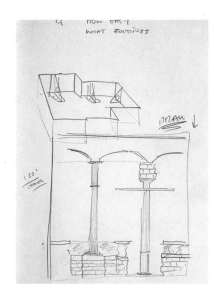

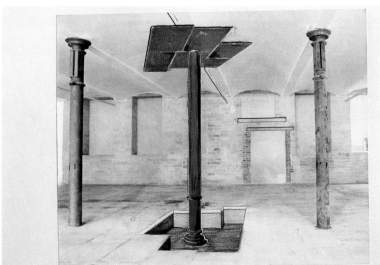

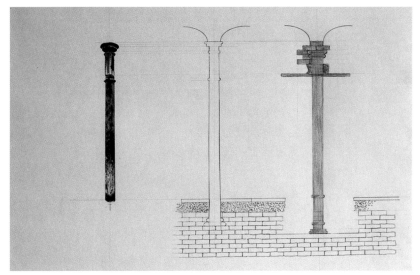

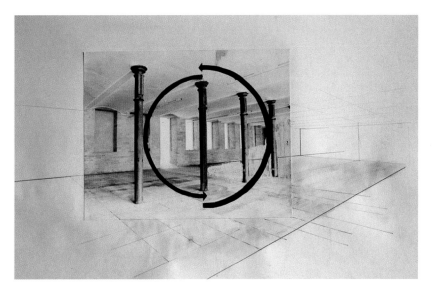

Hyde Park Concert 2, 1993
Unrealized proposal for Serpentine Gallery, London

The artist was invited to propose an outdoor work to run
concurrently with a Gordon Matta-Clark retrospective. The proposal
involved the insertion of a four-sided conical projection screen into
the fabric of a prefabricated sports pavilion. A video projector
located inside the structure would have projected footage relocating
the legendary Rolling Stones concert of 1969 from Hyde Park to
Kensington Gardens.

6

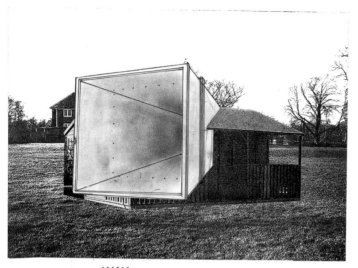

SKETCH

showing the Pavilion positioned on the site with the cut out
section accomodating the projection cone. The screen is not
shown here as its position is defined by the amount of sunlight
entering the cone

8

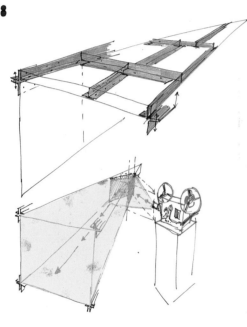

THE PROJECTION CONE is of steel sheet
with an external ribbed stiffening structure. The cone
comprises of four flat sections bolted at 90 degrees to
one another at the corners.The tapered flat sections are
to be constructed flat and then bolted together on site
as they are located within the Pavilion.
The frame work exterior is made up from a three inch
angle iron edging with T section fillets all welded and
then sheets bolted to it.The four sections use strips of
angle iron to fasten together and wing nuts located.
Angled lugs hold it firm to the Pavilion.Overall
length of each section is approx 20 feet.
Facing the projection mouththe right panel at the
back has a section cut away to allow for the projection to
bounced at 90 degrees from the projector, this is achieved
by positioning a mirror inside the neck of the cone.
This allows the size or bulk of the projector to be housed
within the Pavilion.

14

SKETCH FOUR

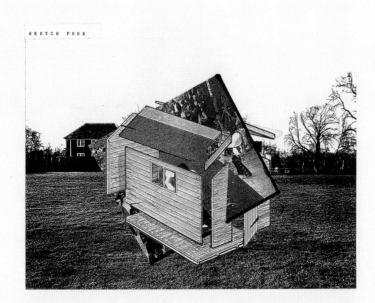

15a

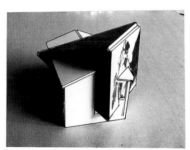

15b

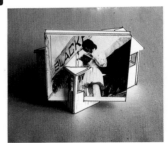

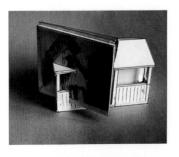

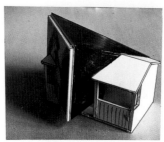

Watertable, 1994
Matt's Gallery, London

A full-size billiard table was placed in a hole excavated in the floor of
Matt's Gallery. A 28-inch concrete drainpipe was sunk through the
table and the ground beneath until it met the natural water table four
metres below the building. Twin motorized paddles disrupted the
water at the base of the pipe, creating an intermittent gurgling noise.

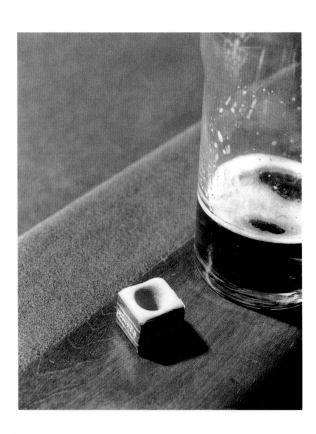

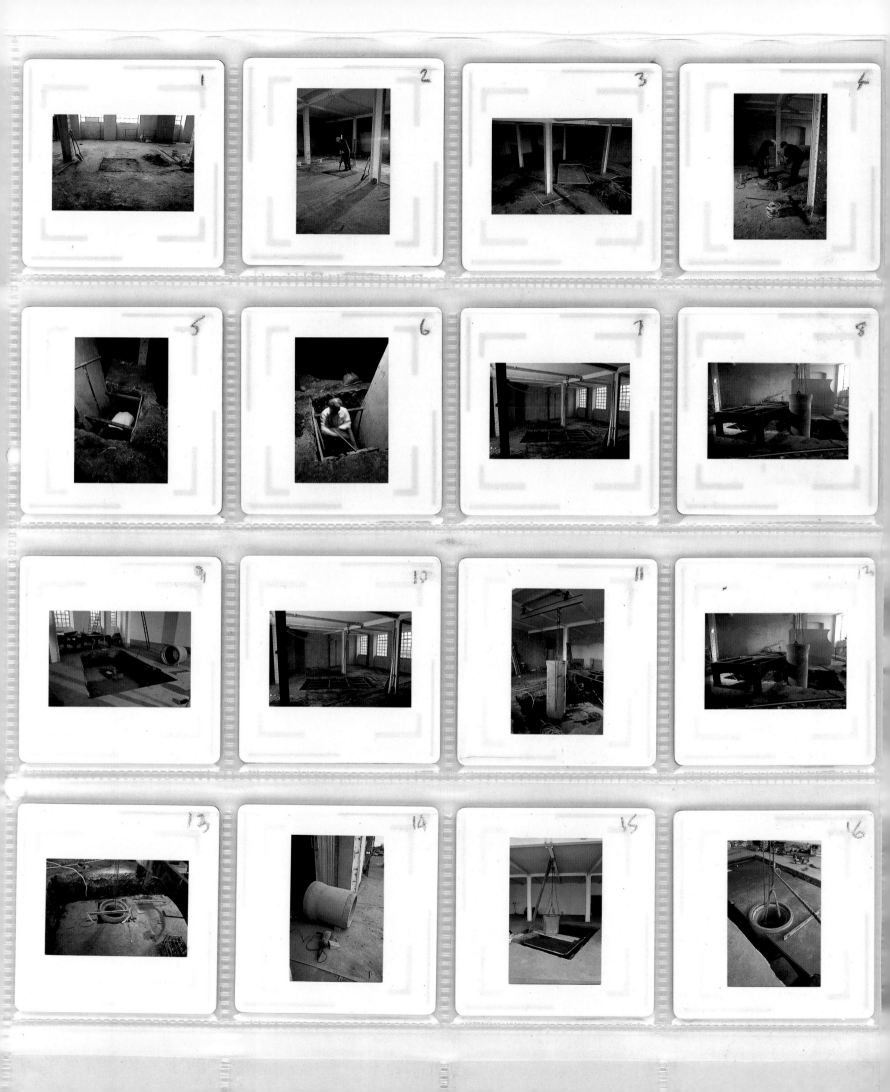

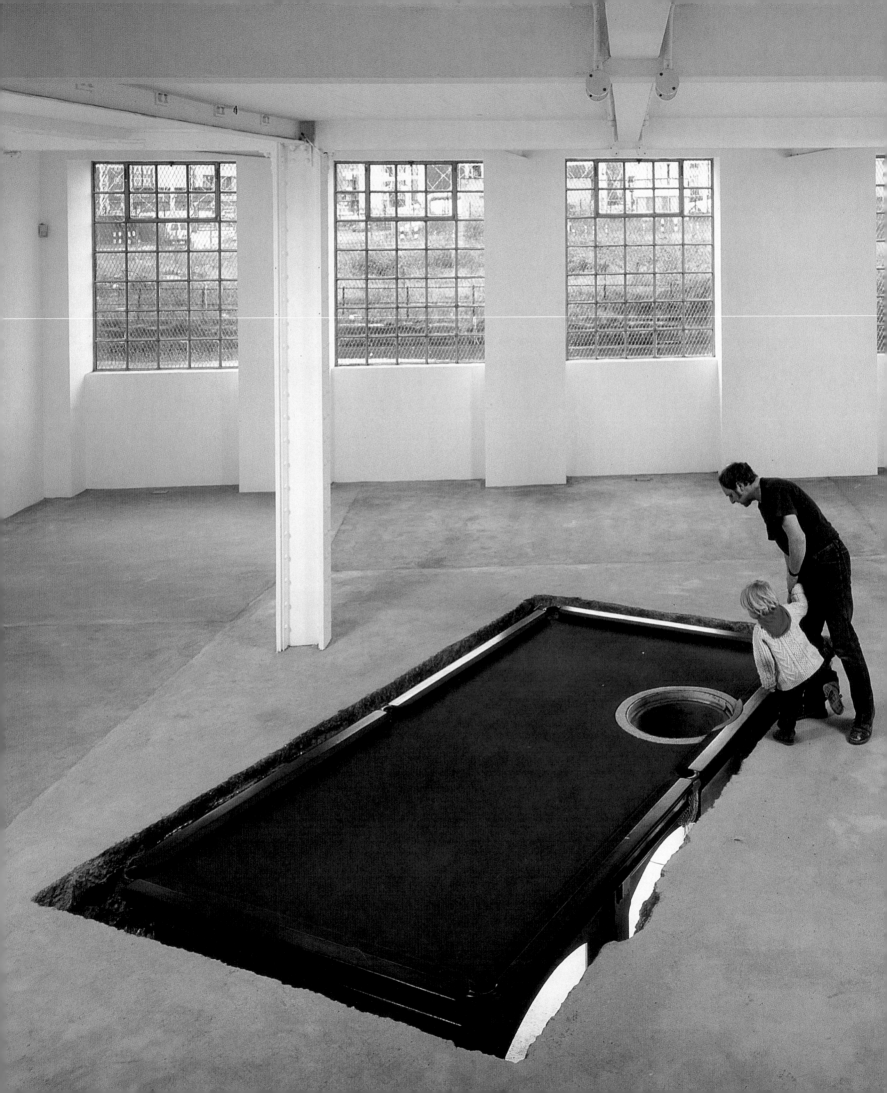

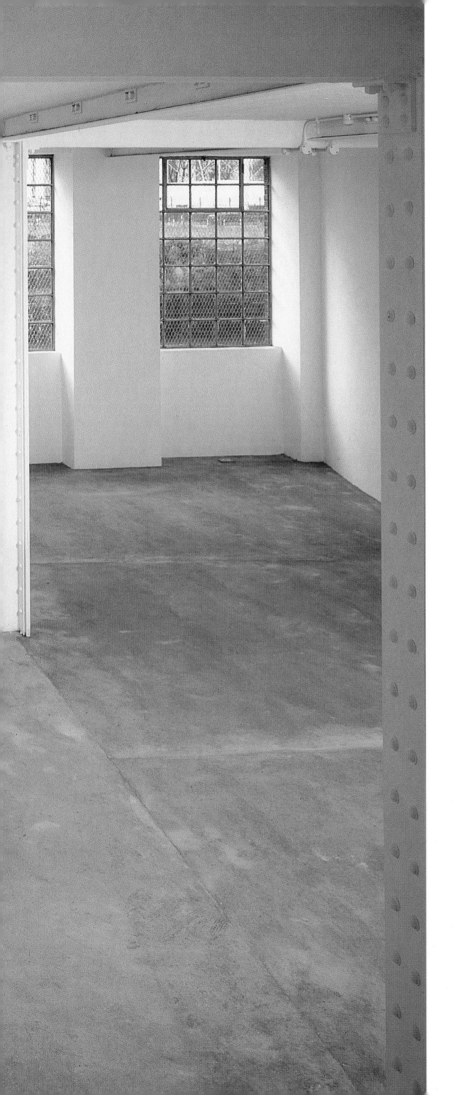

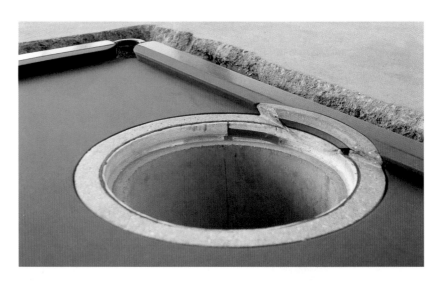

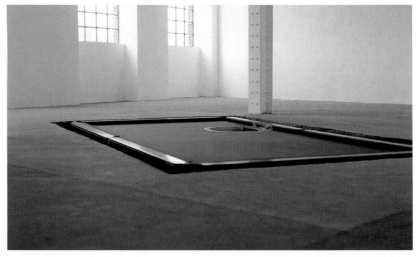

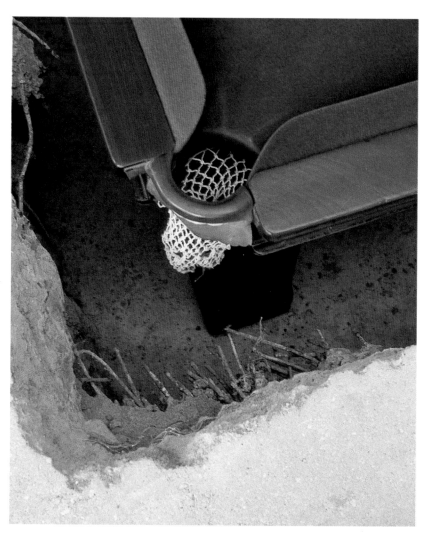

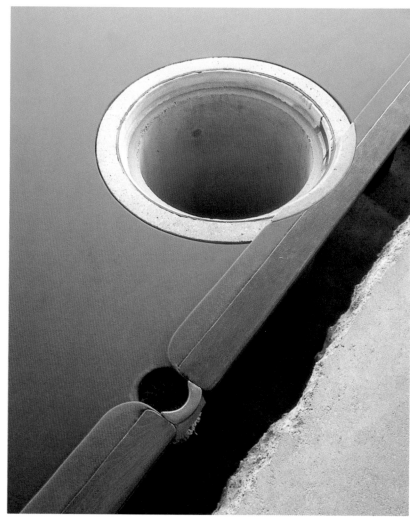

Deep End, 1994
Museum of Contemporary Art, Los Angeles

A Cattalina III fibre-glass swimming-pool shell was suspended
upside down from a sixty-foot pipe inside MOCA's subterranean
gallery. The pipe ran up to a pyramidal skylight in the ceiling and out
into the street, funnelling sound back into the gallery. The swimming
pool, although structurally unaltered, was perforated with a series of
strategically placed holes.

Deep End, 1994
Museum of Contemporary Art, Los Angeles

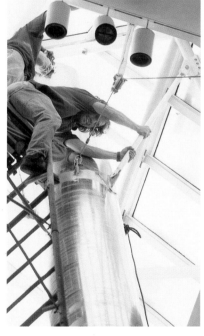

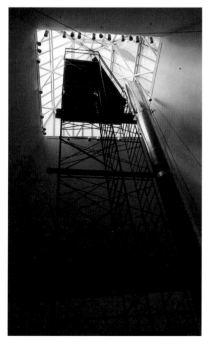

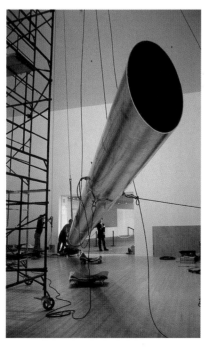

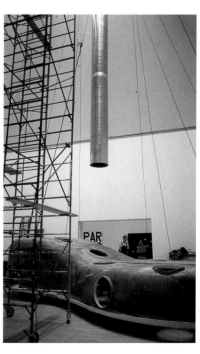

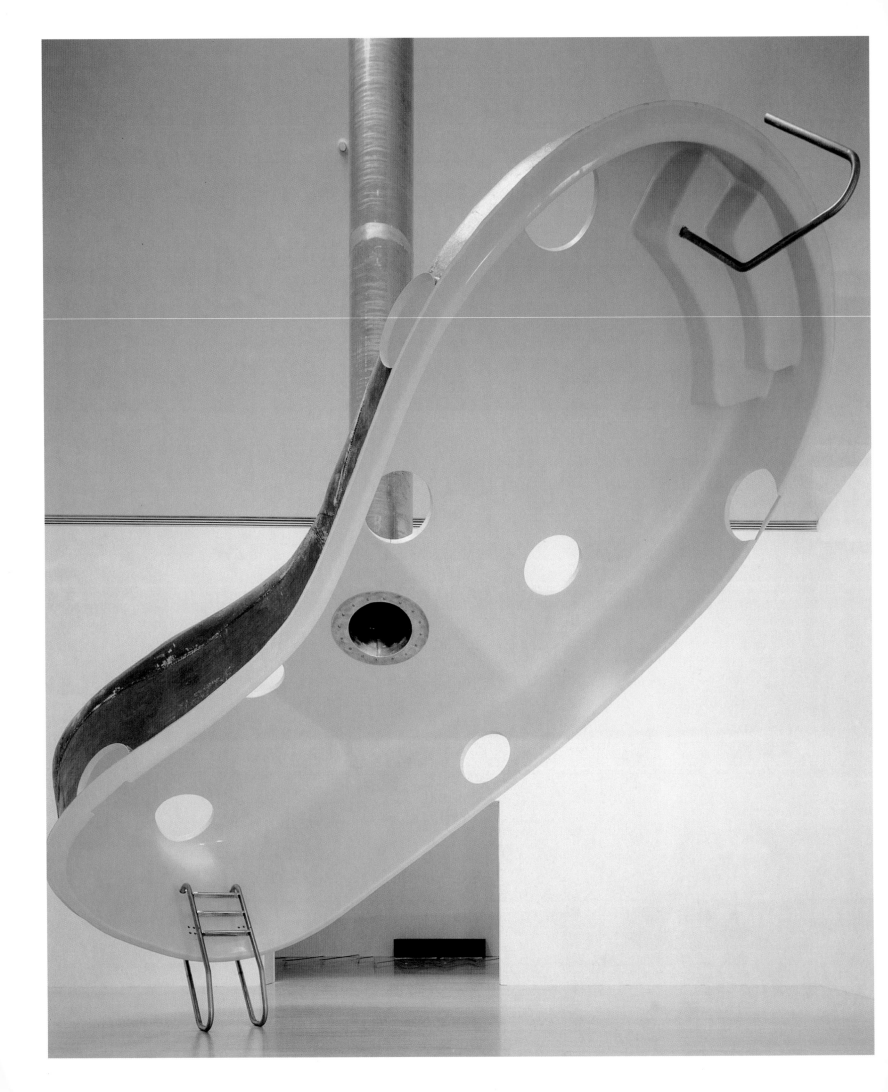

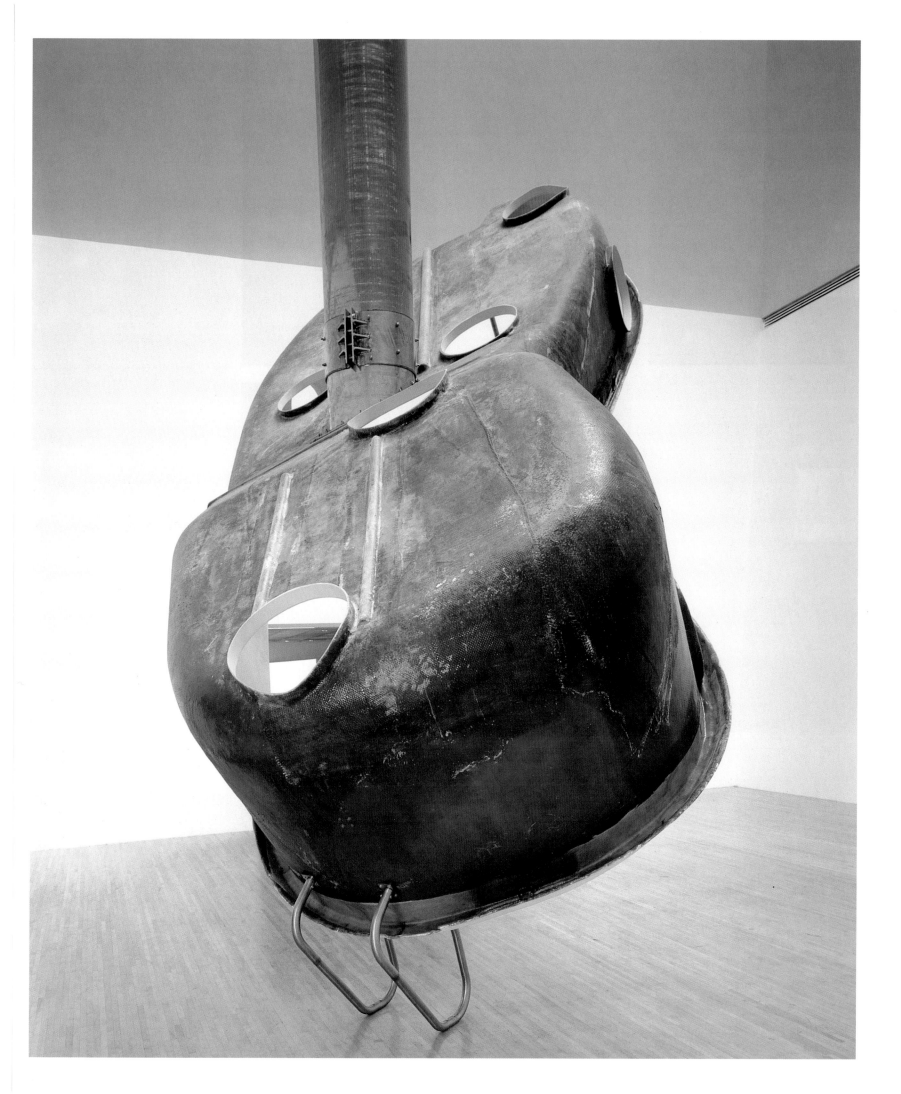

Entrance to the Utility Tunnel, 1994
Faret Tachikawa Urban Renewal Project, Tokyo

Created to conceal a maintenance stairwell, the sculpture took the
form of a replica of a traditional English staircase, made from
stainless steel and cast aluminium and increased in size by 133%.

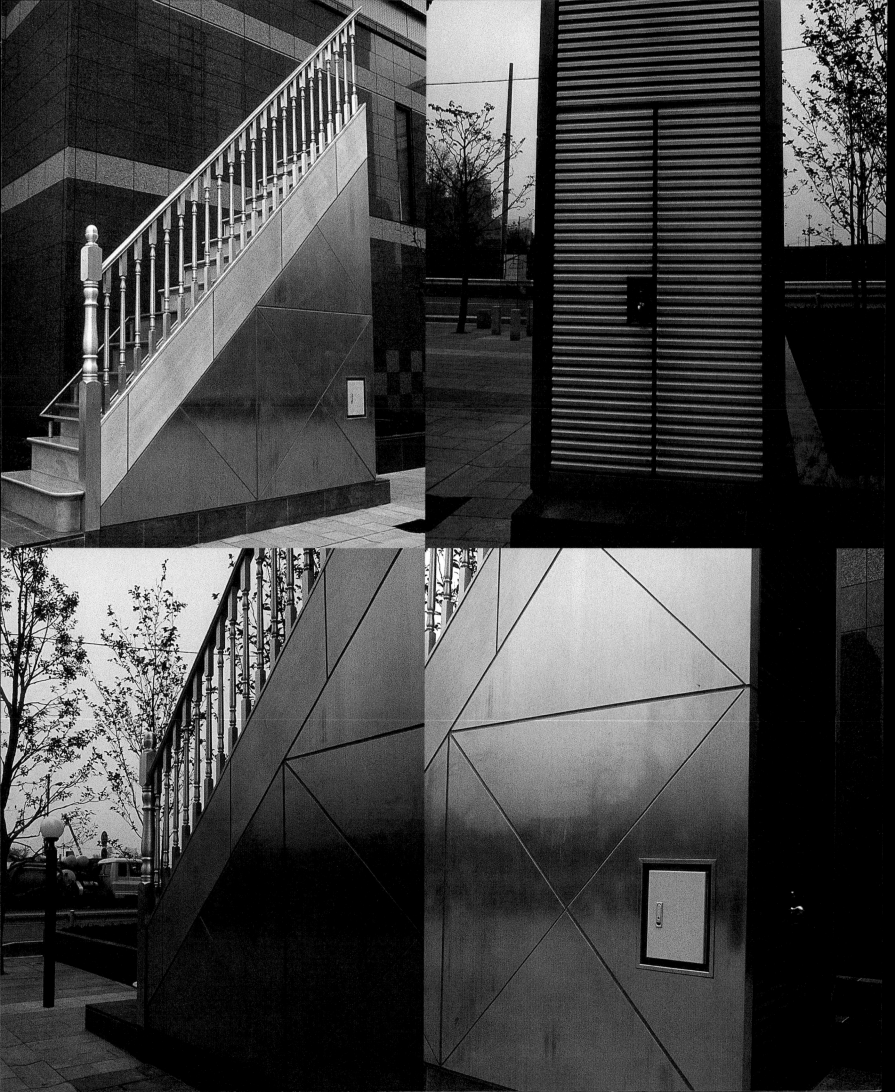

Pleasure Trip, 1995
Co-existence: Construction in Process, Mizpe Ramon, Negev desert,
Israel

The work consisted of a slide projection of Tower Bridge in London
on to a miniature screen created from a postcard of the Negev
desert, creating the illusion of the bridge being in the desert. The
soundtrack was of a guide on a sightseeing boat trip on the River
Thames. This monologue culminated in a joke about an American
buying London Bridge in mistake for Tower Bridge and subsequently
relocating it to the Arizona desert.

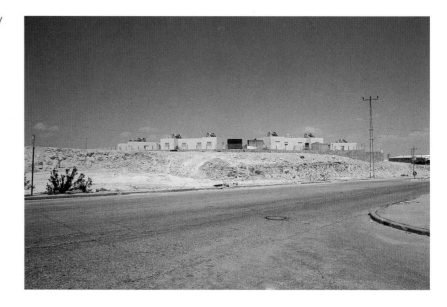

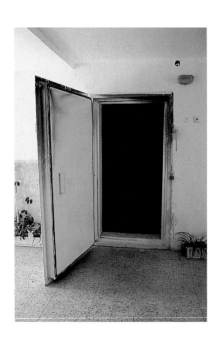

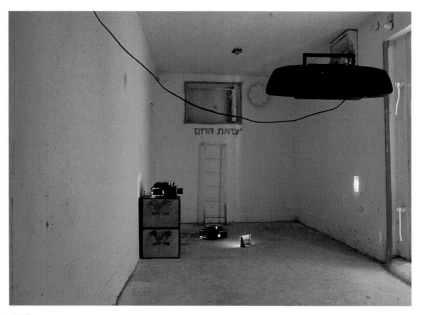

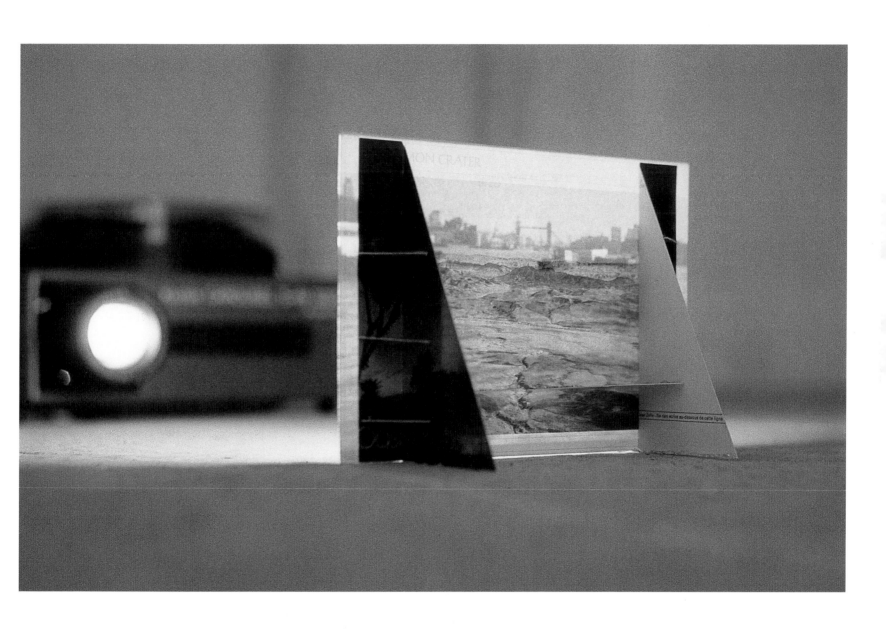

Cutting Corners, 1995
Galleria Valeria Belvedere, Milan

Two identical filing cabinets were positioned in opposite corners of
the room. The room, however, was not square, one corner being
obtuse and the other equally acute. A section from one cabinet was
therefore removed and inserted into its partner, thereby increasing
the exterior angle of one cabinet while reducing that of the other.
Once the altered cabinets had been riveted back together, they
fitted the opposing angles of the room exactly.

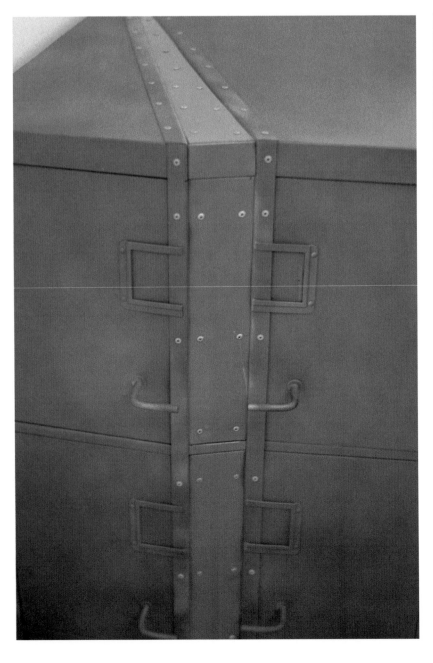 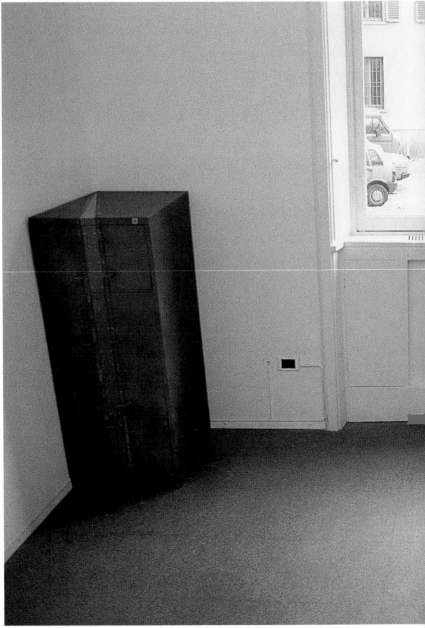

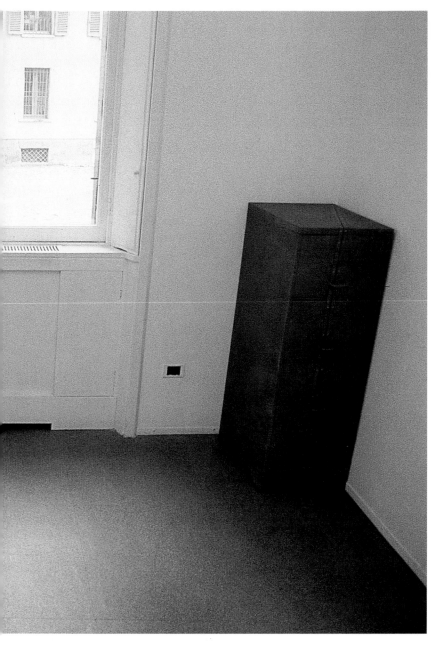

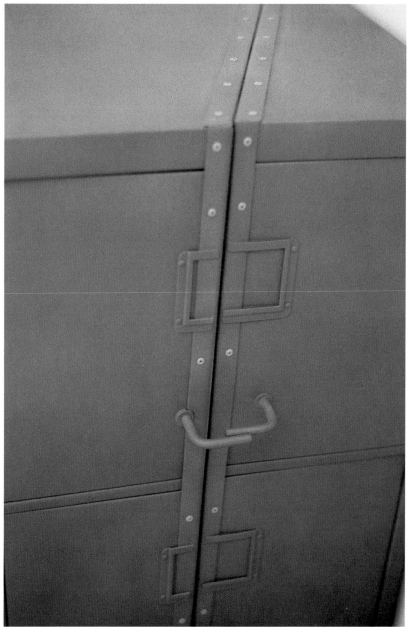

Corner, 1995
Galleria Valeria Belvedere, Milan

A circular section mimicking the corner spot on a football field was
cut from a typical Italian table-football machine and mounted in the
corresponding corner of the gallery, emphasizing its 90-degree
angle. Sliced vertically, the cut at once revealed the machine's
internal workings and rendered it unplayable. This work was a
companion piece to *Cutting Corners*.

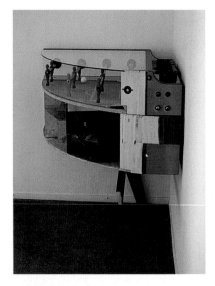

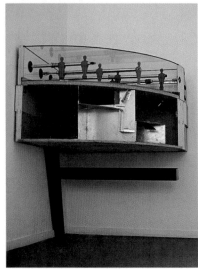

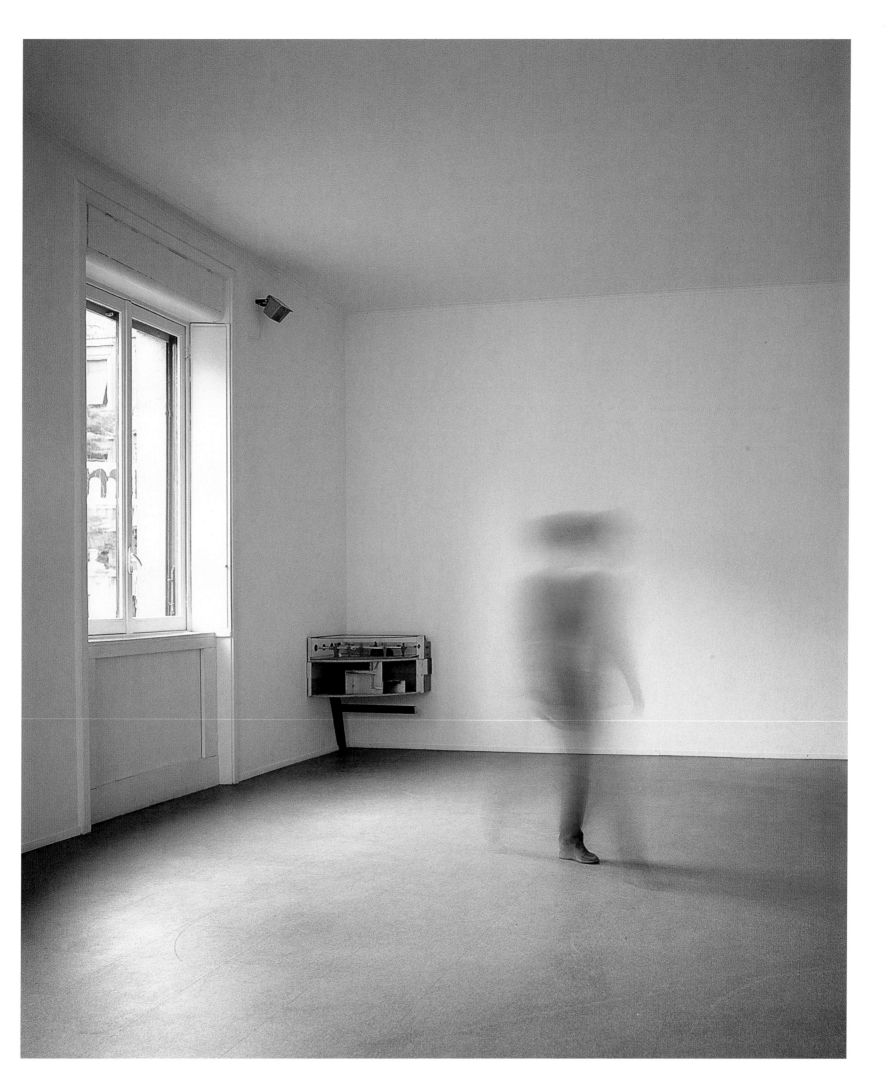

Hotel: Zimmer 27, Central Hotel, 1996
Städtische Ausstellungshalle am Hawerkamp, Münster, Germany

The work used the anonymity of the hotel room as its starting point.
A line drawing of the room in which the artist stayed while installing
the exhibition was constructed in Dexion steel speed-frame to
create a three-dimensional drawing of the space. Within this
framework, colour Polaroids were littered, representing the artist's
personal possessions scattered about the room.

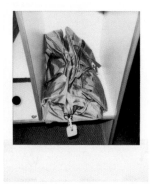

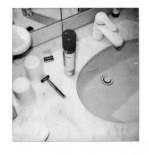

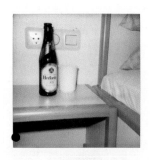

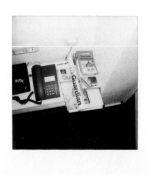

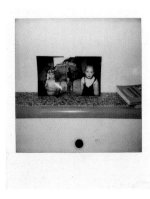

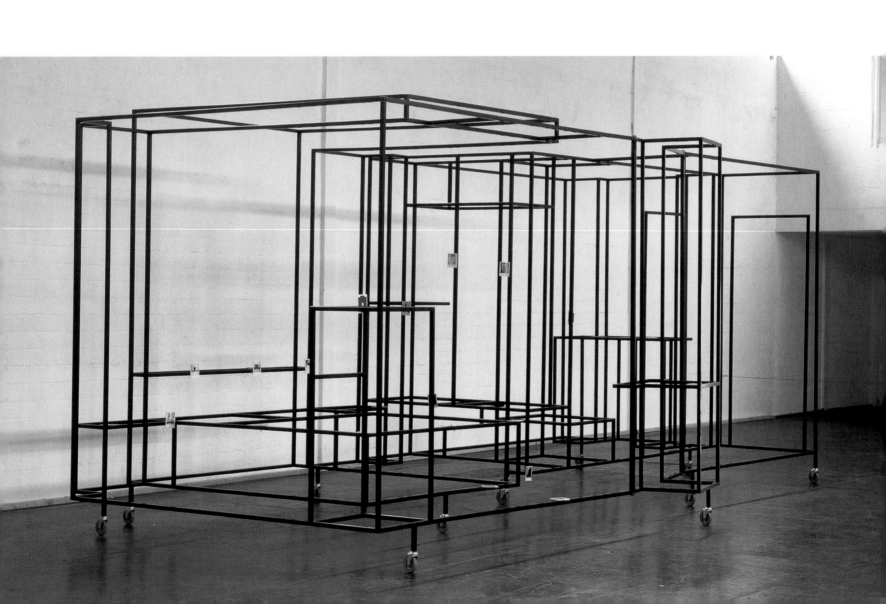

Hotel: Room 6, Channel View Hotel, 1996
Towner Art Gallery, Eastbourne

A three-dimensional line drawing of the hotel room in which the
artist stayed while installing the work was jammed into the main
space of the gallery. Owing to the approximately equal volumes of
the spaces, but their different dimensions, the framework of the
hotel room had to be installed around the gallery's lighting track,
locking the two volumes together. Postcards of the artist's
possessions in the hotel room were fixed to the framework,
corresponding to where they were photographed.

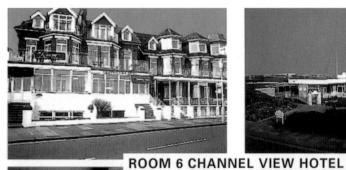

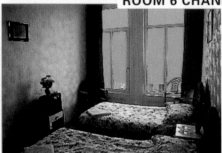

ROOM 6 CHANNEL VIEW HOTEL

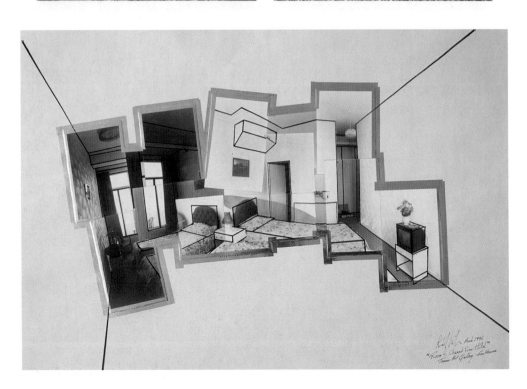

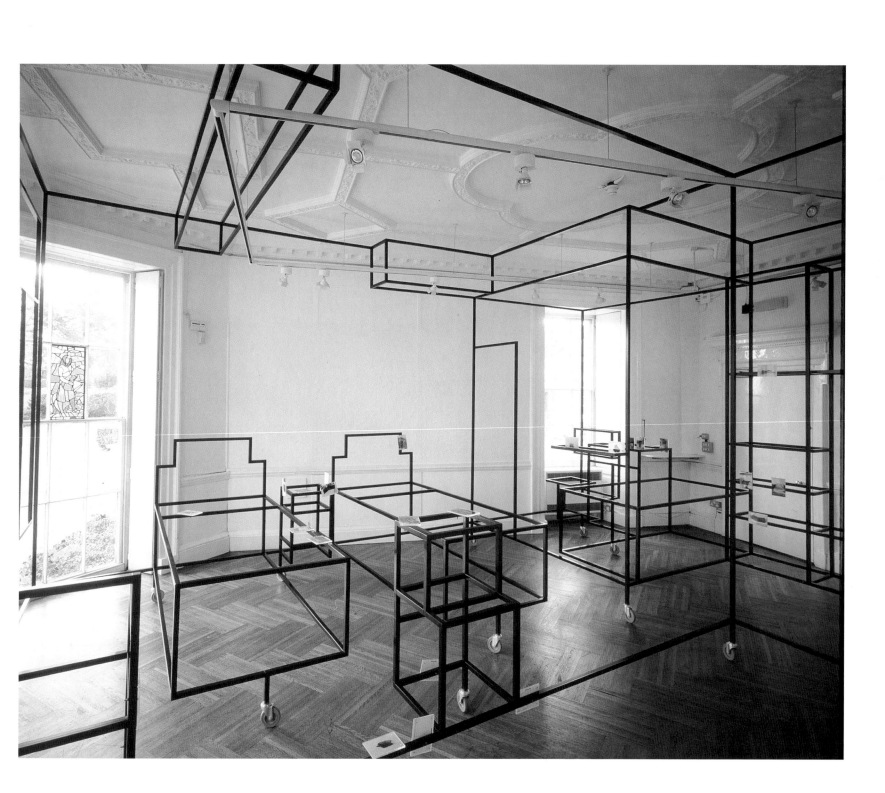

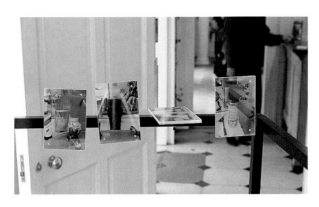

Bronze Pole of the North, 1995
Unrealized proposal for Tate Gallery Liverpool

The work would have taken the form of a single bronze pole
located in the middle of the gallery, descending from the top floor
down through the building and anchored into Liverpool's bedrock.
At high tide the tip of the pole would have been located level with
the parquet floor of the greatest part of the interior of the gallery.
At low tide one and a half inches of the pole would have been
exposed, proving that the Albert Dock, where the gallery is situated,
rises and falls on each tide.

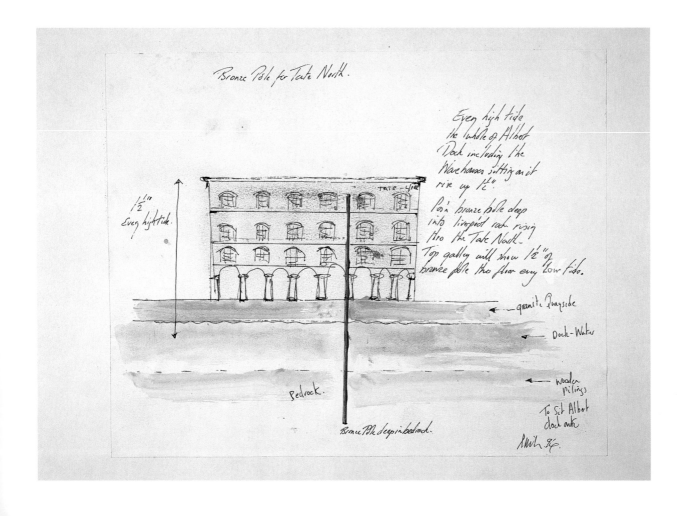

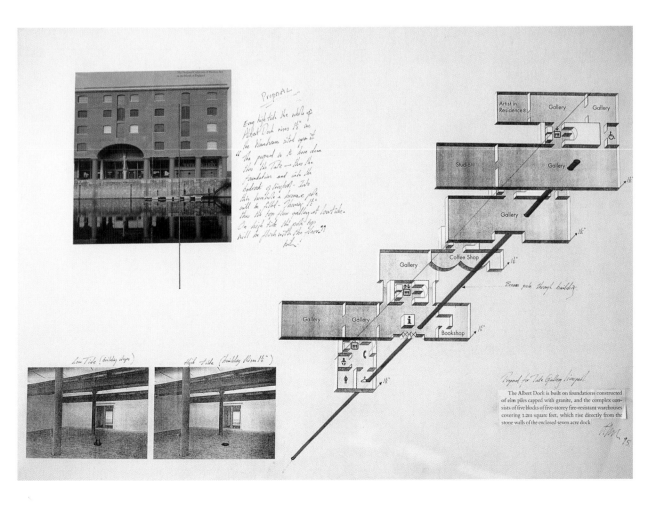

The Joint's Jumping, 1996–99
Unrealized proposal for Baltic Centre for Contemporary Art,
Gateshead

The building's architectural form would have been outlined in orange
neon light, both at its actual position and at a displaced angle. At
night the neon outlines would have fluctuated, making the building
appear to tilt or shake on its foundations.

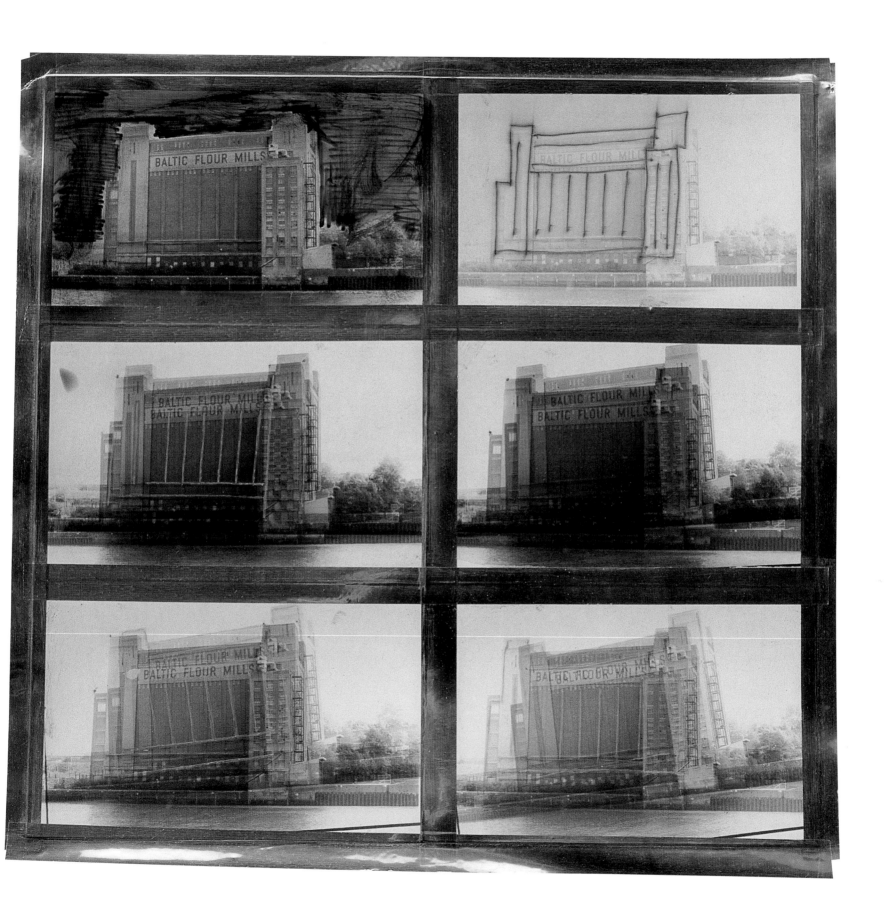

Doner, 1996
Mirades (Sobre el Museu), Museu d'Art Contemporani, Barcelona

Located in an irregularly shaped room that protruded from the main body of Richard Meier's new museum of contemporary art, a square, prefabricated, building-site office was levitated above floor level on two cantilevered steel L-beams. One beam entered the space through its doorway, while its companion support punctured the fabric of the museum to pass outside, before re-entering the protruding room.

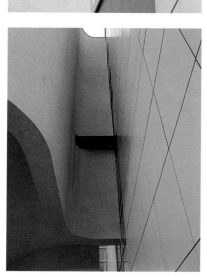

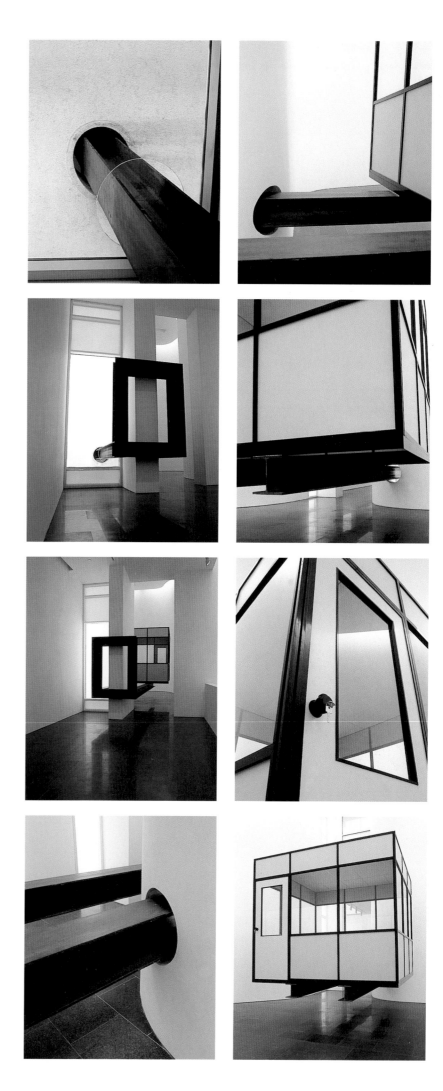

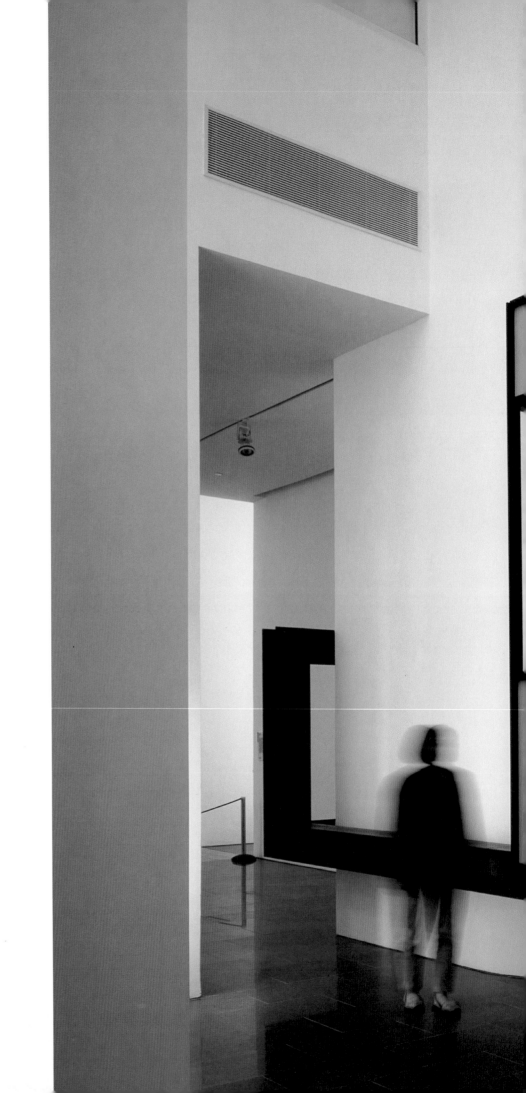

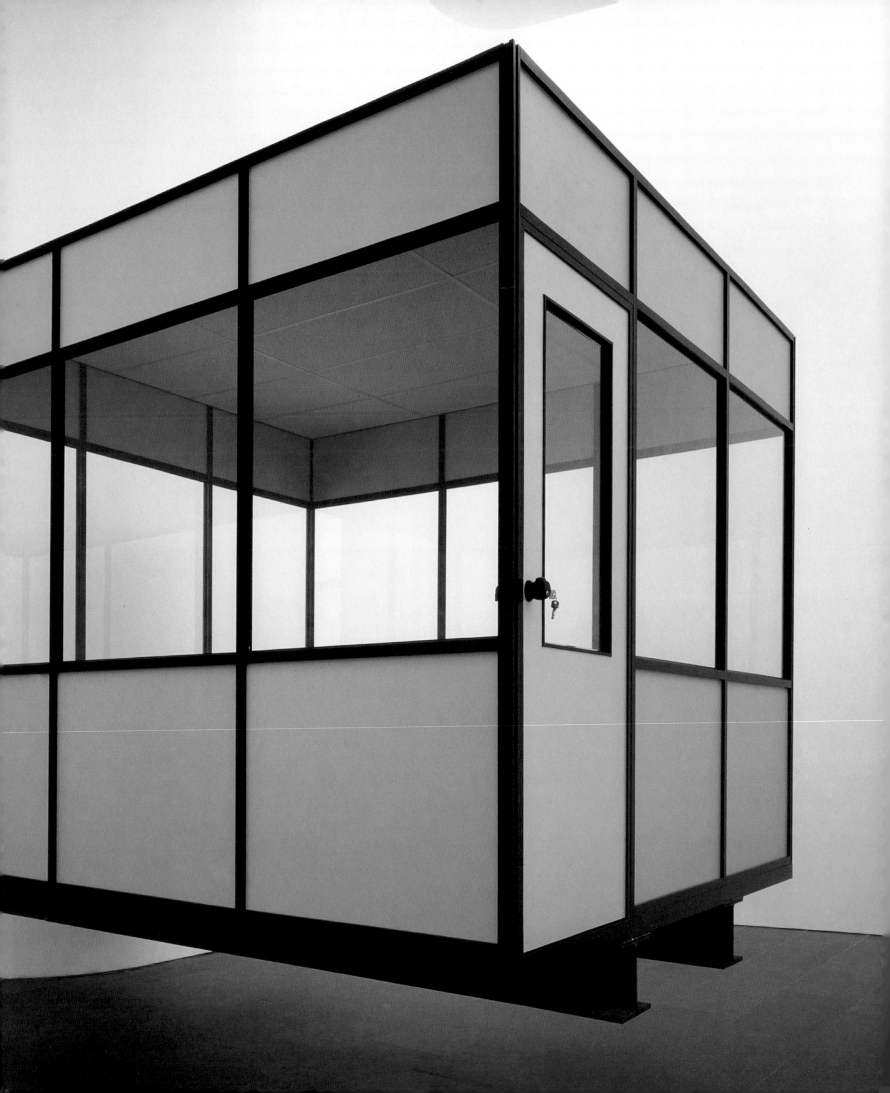

Formative Processes, 1996
Gimpel Fils, London

A temporary eighty-foot-long cavity wall, constructed from plywood
and scaffolding Acro-props, was inserted diagonally into the gallery
space. The structure was perforated with rectilinear openings to
house a selection of the artist's preparatory drawings.

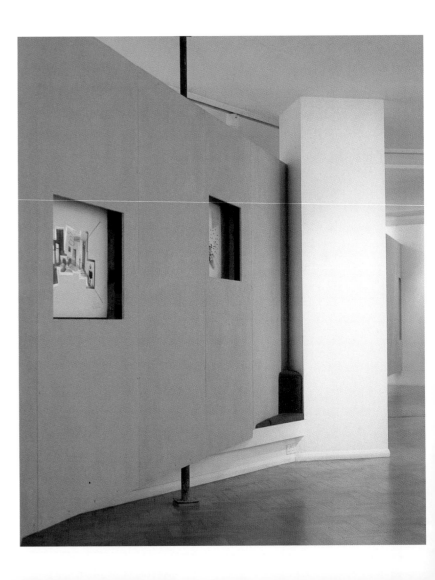

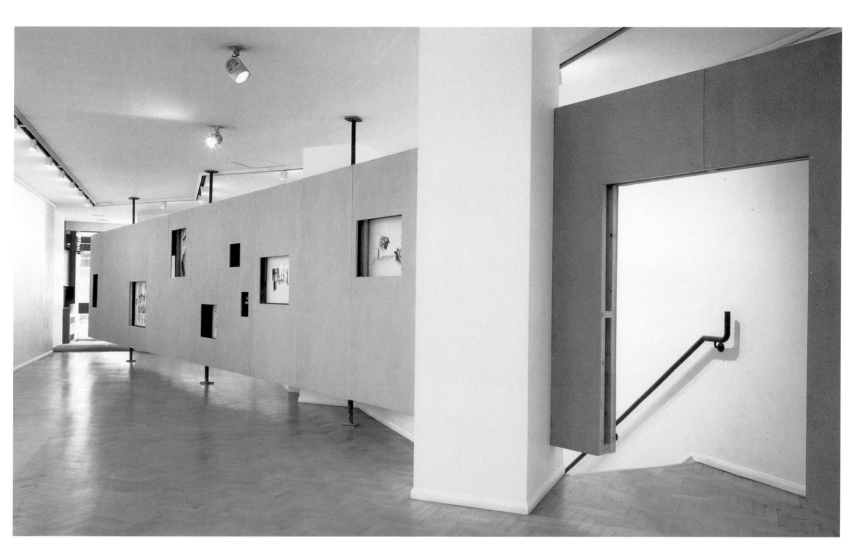

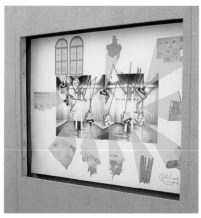

Jamming Gears, 1996
Serpentine Gallery, London

The installation comprised the displacement of sections of the
architecture of the gallery through the prefabricated architecture
and techniques of the construction industry. An industrial coring
machine was used to remove cylinders of material from the gallery's
walls and floors, which were subsequently inserted into the
prefabricated site cabins. These cabins were themselves placed on,
through or in the fabric of the gallery.

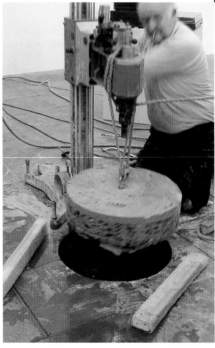

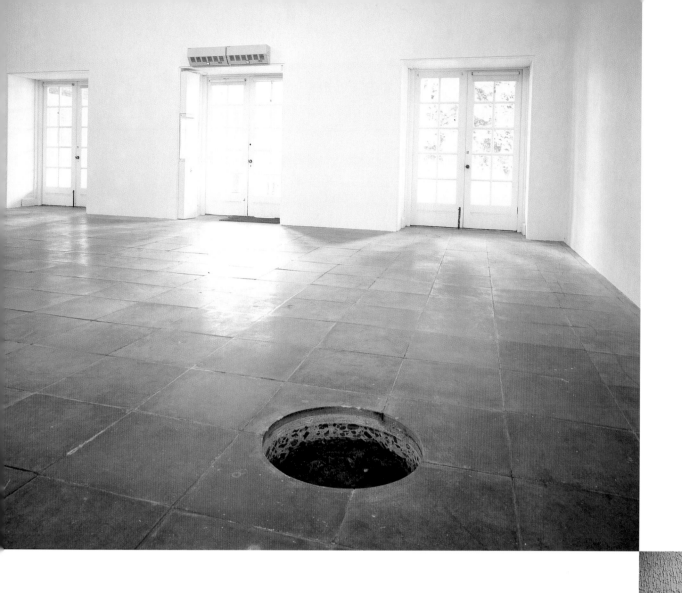

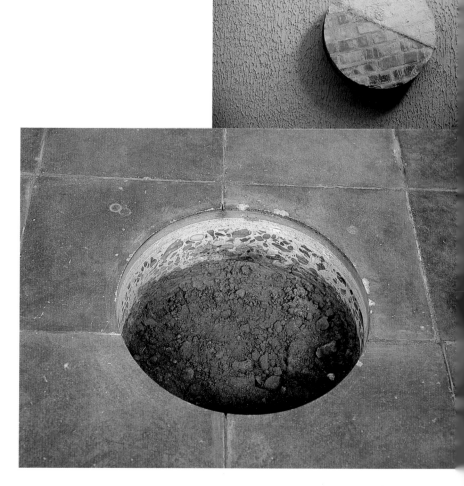

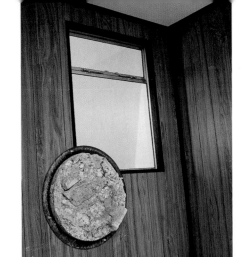

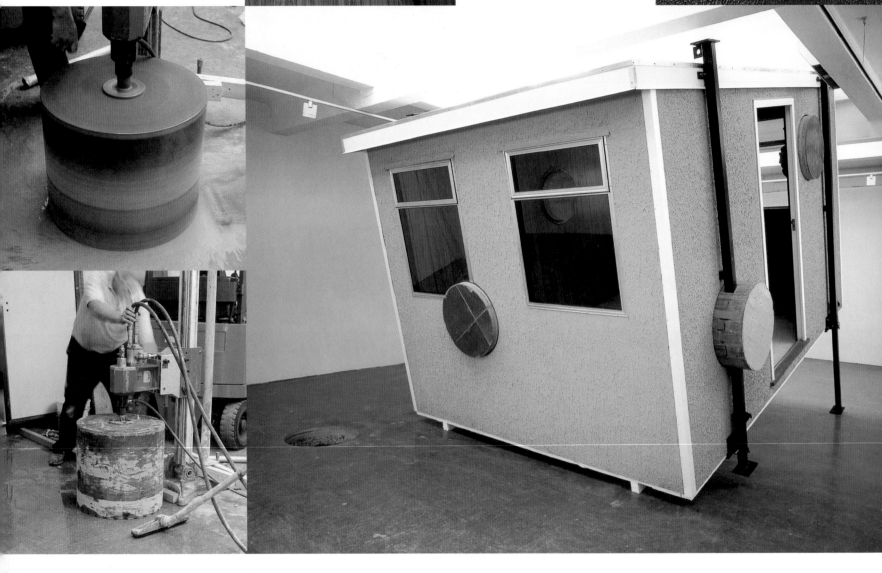

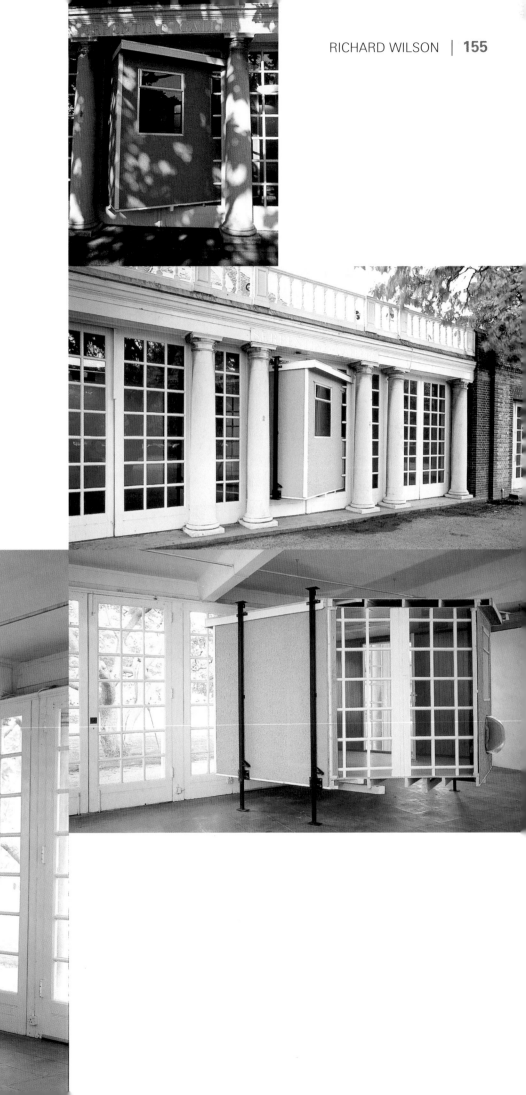

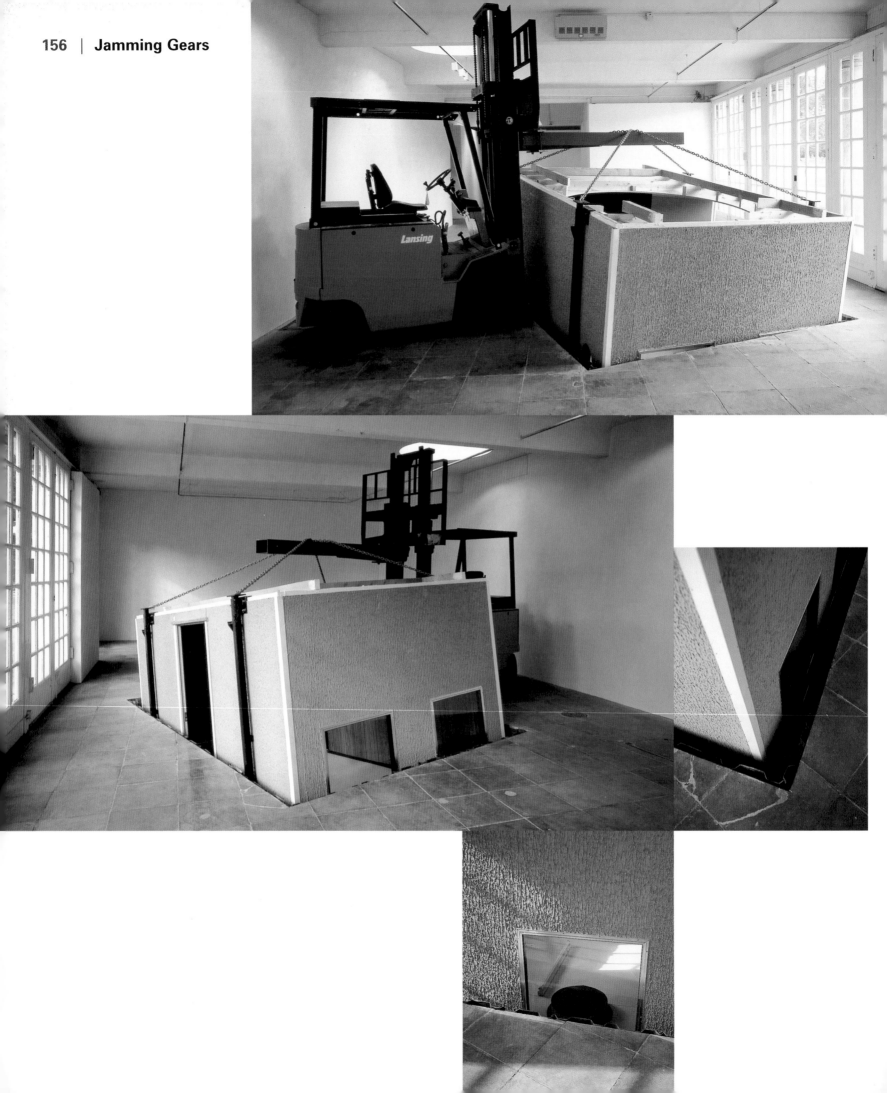

Ricochet (Going in/off), 1997
Château de Sacy, Picardie

In the billiard room of the château, two customized stands were installed that held an 8 mm film projector and a small articulated mirror. The projector played a film backwards of a burst water main beneath a lawn. This was projected on to the mirror and subsequently reflected on to the white billiard ball, creating the illusion that water was rushing into a hole in the ball.

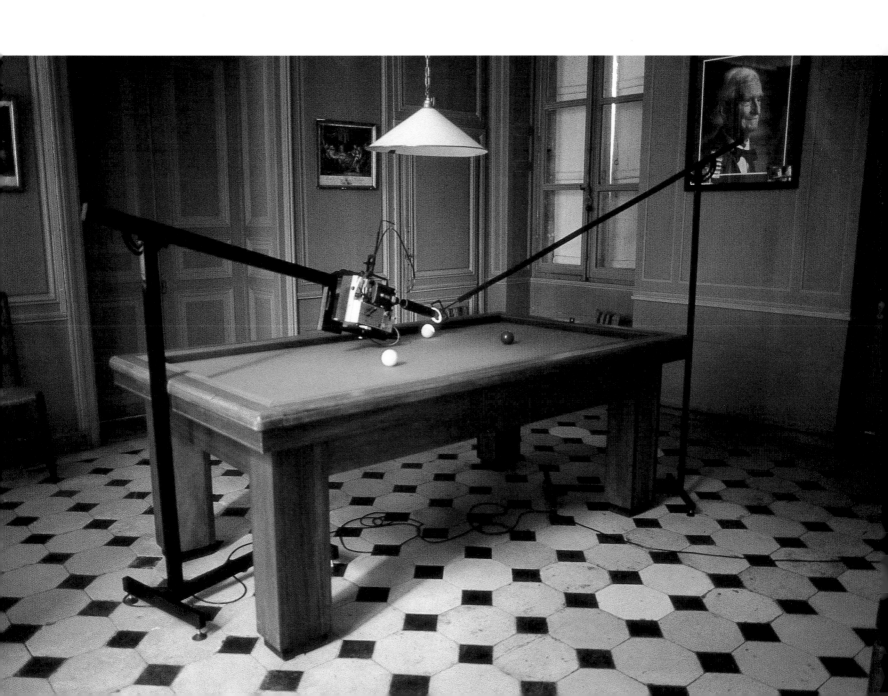

Hung, Drawn and Quartered, 1998
Städtisches Museum, Zwickau

The installation consisted of four paired forms that were
reconfigured into single objects. The resulting objects, all derived
from office, domestic or workshop furniture, were installed on the
rectilinear markings on the floor of the museum's ornate central
circulation space.

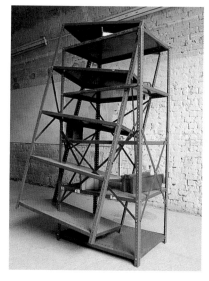

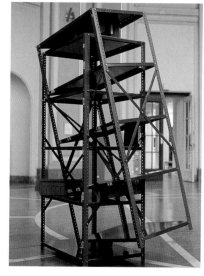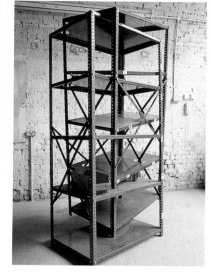

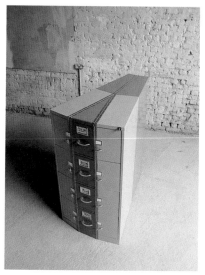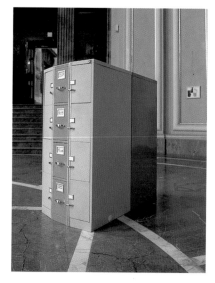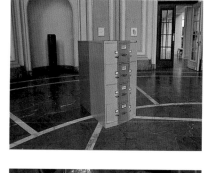

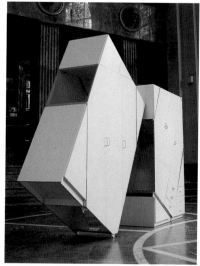

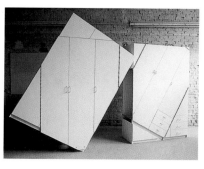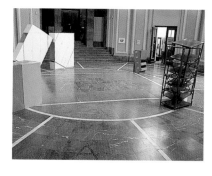

Outsize, 1998
Proposal in development

The work is a collaboration with Mark Lucas and Jane Thorburn of
After Image Productions.

At Trichur Poorum in southern India an elephant will be prepared according to
our instructions. Dressed in ceremonial splendour with a houda on its back,
glittering robes, beads, braid and hand-decorated chalk markings, the elephant
will also bear the lines that will predetermine the path two video cameras will
take across its skin.

Placed back to back, looking in opposite directions, the video cameras will
progressively track across the surface of the elephant. One camera will detail an
extreme close-up, spiralling around the trunk, wrapping an intricate route around
the huge body, the legs, ears and tail, recording the extraordinary detailed
landscape of both the skin and its beautifully adorned details.

The second, outward-facing camera will simultaneously record the panorama of
the environment and the landscape in which the huge animal stands. The vivid
blue sky, the yellow dusty ground, the surrounding bamboo scaffolding, some
spectators and the artists manipulating the camera will all be recorded.
The camera apparatus will be passed from hand to hand down a line of specially
trained mahouts, who will relay the predetermined choreographed moves.
The elephant munches its favourite palm leaves. A drummer and musicians
strike up. The weather changes. An argument breaks out. The elephant
trumpets. Digital recordings of both sound and images will capture the richness,
colour and detail of both the macrocosm and microcosm of the event.

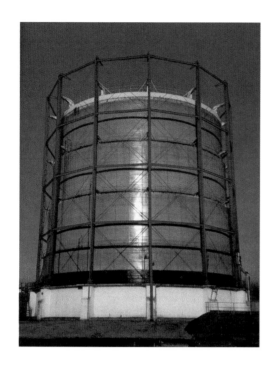

A disused, rusting and blackened gas holder contains an assembled audience. Normally supported by domestic gas under pressure, the gas holder is now held up by air pressurized at one-and-a-half atmospheres. The audience enters *via* air locks.

At the centre of the cathedral-like industrial void stands a robotic arm. The arm supports two high-resolution video projectors facing in opposite directions. The projectors display on the white painted interior of the gas holder the respective micro and macro moving images captured in India. The prehensile arm moves, mimicking the spiralling and scanning tracks traced across the bulk of the elephant thousands of miles away.

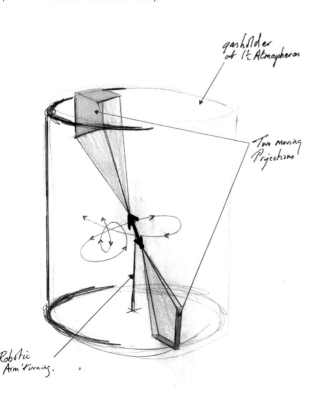

One projector slowly reveals an ambiguous landscape: the gloriously detailed intricacies of the Indian elephant's hide and its decorations. The other shows the sky, ground and people of India, surrounding the standing elephant. The audience is positioned between the robotic arm and the walls, as though floating in mid-air between an alien landscape and the atmosphere that surrounds it. The recorded stereo sounds follow the moving images around the space, being projected in the same manner as the video images.

Over Easy, 1999
The Arc, Stockton-on-Tees

The work consists of a section of curtain walling placed within an
8-metre-diameter purpose-built bearing of a newly built performing-
arts centre. The work functions as part of the structure of the
building rather than an addition to it. The work oscillates through
300 degrees at approximately the speed of the minute hand on a
clock, slowly revealing the internal workings and activities of the
space through the windows enclosed in the bearing.

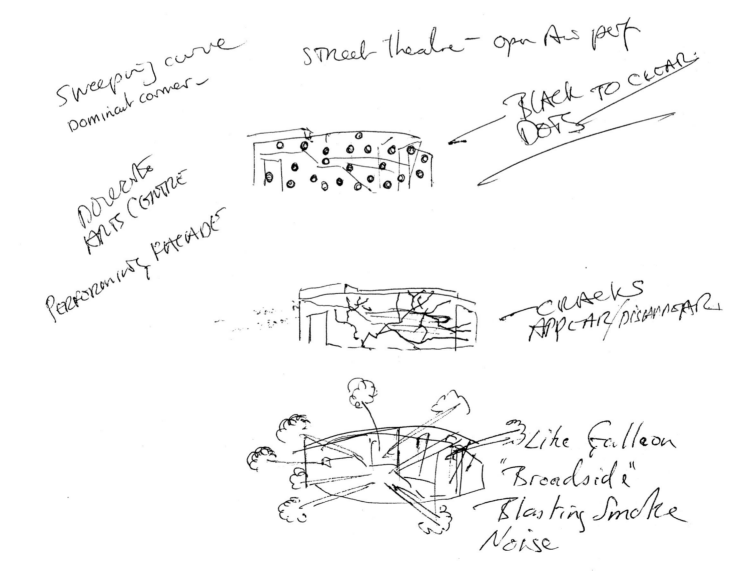

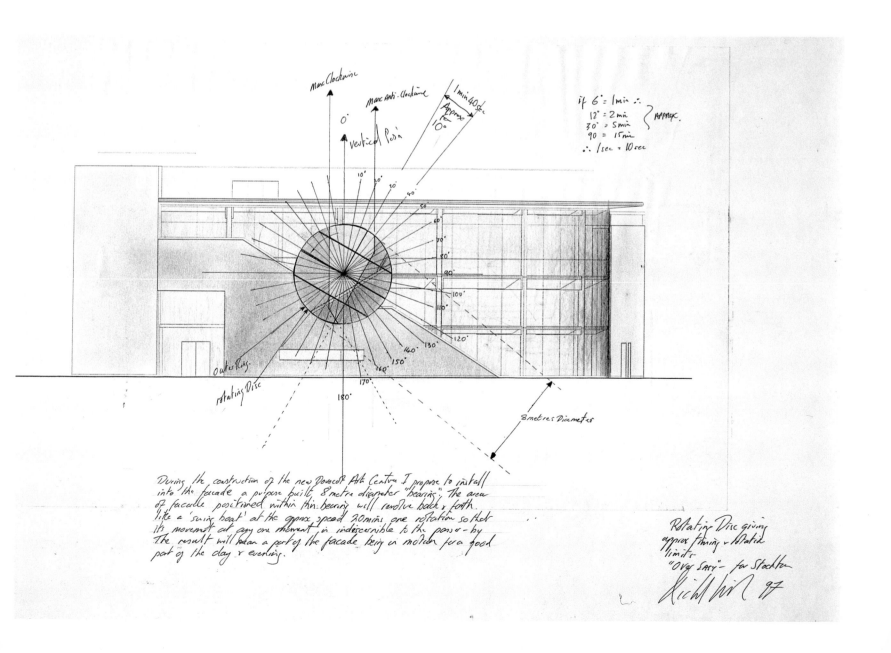

Max Clockwise

Max Anti-Clockwise

1 min 40 sec

Approx = 10°

0°

Vertical Pos'n

10°
20°
30°
40°
50°
60°
70°
80°
90°
100°
110°
120°
130°
140°
150°
160°
170°
180°

if 6° = 1 min ∴
12° = 2 min
30° = 5 min } APPROX.
90 = 15 min
∴ 1 sec = 10 sec

Outer Ring

rotating Disc

8 metres Diameter

During the construction of the new Dovecot Arts Centre I propose to install into the facade a purpose built 8 metre diameter "bearing" the area of facade positioned within this bearing will revolve back & forth like a 'swing boat' at the approx speed 20 mins one rotation so that its movement at any one moment is indiscernible to the passer-by. The result will mean a part of the facade being in motion for a good part of the day & evening.

Rotating Disc giving approx timing & rotation limits
"Over Easy" for Stockton

Richard Wilson 97

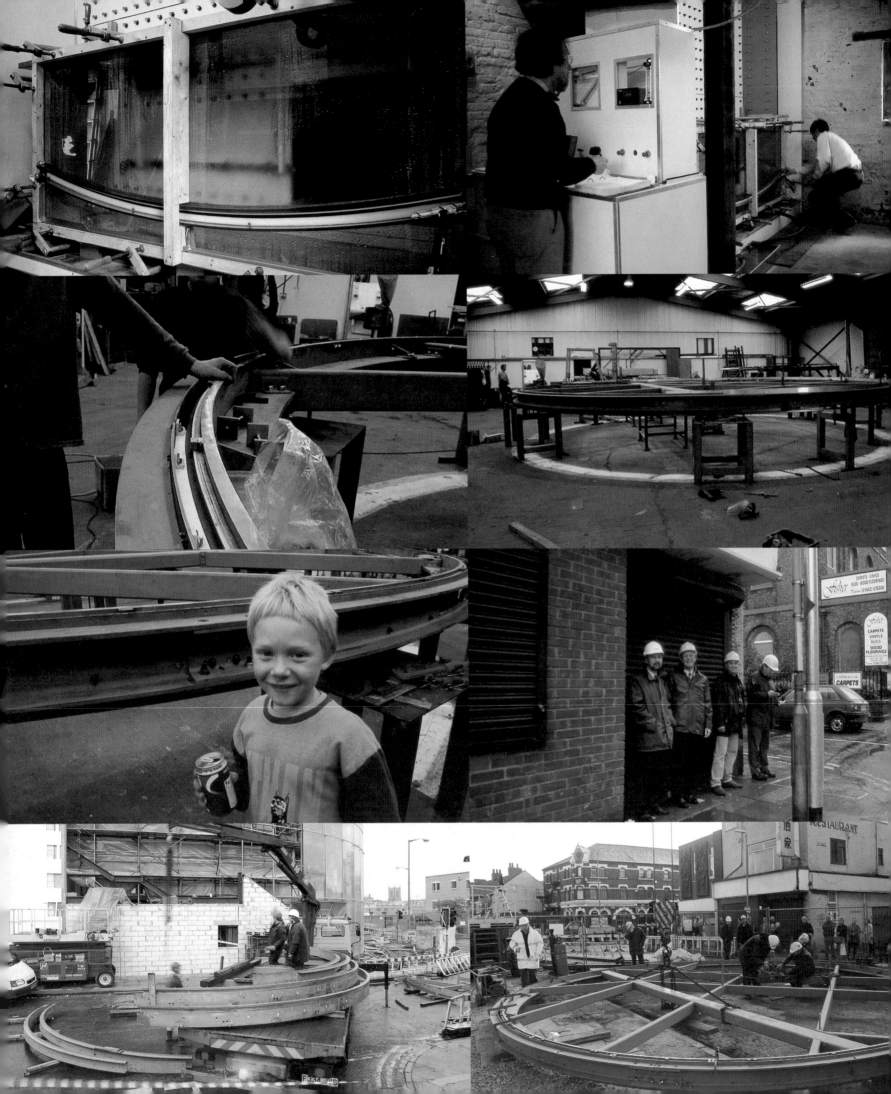

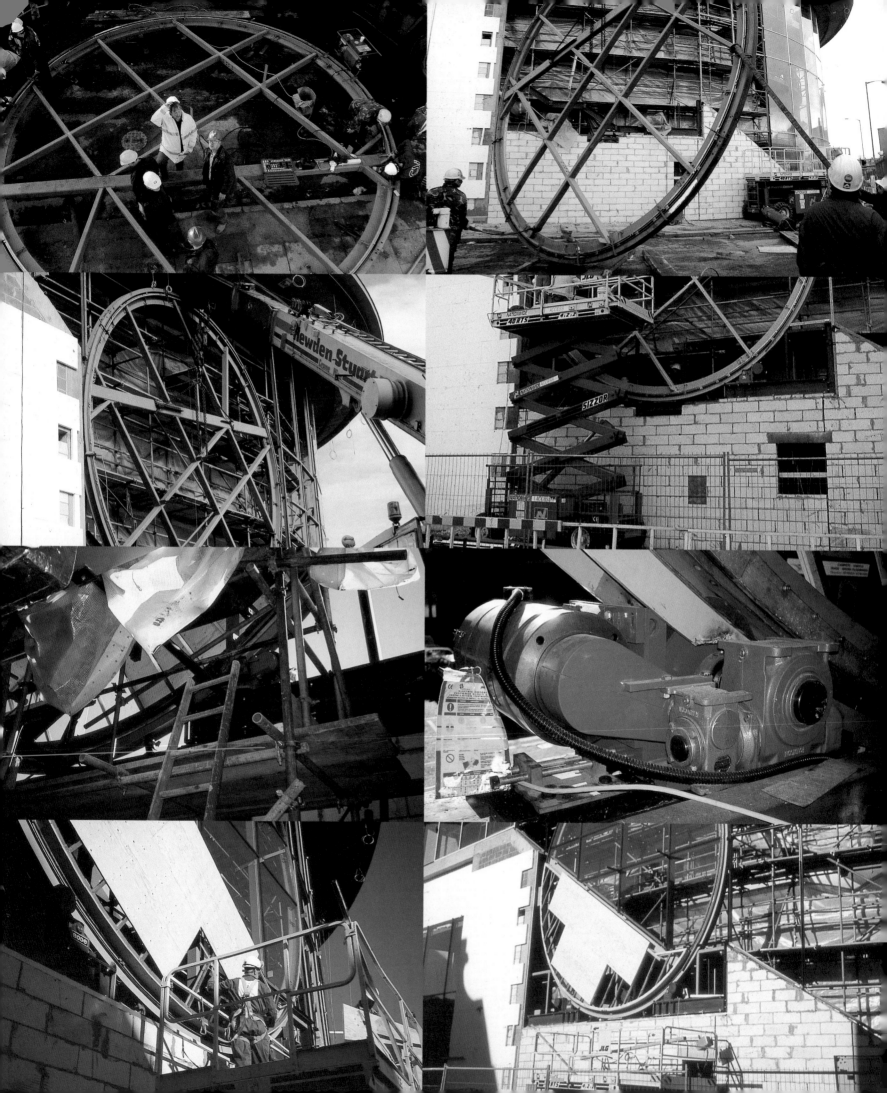

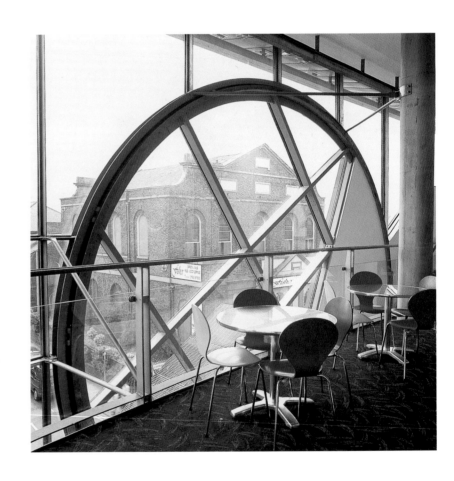

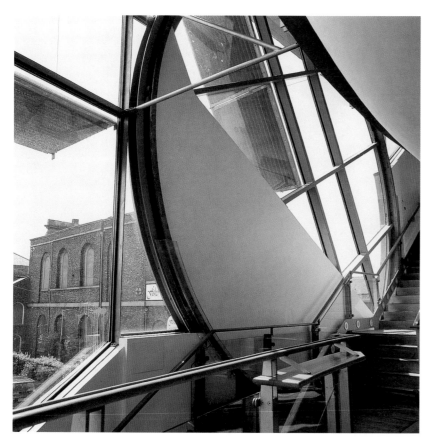

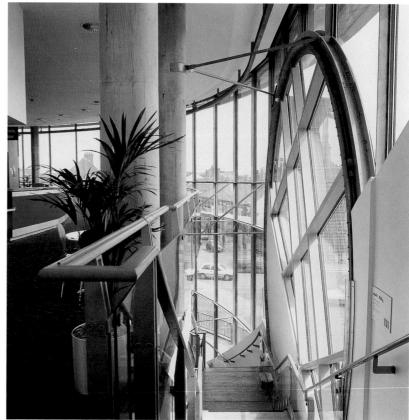

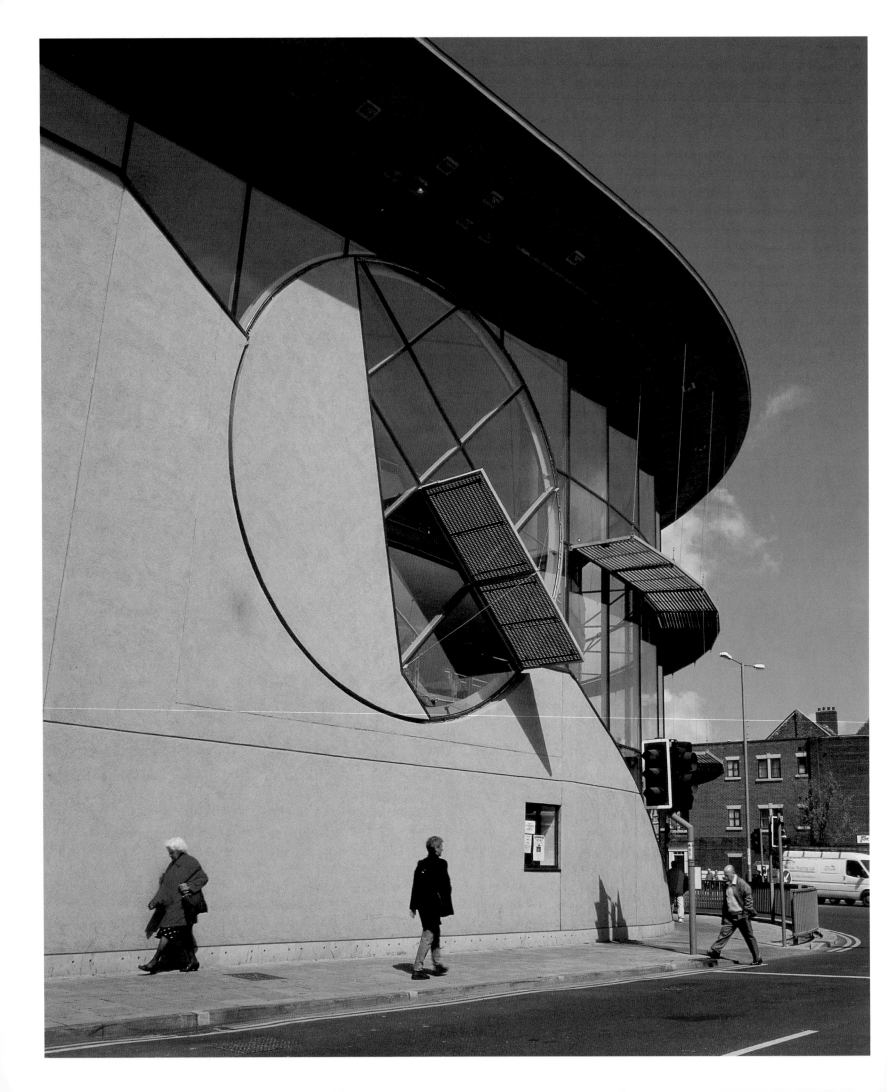

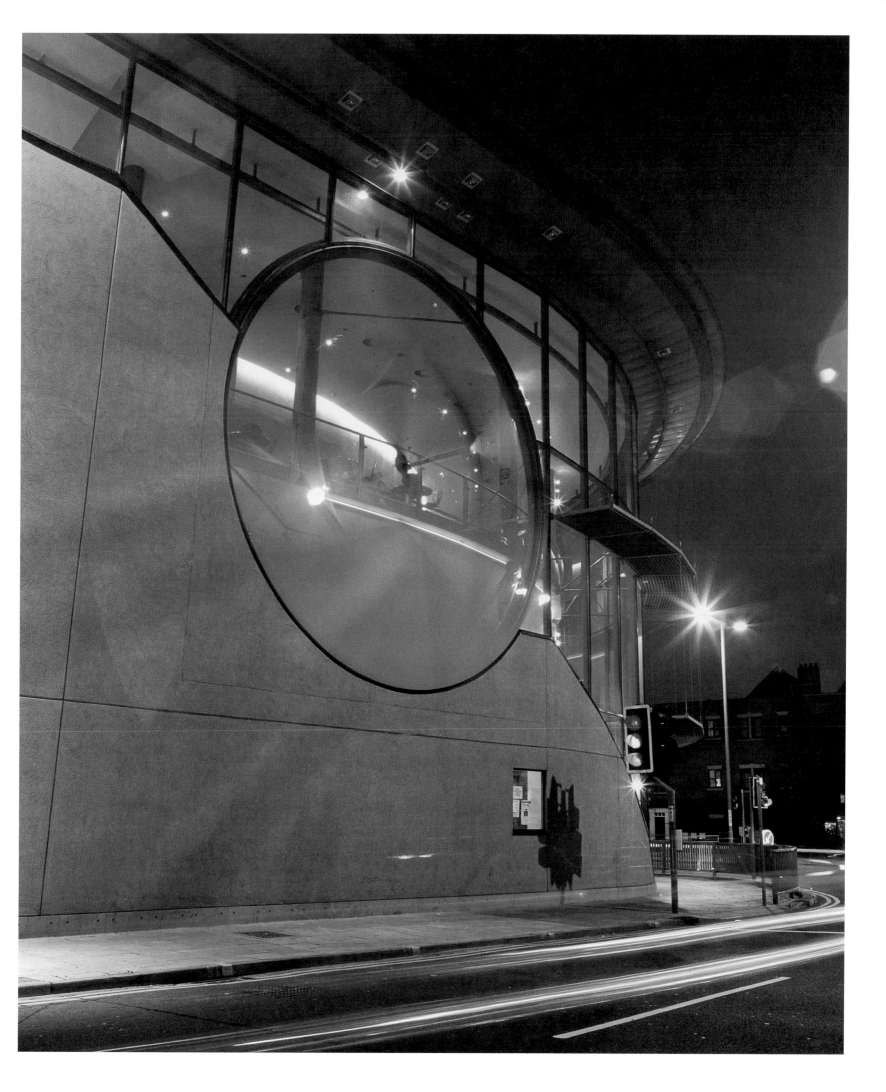

Over Easy?: Engineering Richard Wilson

Harry Stocks, Price & Myers Consulting Engineers, London

January 1994

Price & Myers Consulting Engineers first came into contact with Richard Wilson when he was considering an installation at Matt's Gallery off the Mile End Road in East London. The gallery is in an old warehouse flanking a canal. Richard's initial idea was to bury a traditional garden shed upside down in the gallery floor. The gallery asked us to consider the effect of digging a two-metre-deep hole through the concrete floor of their space. We were concerned that the hole would undermine the foundations of the building. We therefore arranged for a trial pit to be dug. Although, in our terms, the problem was a relatively straightforward one, Robert Myers, founding partner of Price & Myers, developed a personal interest in Richard's project. He inspected the trial pit and deepened it with a hand auger to probe the underlying ground. He soon reached the water table caused by the adjacent canal and explained that it would be difficult to construct the hole that Richard needed to bury the garden shed.

What is perhaps most notable about this discovery is that what might have appeared to be a barrier to Richard's idea quickly became the inspiration for the finished work. Rather than pursuing his original idea, Richard decided to set a billiard table into a hole in the ground, pierced by a concrete pipe. The pipe finished just above the water table, allowing the water beneath the ground to be seen and heard. The piece was aptly named *Watertable*.

February 1997

The next time we were to work with Richard it was on a much more ambitious scale, and the engineering process was inevitably to prove to be in a very different league to that for *Watertable*.

Over Easy is a rotating sculpture set into the curved glass facade of the Arc, the performing-arts centre in Stockton-on-Tees in the North of England that opened in January 1999. The sculpture consists of an 8-metre-diameter disc that encloses a section of the glazing, the rich yellow rendering and steel *brise-soleil* that make up the main exterior wall of the building. The disc moves alternately clockwise and anti-clockwise so that its glazed and rendered sections are gradually dislocated from their counterparts in the static façade.

Richard's involvement with the Arc began in autumn 1996, after architects Renton Howard Wood Levin Partnership (RHWL) had come up with designs for the new arts centre. He was approached by David Metcalfe, who was managing a number of site-specific commissions to mark the opening of the building, with the idea of making a permanent work for the Arc. The brief was to develop a work that would function as a unique 'flag' for the arts centre.

In November, Richard met the architects and the Arc management team to present the preliminary designs for his intervention. He had aimed for a work that would be memorable and simple, that would pierce the building and make it move, disrupting the main façade. The proposal was greeted with unanimous enthusiasm, even from the architects themselves, even though the work would interfere with the architecture and inevitably complicate the building.

Richard came to talk to me and several colleagues at Price & Myers about the feasibility of *Over Easy* in early 1997. Although we were able to reassure Richard that we thought his idea could be achieved, we realized that we needed expert advice on the drive mechanism and sealing system. Richard's proposal was to insert a steel bearing into the façade of the Arc, which would allow the section of wall to rotate. W.S. Atkins were commissioned to carry out a feasibility study for the mechanical engineering needed for this, and Price & Myers undertook the structural-engineering aspects of the project. The purpose of the study was to report on the technical difficulties in designing, fabricating and maintaining the piece, and therefore give some measure of confidence to the Arc's management to take the project forward to detailed design stage.

The mechanical-engineering brief was to look at three aspects of the piece. First, how the disc was to be laterally restrained within the fixed outer ring; secondly, the support and drive system for the disc; and, finally, the sealing system that was to protect the annular gap between the moving disc and outer ring against the ingress of dirt and water.

The structural-engineering brief was to design the piece and its supporting structure. This meant making sure the disc would be strong enough not to distort as it turned and therefore jam inside the outer ring, and that the framing would be adequate to transmit the loads back into the building. It also meant liaising with the Arc's structural engineers to make sure that *Over Easy* would not overstress their building.

Richard was naturally very keen that the engineering solution should satisfy his requirements for how the piece should look and perform. It was important that the disc should look as if it were part of the building and not something just bolted on. This meant keeping the joint between the disc and the ring as unobtrusive as possible by masking the seals behind the glazing and cladding. It also meant keeping the disc as thin as possible.

As the disc cut partly through the rendered wall this meant that the thickness of the wall was to be the thickness of the disc. Similarly, where the disc cut through the glass curtain wall, we needed to use the same-size mullions and transoms as those that supported the glazing.

There was also the *brise-soleil*. This jutted out of the building by 1200 mm and ran around the building at mid-height. If it had ended at the outer ring then it would have clearly signalled that *Over Easy* was not part of the building. So incorporating it into the piece was considered vital.

Richard was also very precise about how the disc was to move. He had drawn several elevations of the disc at various angles. It was to oscillate gently from side to side, and the movement was to be indiscernible to the eye. The concept was that passers-by would never know which position the disc would be in. It was thought that the speed of the minute hand of a clock would be perfect for this.

Finally, there was the biggest challenge of all: simply the cost of the piece. If a solution could not be found to keep the cost at around £120,000 then the project would have to be abandoned.

June 1997
By early summer the engineering feasibility studies were completed, and results looked promising.

W.S. Atkins had looked at five options for the lateral restraint of the disc within the ring. Four of the options were eliminated owing to a variety of reasons: cost, excessive vibration, difficult access for maintenance and excessive wear rate. The favoured option was to fix to the ring eight wheels that would run in a continuous steel guide. One disadvantage was that the rear edge of the disc would probably need machining, which would be fairly costly. But, more importantly, it meant that the guide track would protrude into the building. However, this was a compromise that simply had to be made.

Richard had produced some preliminary ideas of how the disc could be powered. A rack-and-pinion drive system looked elegant but was found to be too expensive. Other systems were looked at but quickly eliminated as being too noisy or too costly.

Only one system satisfied all the requirements, and this was made by Bode Positioners Ltd. Their positioners have a hard polyurethane wheel attached to a drive motor and can support loads of up to five tons. They have been used for many years in the chemical industry to rotate circular tanks, and two of these units would be able to both support the disc and power the circular motion. They had the further benefits of being very quiet in operation and, most importantly, as they were standard components they were relatively inexpensive.

Only two types of seal for the gap between the disc and ring were investigated – namely brush seals and blade seals. As in the case of the selection of the drive system, to keep the cost down the sealing system had to be made from standard components. This immediately eliminated a bespoke one-piece seal to fit around the 8-metre-diameter disc, and the study concentrated on how to fit the seal in short lengths. In order for the brush-type seal to work, the brush had to be pushed hard against the sealing surface. This meant that when the seal was new, it produced considerable resistance to motion. To get an idea of this, imagine pulling a heavy rope twenty-five metres long along a road. In addition, the brush would have a fairly limited lifespan, as the bristles would inevitably become choked with dirt. The study therefore concentrated on the use of blade seals.

Richard had already looked into the sealing problem and had contacted the firm Sealmaster. They specialize in draught and weather sealing systems and were very helpful in finding three workable sealing options using neoprene blades. These all satisfied the basic requirements that the seal keep out the wind and rain in all positions on the ring, the blades be easily replaceable and the frictional resistance be low. However, two of the options required silicone-grease lubricant to achieve this. There was a worry that the heat from direct sunlight (even in Stockton-on-Tees) could melt the grease and let it run down the face of the building. It was therefore decided to recommend the greaseless system. This was a simple 'off-the-shelf' neoprene-blade seal pressed against a continuous nylon block mounted on the ring. It was also felt that if this system was mounted on the outside of the ring it would still work within the tolerances of the lateral movement of the disc, as well as radial movement arising from any ovality of the disc.

We found the structural engineering of the piece also threw up problems to be overcome. The piece was part of the building, but design codes for buildings do not cover moving structures. In addition, we did not know anybody who had tried this before and so we had to rely on our own engineering experience and common sense to make the preliminary design. As described before, the width of many of the components of the piece was governed by the depth of the existing façade, which limited our room to manoeuvre. Other structural problems arose from the structure of the Arc. We were told that the steelwork in the roof would not be strong enough to restrain the piece at high level, and so we

should have to provide our own restraint system. At the end of June, we submitted our drawings and reports to the Arc and kept our fingers crossed.

August 1997

At the end of August we got the news we had been waiting for. The feasibility study had been accepted, and we could start the detailed design.

Up until this stage in the project, W.S. Atkins had put in most of the work, since they had been carrying out the bulk of the research. But now the pressure was definitely on us to design and draw the steel framework so that a fabricator could actually build it. All future design work would be based on this drawing.

It was clear even at the feasibility stage that the disc rim would be designed with stiffness in mind rather than strength, and we had already put the geometry and load cases into the analysis computer. One of the situations we looked at was with the disc in its weakest position, which was upside down. Although this wasn't going to happen in daily use, it would be a position used during maintenance. It would have been great if we could have put the data in, pressed a button and got the answers out. In fact, the computer refused to recognize the disc until we fooled it with some fake supports. So much for the technology. It was also clear that the disc would need a very stiff cross-beam to stop excessive deflection of the glass under wind load and to support the mullions.

Data for the outer ring was also fed into the computer. We wanted to use the smallest section possible, so it would be unobtrusive but the analysis showed it would be too flexible unless we increased the size. But then we found that the existing façade could provide enough restraint to stop the ring deflecting if we detailed the connections carefully.

The *brise-soleil* was also not without its problems. On the rest of the building, one side was fixed to the mullions and the other suspended on wires from the roof. Obviously, this was not an option open to us. We wanted to cantilever it out from the glass mullions in the disc, but it was just too heavy, so we tied it top and bottom with stainless-steel cables fixed to the disc rim.

There was one final difficulty to overcome: time. I was working flat out on several other projects, and there was a real danger that the solutions to Richard's problems might stay in my head and not reach paper. The January deadline loomed, and by burning the candle every which way I somehow got the plans out to the rest of the team on schedule.

January 1998

At this point the rôle of Commercial Systems International (CSI) became crucial. CSI was the contractor for the Arc's glazed curtain wall. An option had been included in the tender documents for the fabrication and installation of *Over Easy*. It was awarded to CSI. However, the thorny issue of warranties had not been sorted out. Basically, the problem was this: Richard could not be expected to take a personal liability for the project. We were willing to warrant our structural design, as this is what we are insured for, but we couldn't warrant that the piece would work, as our professional indemnity insurance could not cover CSI's workmanship. On the other hand, CSI would not warrant the piece, as they considered the way it was made to be a design issue. This meant that during the fabrication phase CSI

	Job No.		Page		Rev	
PRICE & MYERS		7895		SK2		
CONSULTING ENGINEERS	Date	Sept 99	Eng.		Chd.	
	Job	THE ARC				
		STOCKTON−ON−TEES				

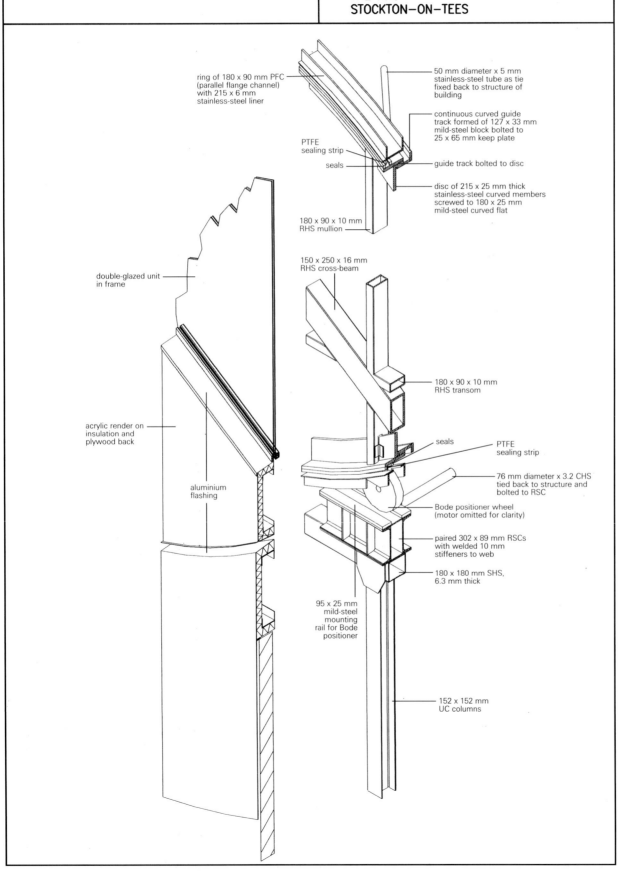

ring of 180 x 90 mm PFC (parallel flange channel) with 215 x 6 mm stainless-steel liner

50 mm diameter x 5 mm stainless-steel tube as tie fixed back to structure of building

continuous curved guide track formed of 127 x 33 mm mild-steel block bolted to 25 x 65 mm keep plate

PTFE sealing strip

seals

guide track bolted to disc

disc of 215 x 25 mm thick stainless-steel curved members screwed to 180 x 25 mm mild-steel curved flat

180 x 90 x 10 mm RHS mullion

150 x 250 x 16 mm RHS cross-beam

double-glazed unit in frame

180 x 90 x 10 mm RHS transom

acrylic render on insulation and plywood back

seals

PTFE sealing strip

76 mm diameter x 3.2 CHS tied back to structure and bolted to RSC

Bode positioner wheel (motor omitted for clarity)

aluminium flashing

paired 302 x 89 mm RSCs with welded 10 mm stiffeners to web

180 x 180 mm SHS, 6.3 mm thick

95 x 25 mm mild-steel mounting rail for Bode positioner

152 x 152 mm UC columns

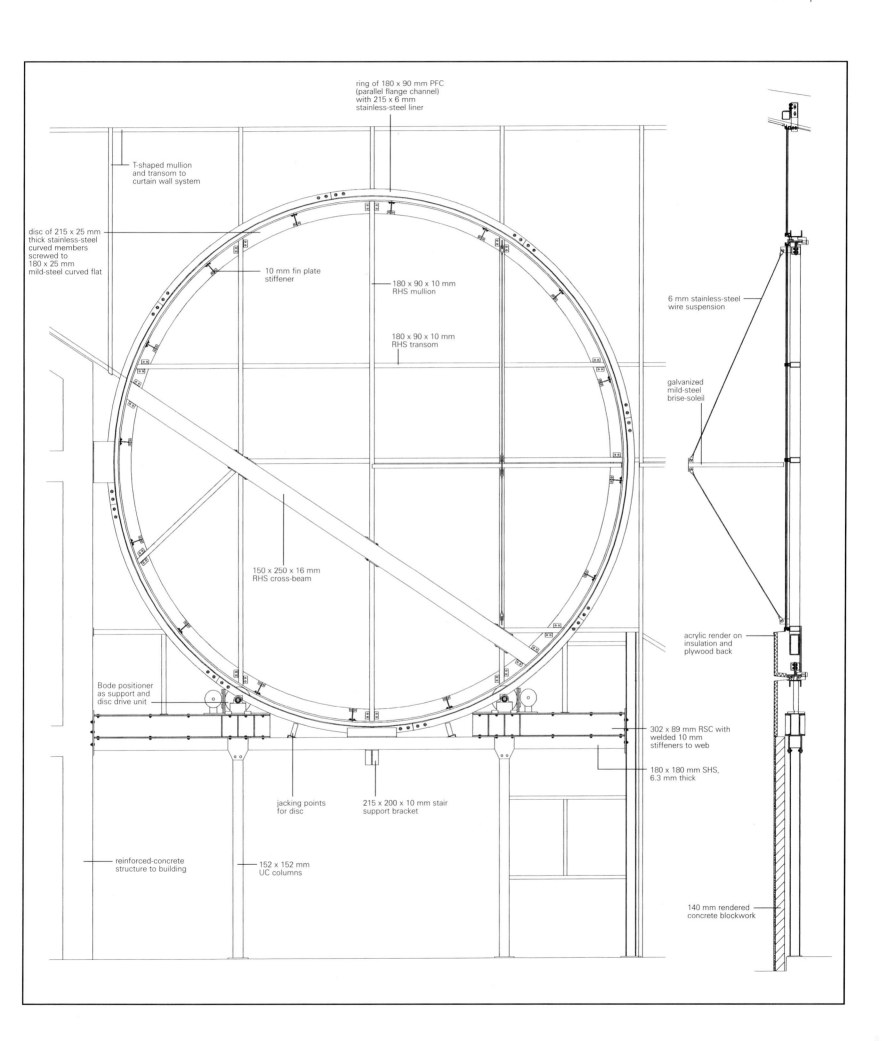

ring of 180 x 90 mm PFC (parallel flange channel) with 215 x 6 mm stainless-steel liner

T-shaped mullion and transom to curtain wall system

disc of 215 x 25 mm thick stainless-steel curved members screwed to 180 x 25 mm mild-steel curved flat

10 mm fin plate stiffener

180 x 90 x 10 mm RHS mullion

180 x 90 x 10 mm RHS transom

6 mm stainless-steel wire suspension

galvanized mild-steel brise-soleil

150 x 250 x 16 mm RHS cross-beam

acrylic render on insulation and plywood back

Bode positioner as support and disc drive unit

302 x 89 mm RSC with welded 10 mm stiffeners to web

180 x 180 mm SHS, 6.3 mm thick

jacking points for disc

215 x 200 x 10 mm stair support bracket

reinforced-concrete structure to building

152 x 152 mm UC columns

140 mm rendered concrete blockwork

kept insisting that every aspect of it had to be designed by the professional team, for fear of increasing the company's liability.

It was against this background that we were trying to resolve the many fabrication issues. The first and most important decision to make was how the disc and outer rings were to be constructed to the tight tolerances required. We favoured laser-cutting the ring out of flat pieces of steel and then welding the pieces together. CSI thought that this would not be accurate enough and wanted to bend the pieces and then bolt them together. Although we had reservations about this we decided to concede to CSI. The next decision was to separate the construction of *Over Easy* from its supporting structure (nicknamed 'under easy' by the fabricator). Other fabrication issues were even more problematic, and because of the liability issue the resolution of details often took the form of a frantic exchange of faxes between CSI and ourselves.

June 1998
This unconventional set-up inevitably led to delays and programme slippage. By June we were asked to travel to Stockton-on-Tees for a meeting with CSI, the rest of the project team, John Laing Construction (construction management for the building) and the building project manager to hammer out details of liability, deadlines and cost once and for all. To allay CSI's anxieties over liability, the project team agreed to inspect and sign off the work at various stages during fabrication. In return, CSI agreed to make the piece for a guaranteed price.

The first of these inspections was at the Tipton works of the Angle Ring Company, which is situated among the canals and endless industrial buildings of the outskirts of Birmingham. It felt like the birthplace of the Industrial Revolution, and the works themselves were awe-inspiring, the sheds simply huge. We were shown a bending machine in operation. The process is simple enough: an operator feeds the steel section into three large revolving steel 'posts'. These press on the sides of the steel section as it passes through, backwards and forwards, until the operator decides the curvature is about right. The section is then eyed against the desired curve chalk-marked on the concrete floor. This time, it was not quite right, but a judicious tap with a fourteen-pound sledgehammer made it spring to the correct shape – and I had been expecting a laser-guided machine. We were assured all our requirements could be achieved and felt greatly comforted.

The second inspection took place at CSI's works in Hull. *Over Easy* was laid flat on specially made trestles in the middle of a large portal-frame shed. As I entered, the first thing I noticed was the sheer size of the disc. It was so big that it was difficult to photograph. I also noticed how tired the fabricators were; this was not their first late night at work and it would not be their last. However, as we talked it was heartening to see their passion and determination to construct the piece. And what a great job they were making of it. The immaculate quality of their work was visible everywhere.

October 1998
Work was forging ahead now, and it seemed that nothing could stop the piece from being completed and delivered to site. However, the liability issue was to crop up one last time. 'Under easy' had already been installed in the building and *Over Easy* was loaded on lorries at CSI's works when they suddenly got cold feet and refused to deliver the piece. It took a flurry of faxes and phone calls from David Metcalfe and Richard before finally the lorries could roll.

Installing *Over Easy* was to prove far from straightforward, as the sculpture had to be both lifted and then pushed into the building to sit on top of its supports. I hit upon the idea that the cross-beam could be used as a lifting beam, if the piece was brought to site in the correct orientation, and a crane jib attached directly on to the beam. This would allow the jib to poke through the disc so it could hang vertically. It could then be simply pushed into position.

Over Easy was due to be lifted into position on Saturday, 30 October 1998 at 7 am. Laing had closed off Dovecot Street with a temporary fence, but even at that early hour curious bystanders had started to gather.

The disc and ring of *Over Easy* lay flat on wooden chocks on the street, with the cross-beam parallel to the building. The mobile crane stood by as a rigger was wrapping lifting chains around the beam. This was not what had been agreed. No lifting lugs had been welded to the beam, and the lifting technique was clearly going to be a conventional lift.

There was a real risk that the chains would slip on the bare steel and shear off the mullions, seriously damaging the sculpture. The lift could not go ahead in this manner, and a serious stand-off ensued between me and the contractors. Eventually an uneasy compromise was reached, alterations made, and the lift began. *Over Easy* was airborne and inching its crooked way on to its supporting structure. Suddenly there was a lot of shouting and everything stopped. It had suddenly become apparent that the handrail to the stairs in the building was in the way. When the blowtorches came out I knew it was going to be a long day.

June 2001

In the end it took three days to install *Over Easy* (and too many more small hiccups to detail) but when it was eventually in and fully powered the piece worked perfectly. A sculpture such as *Over Easy* is a deceptive thing. Like many of Richard's works, it looks effortlessly simple when finished but has often undergone a complex series of procedures and collaborations in order to be successfully achieved.

Since *Over Easy*, we at Price & Myers have continued to help Richard solve the more complex engineering problems he comes up against in his work. Whether this is helping to work out how to core a vast disc from the front of a derelict building and make it oscillate into the street in *Turning the Place Over*, or how to make a full-size steel framework of Richard's house maintain exactly the same orientation in Japan as it does in London in *Set North for Japan (74° 33′ 2″)*, working with Richard always challenges the norm. Perhaps we shouldn't have been so surprised when the house in Japan ended up with its foundations pointing towards the sky.

Slice of Reality, 2000
Greenwich Peninsula, London

Standing on the foreshore of the Thames, the work comprises a
sliced vertical section of an ocean-going sand dredger. The original
ship was reduced in length by 85%, leaving a vertical portion that
houses the ship's habitable sections: bridge, poop, accommodation
and engine room. The slicing of the vessel opened the structure,
leaving it exposed to the effects of weather and tide.

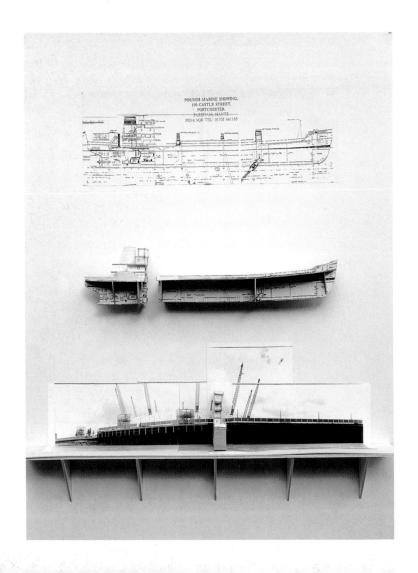

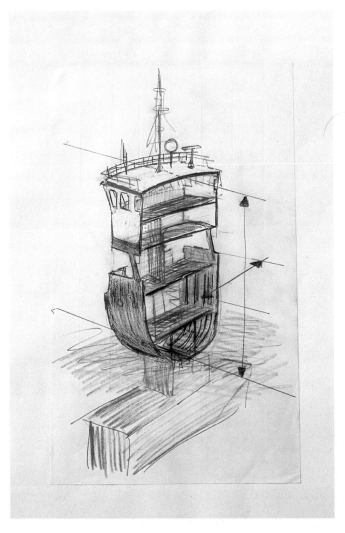

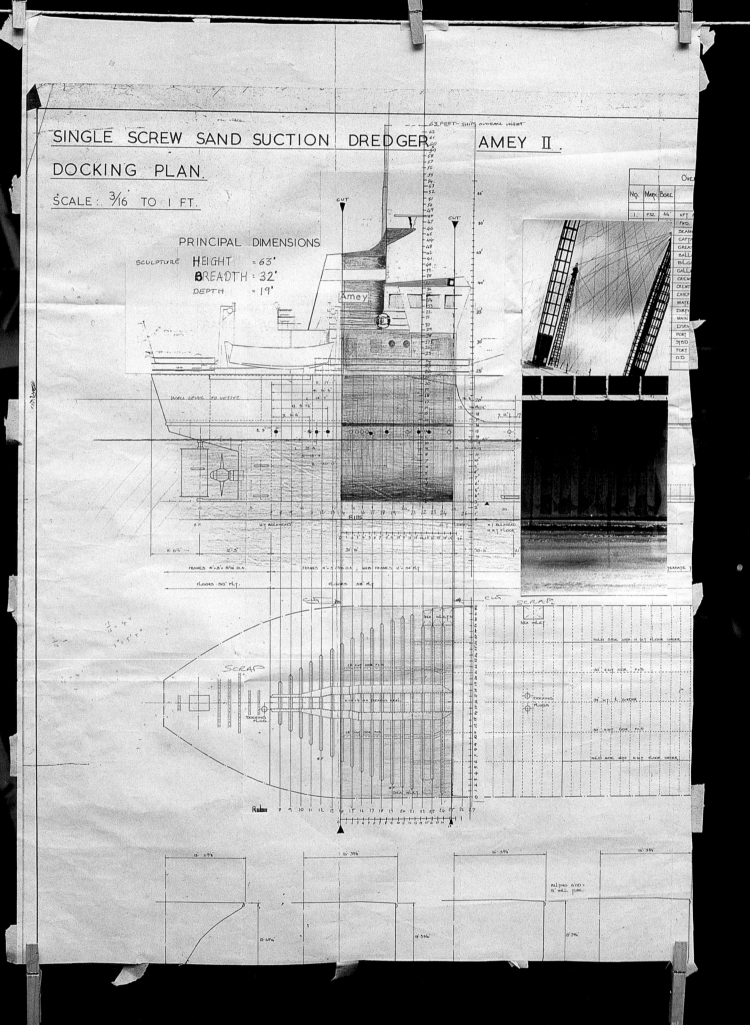

SINGLE SCREW SAND SUCTION DREDGER AMEY II.

DOCKING PLAN.

SCALE : 3/16 TO 1 FT.

PRINCIPAL DIMENSIONS

SCULPTURE HEIGHT = 63'
BREADTH = 32'
DEPTH = 19'

63 FEET — SHIPS OVERALL HIGHT

Amey

SCRAP

DOCKING PLUGS

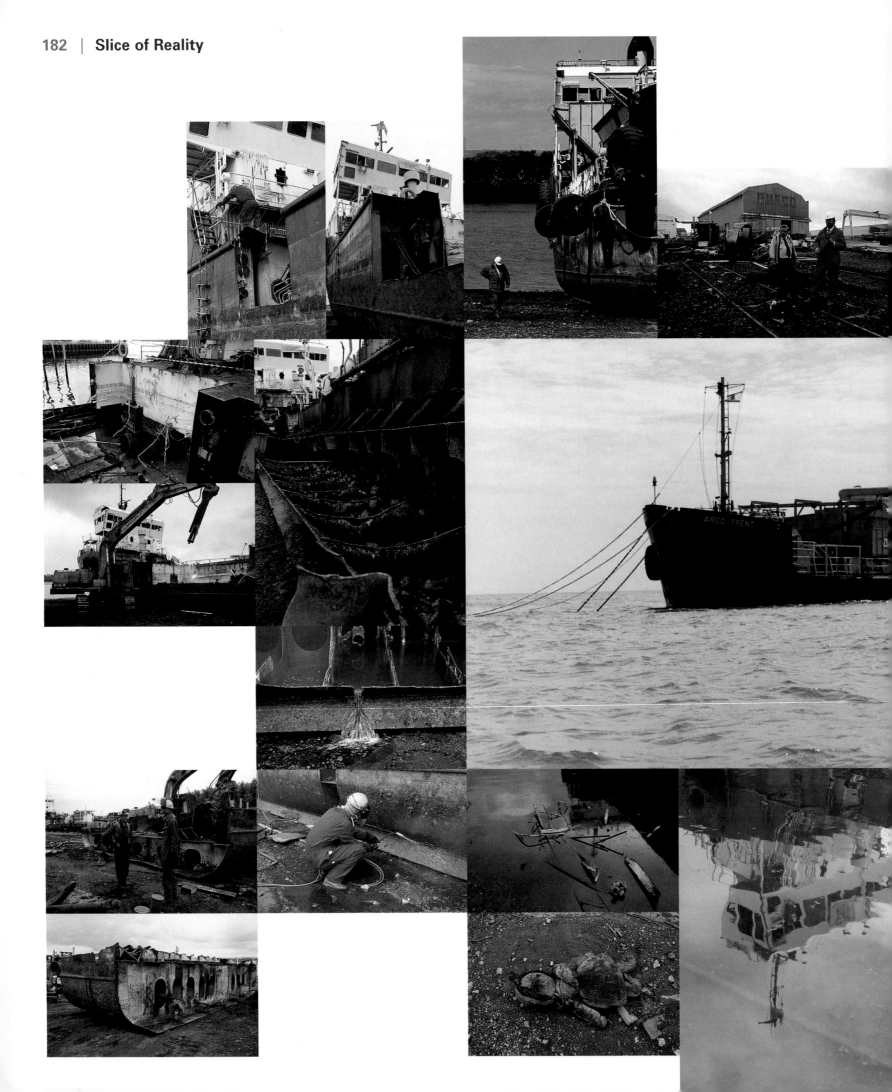

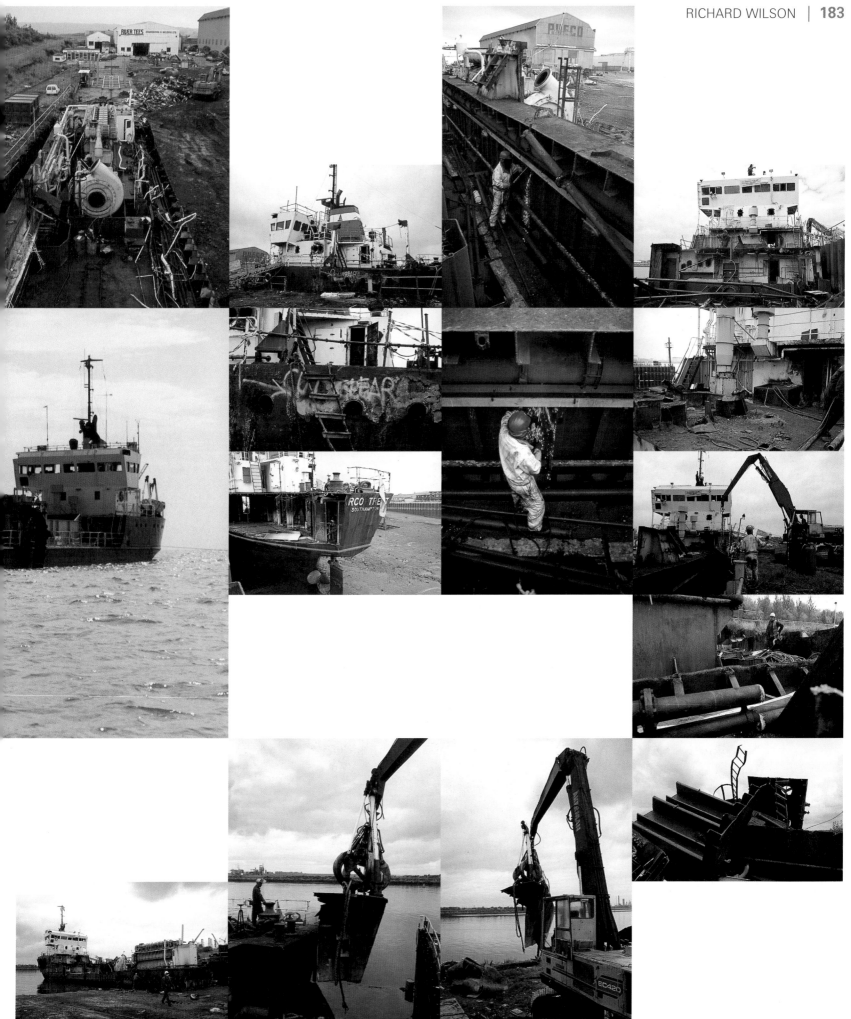

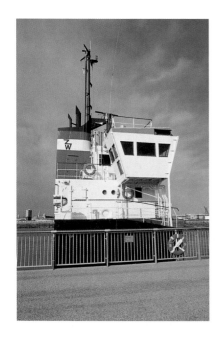

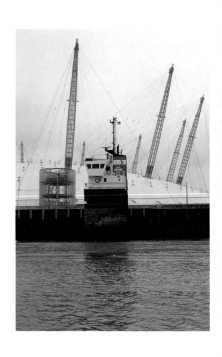

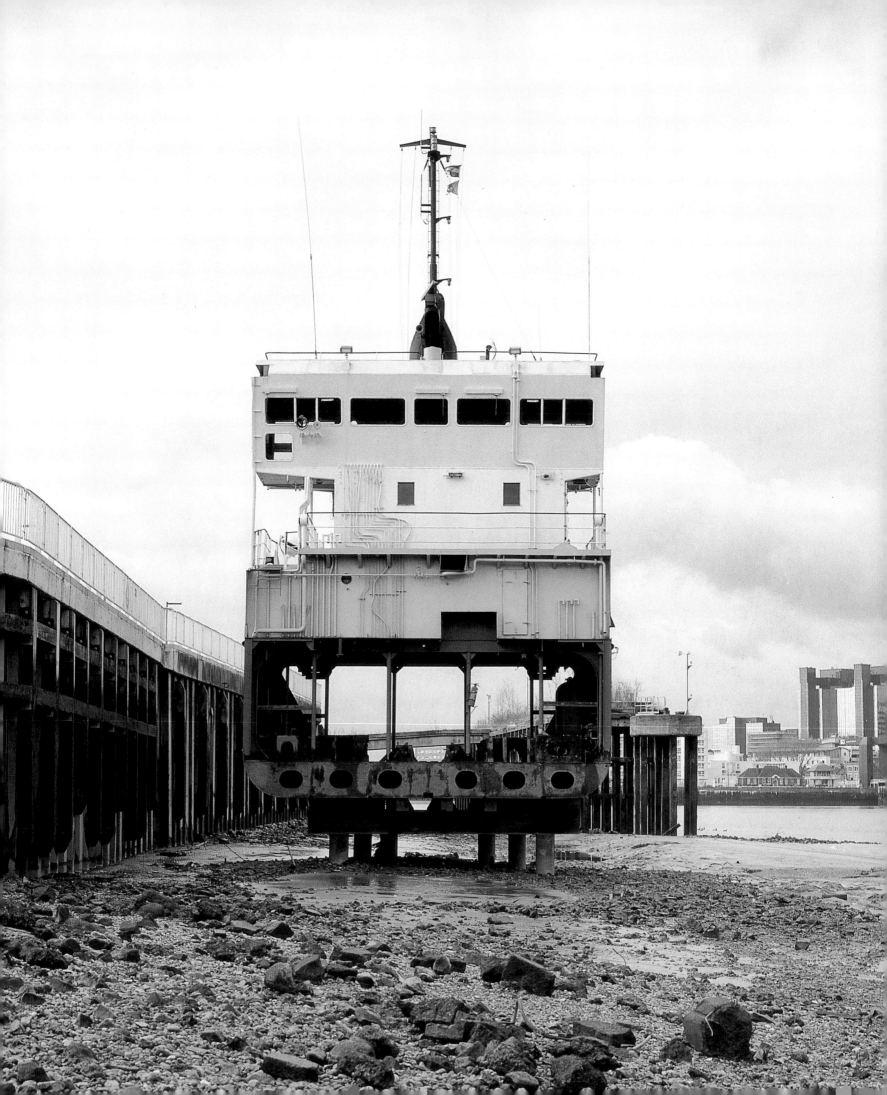

Give me forty acres and I'll turn this rig around, 2000
Ex Convento de Santa Teresa, Mexico City

A Mexican truck and double trailer was crammed into the main
transept of a former convent in Mexico City. The presence of the
mass of the truck and trailers in the rarefied interior appeared
improbable, suggesting a model ship in a bottle. The cab of the
truck was strung with decorative lights, and a loop of country music
endlessly repeated the work's title on the cab's stereo.

He was heading into Boston in a big long diesel truck...it was his first trip to Boston, he was having lots of
luck...he was going the wrong direction down a one way street in town, and this is what he said when the
police chased him down...give me forty acres and I'll turn this rig around, it's the easiest rig I've found,
some guys can turn it on a dime or turn it right down town, but I need forty acres to turn this rig around
when he finally found where to unload he had a dreadful shock, his trailer pointed towards the road and the
cab right to the dock and as he looked around him through his tears he made this sound...give me forth
acres and I'll turn this rig around, give me forty acres and I'll turn this rig around it's the easiest rig that I've
found, some guys can turn it on a dime or turn it right down town but I need forty acres to turn this rig
around
when he finally got unloaded he was glad to leave the town, he was very very happy going back to Alma
bound, when up ahead he saw a sign saying you are northward bound he said give me forty acres and I'll
turn this rig around...give me forty acres and I'll turn this rig around it's the easiest rig I've found, some
guys can turn it on a dime or turn it right down town, but I need forty acres to turn this rig around
he was driving down the right lane when ahead he saw the sign and he had to make the left turn but he
could not get in line and the tears were streaming down his cheek and they all heard him yell, give me forty
sticks of dynamite and I'll blow this place to...give me forty acres and I'll turn this rig around it's the easiest
rig I've found some guys can turn it on a dime or turn it right down town, but I need forty acres to turn this
rig around....

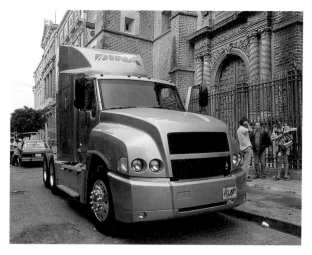

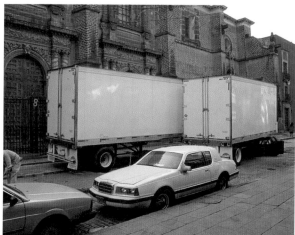

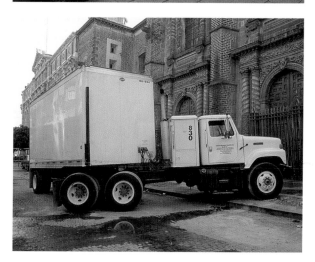

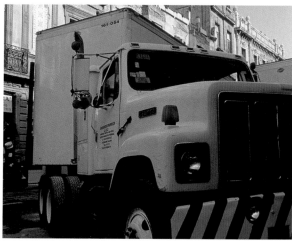

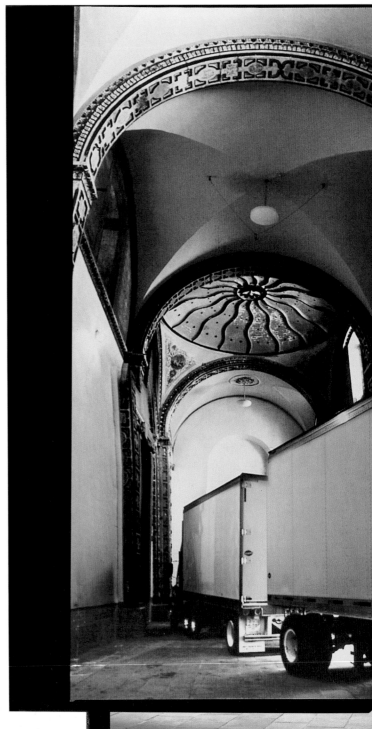

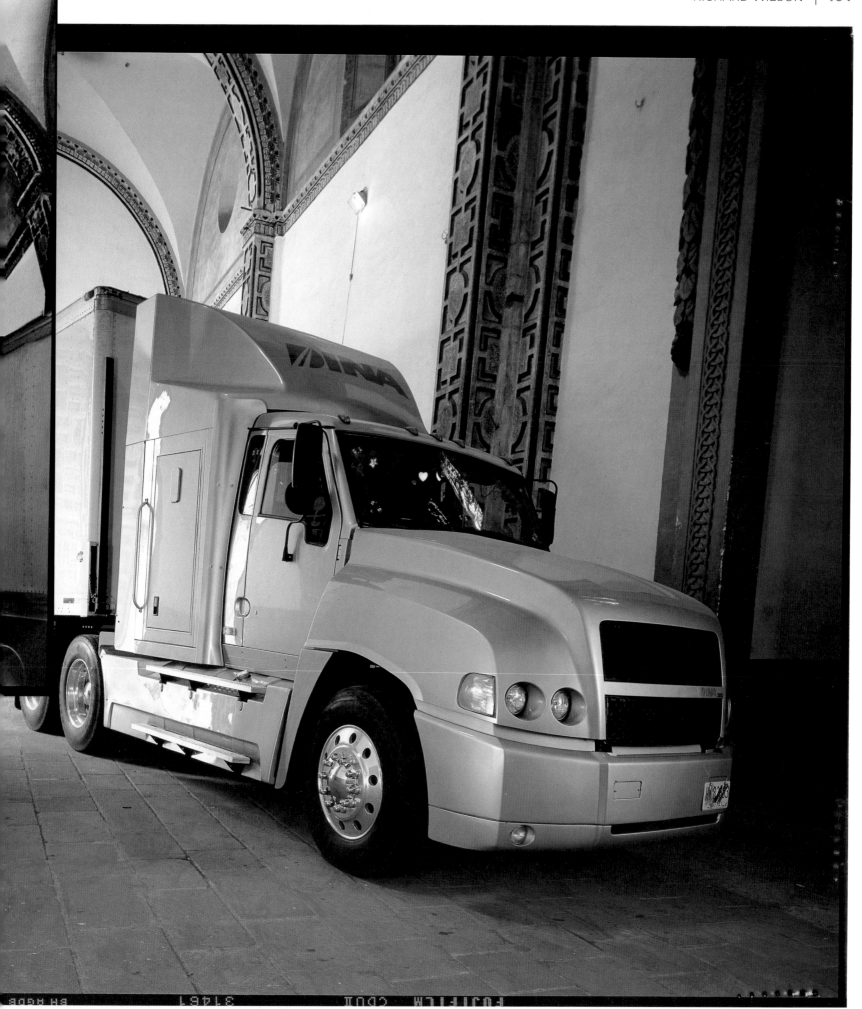

Turbine Hall Swimming Pool, 2000
Former Clare College Mission Church, Dilston Grove, Southwark,
London

The installation, in a former church, comprises a wall fabricated
from insulation material that suppresses the noise of a diesel
generator placed in the space to power a video projection of a
drummer. The drummer is pictured playing against a backdrop of
the derelict local open-air swimming pool, improvising in response
to the noise of the engine.

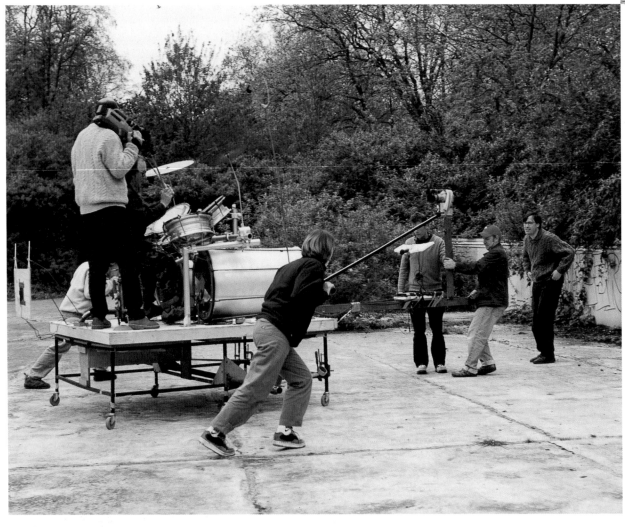

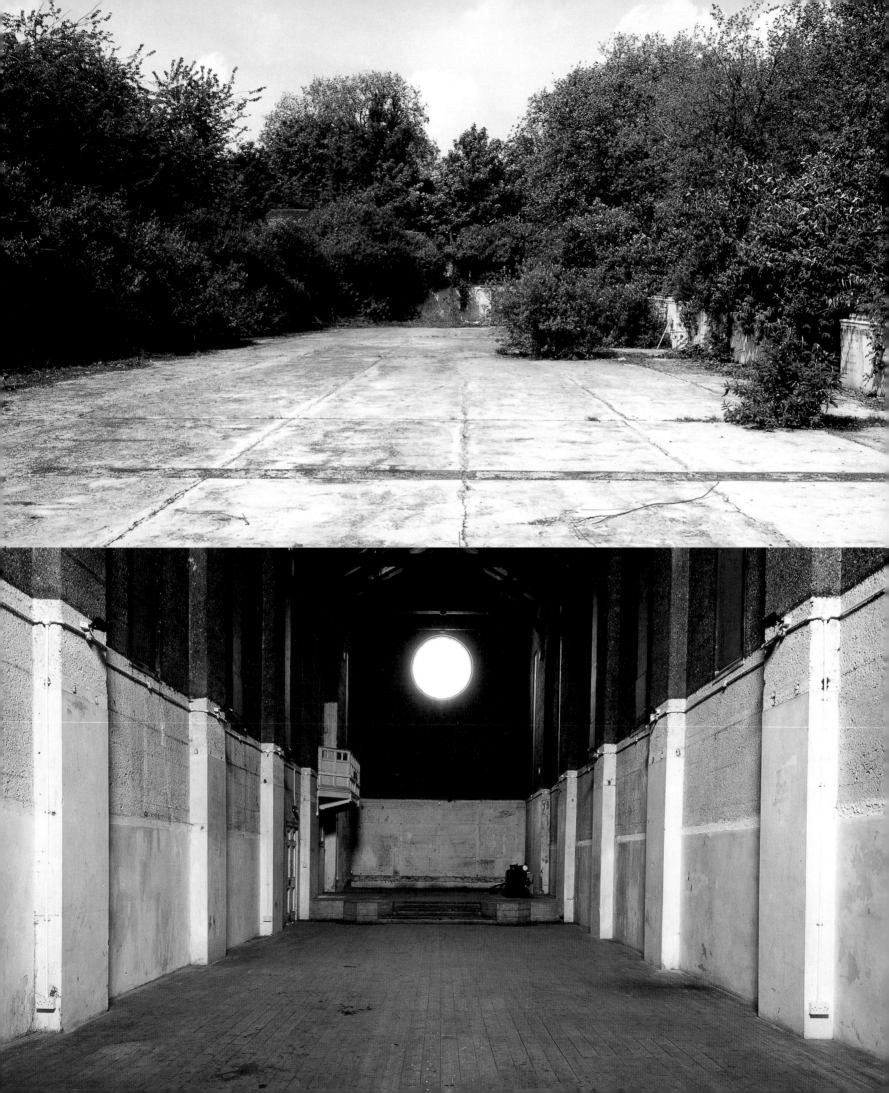

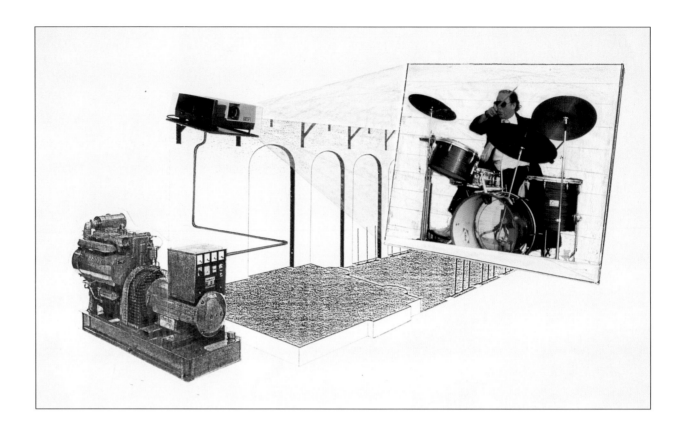

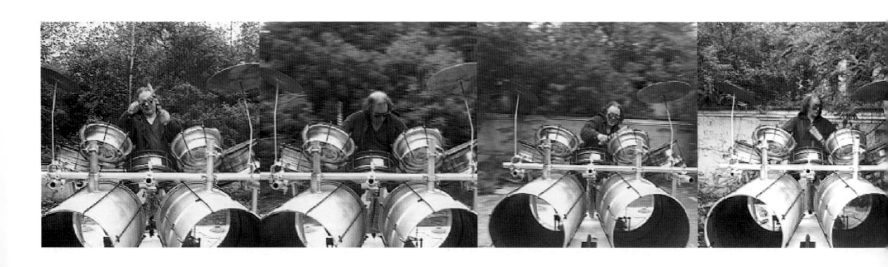

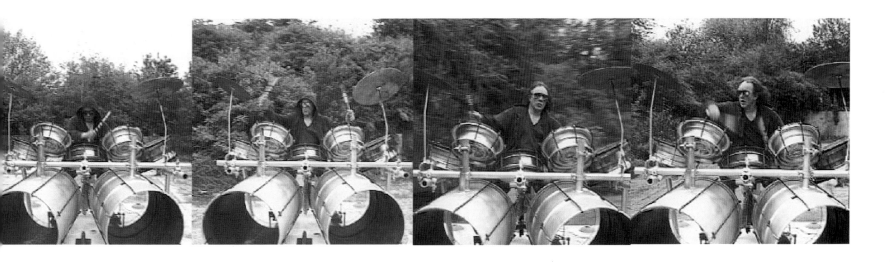

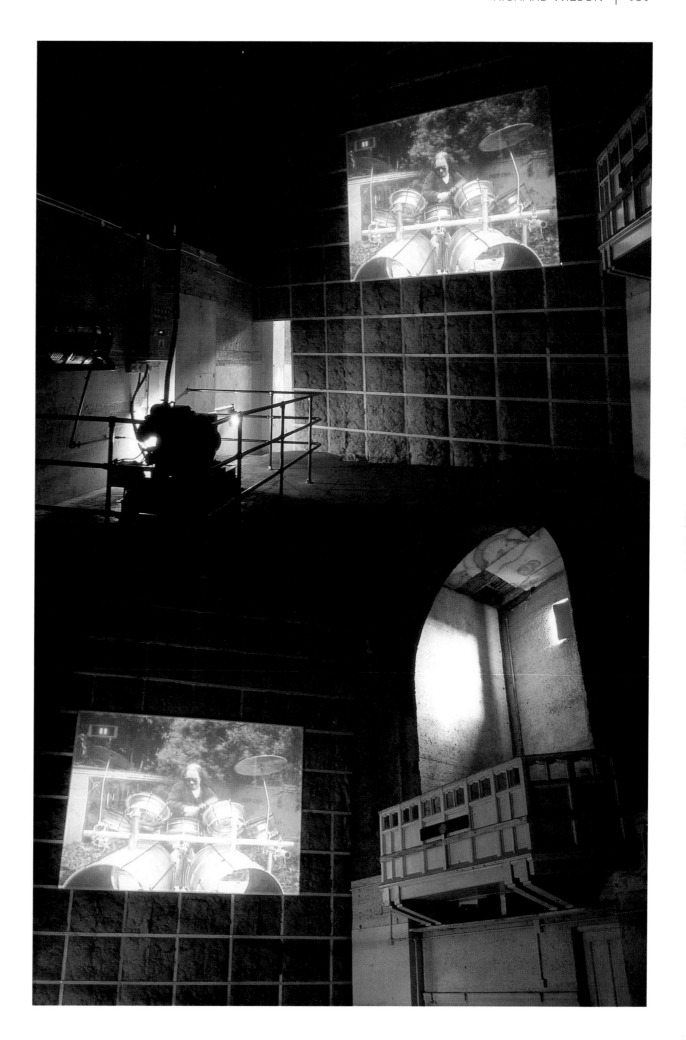

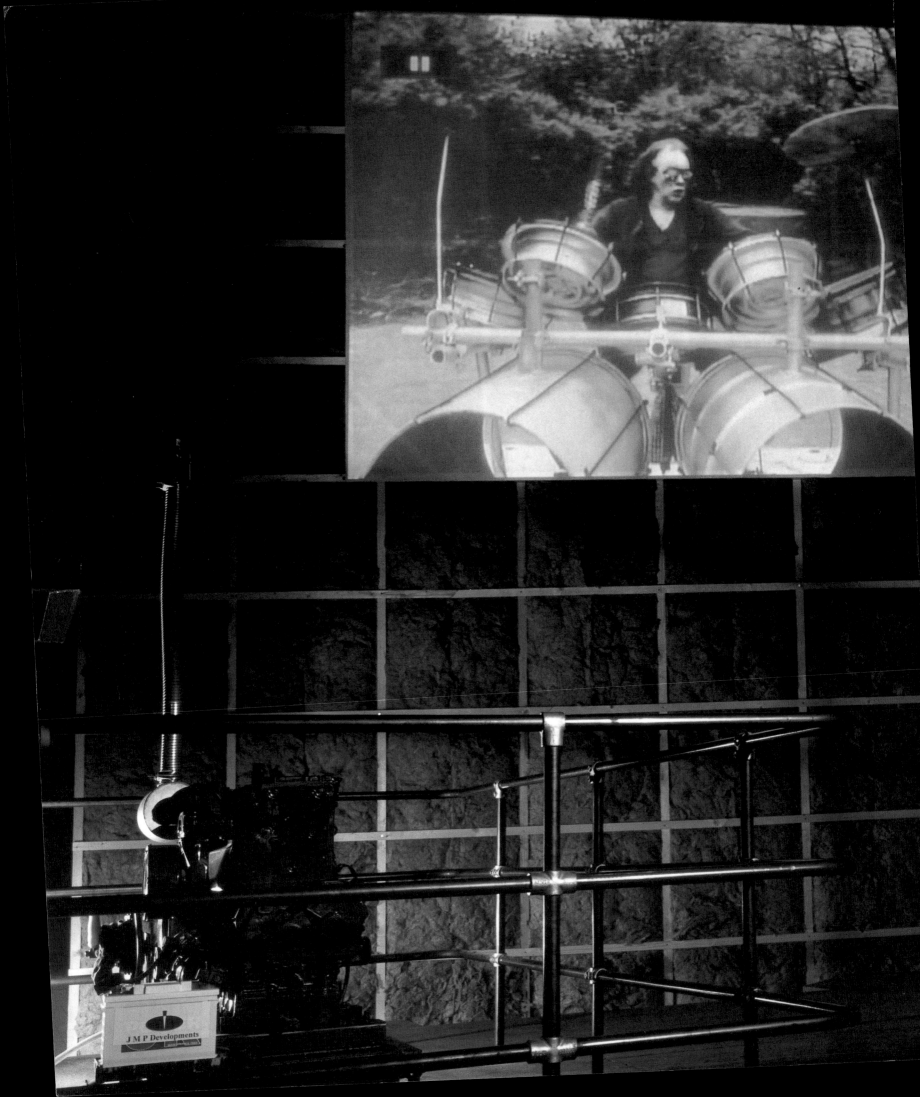

Set North for Japan (74° 33′ 2″), 2000
Nakasato, Niigata Prefecture, Japan

Located at the periphery of the grounds of Nakasato Junior High
School, the work is a full-scale reconstruction of the artist's terraced
house in London, reduced to a metal frame with its roof partially
submerged into the ground. The structure rises up at a displaced
angle, maintaining its exact English perpendicular and horizontal
orientation to true north without regard for the local geography.

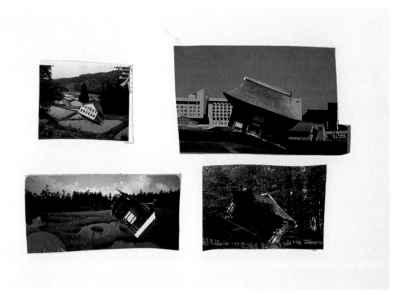

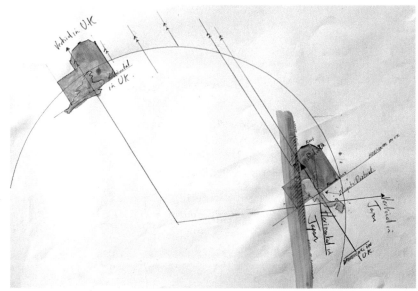

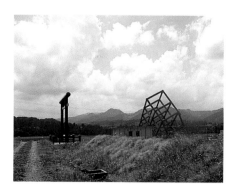

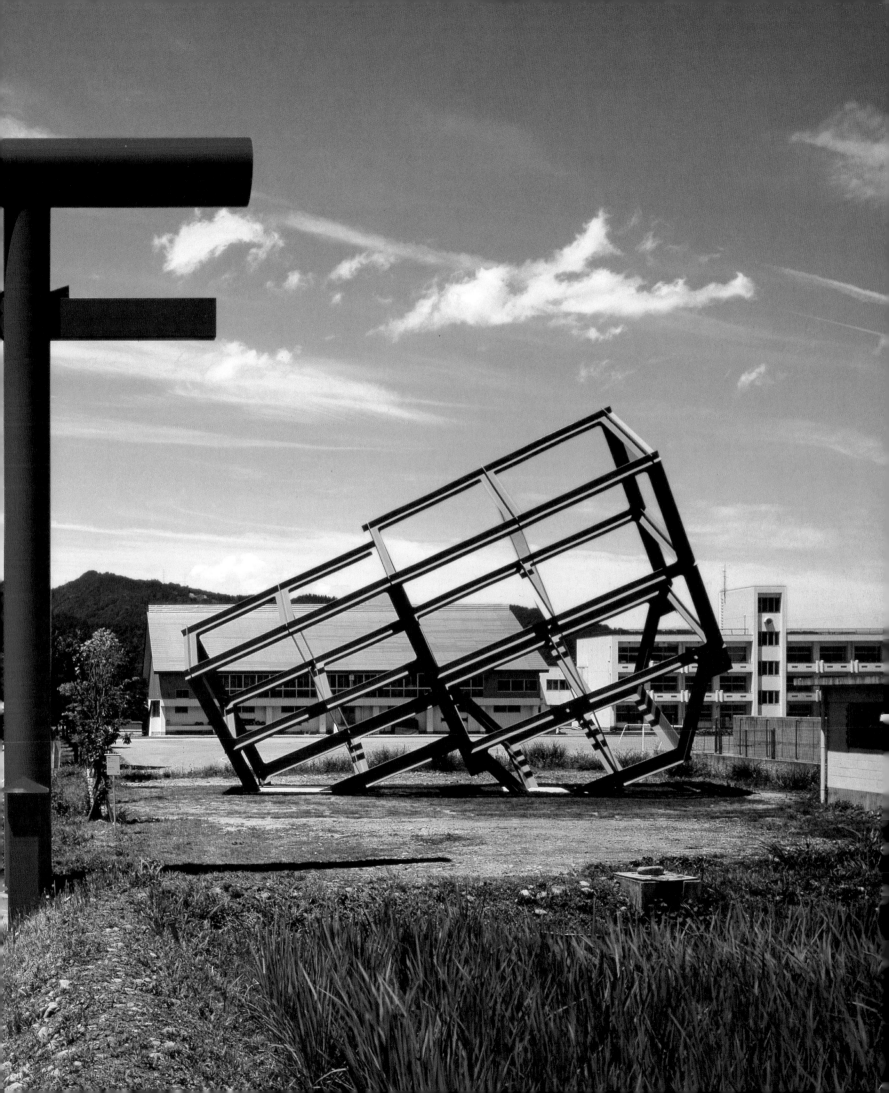

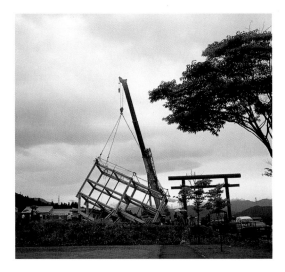

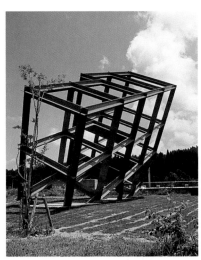

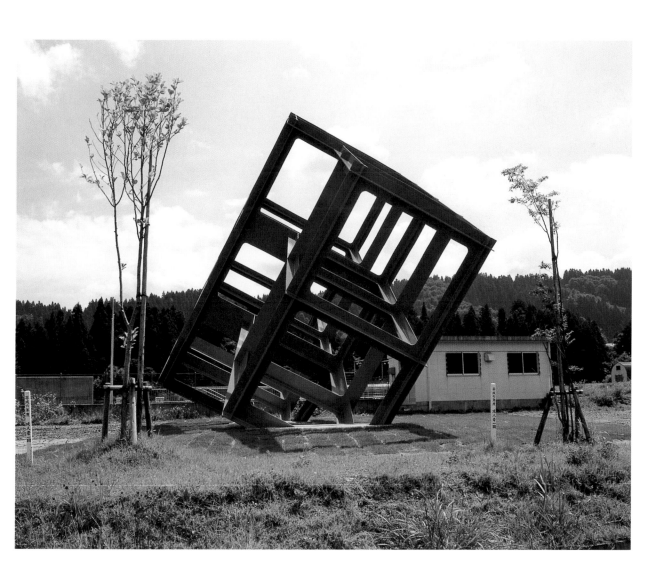

Set North for Japan (74° 33' 2") drawings, 2001
Gimpel Fils Gallery, London

The exhibition documented the sculpture of the same name through
an installation of drawings and a model mounted on a 13-metre long
steel pipe. The pipe was in turn mounted on two Bode Sizzer rollers
on steel frames, which allowed it to rotate, slowly turning the
drawings through the vertical plane. The model of the sculpture was
mounted on a bearing, however, allowing it to maintain an upright
position regardless of its location on the circumference of the pipe.

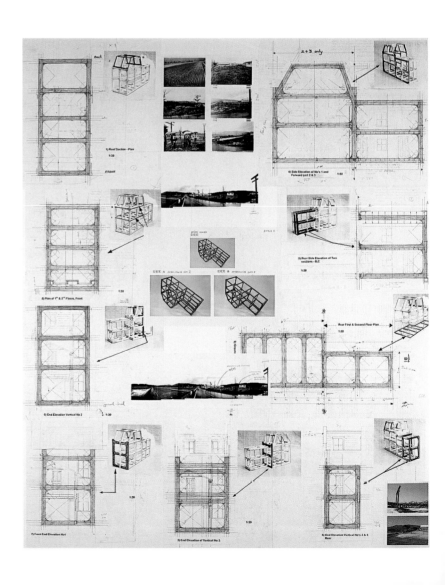

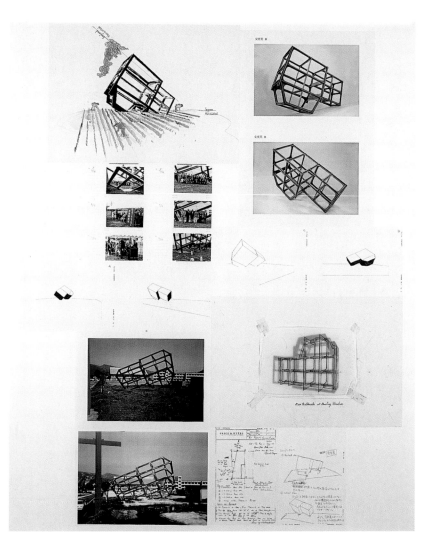

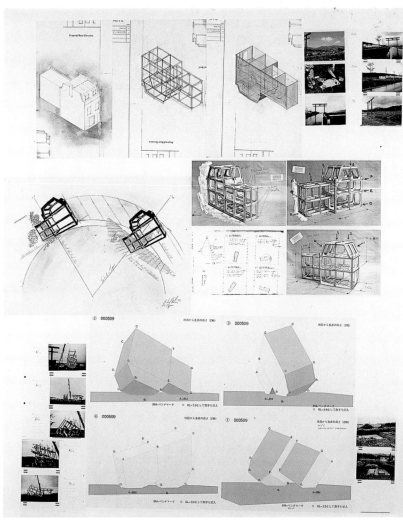

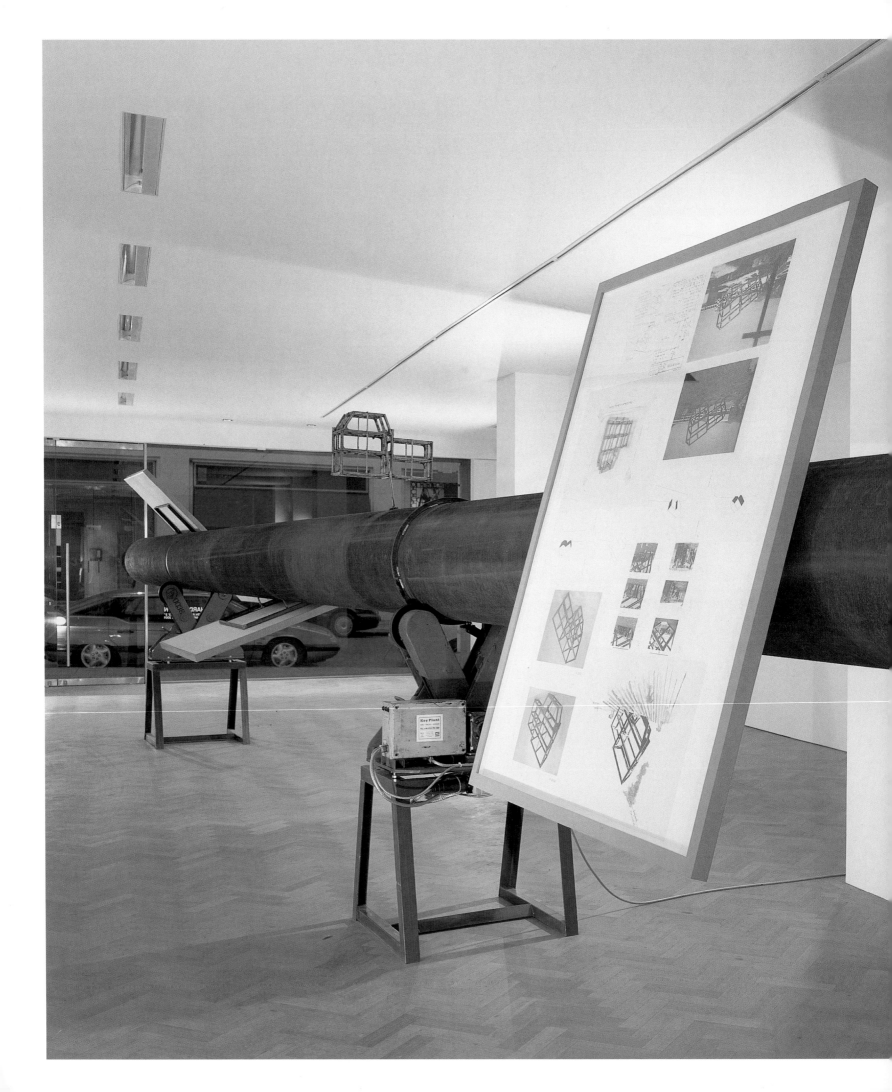

Hotel: Room 921, Empress Hotel, 2001
Taipei Fine Art Museum, Taipei

A substantial three-dimensional matrix, constructed from plywood-faced honeycomb cardboard, delineated a space suggestive of a formulaic hotel room. Fixed to the horizontal mid-beam of the structure, standard colour photographic prints illustrated a furnished hotel room, which on closer inspection could be seen to have undergone disruption that challenged the normal arrangement of its contents and its subservience to gravity. The room number given in the title does not exist in the hotel named, and refers to the earthquake that struck Taiwan on 21 September 1999.

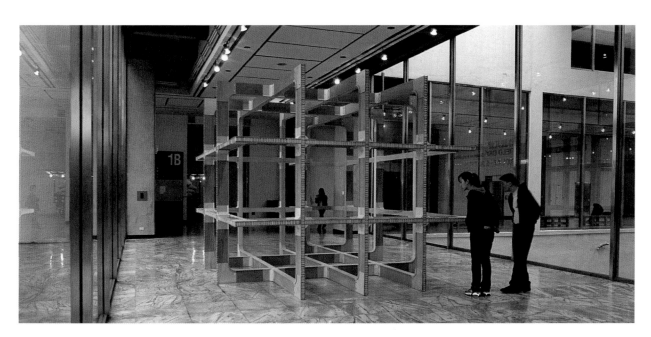

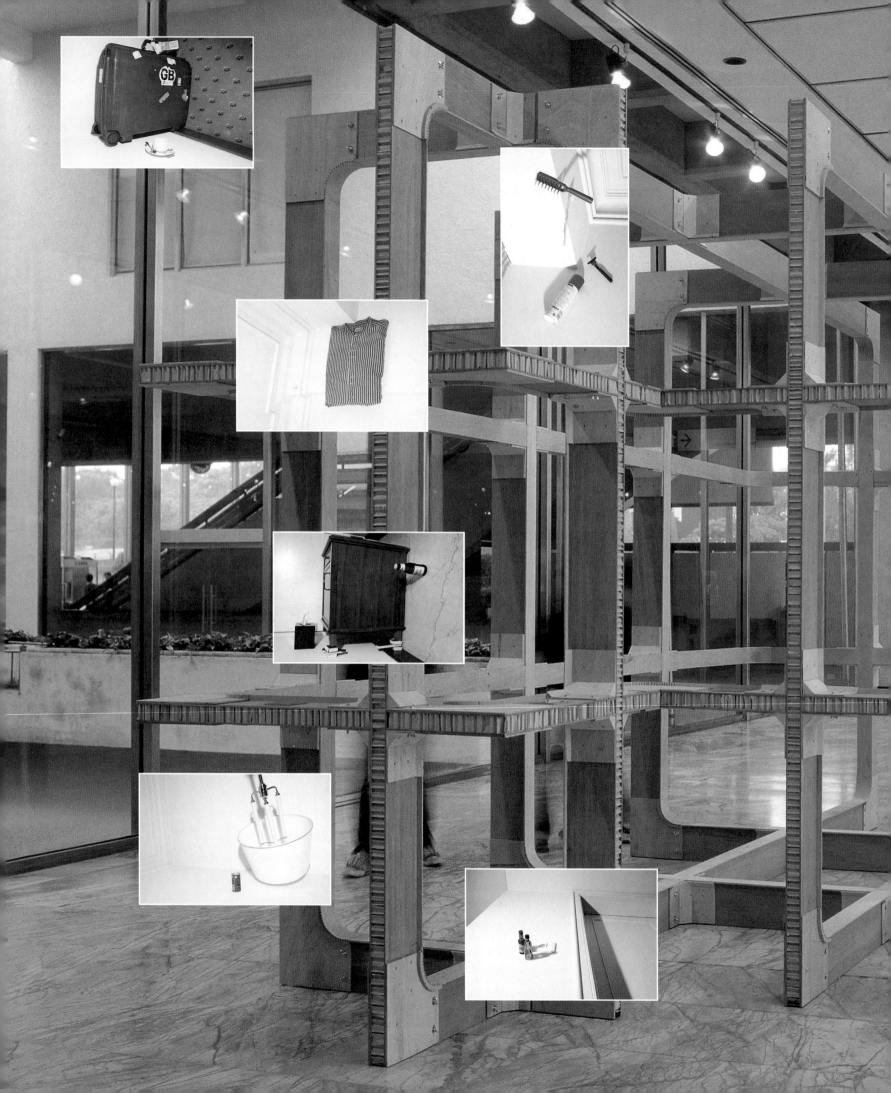

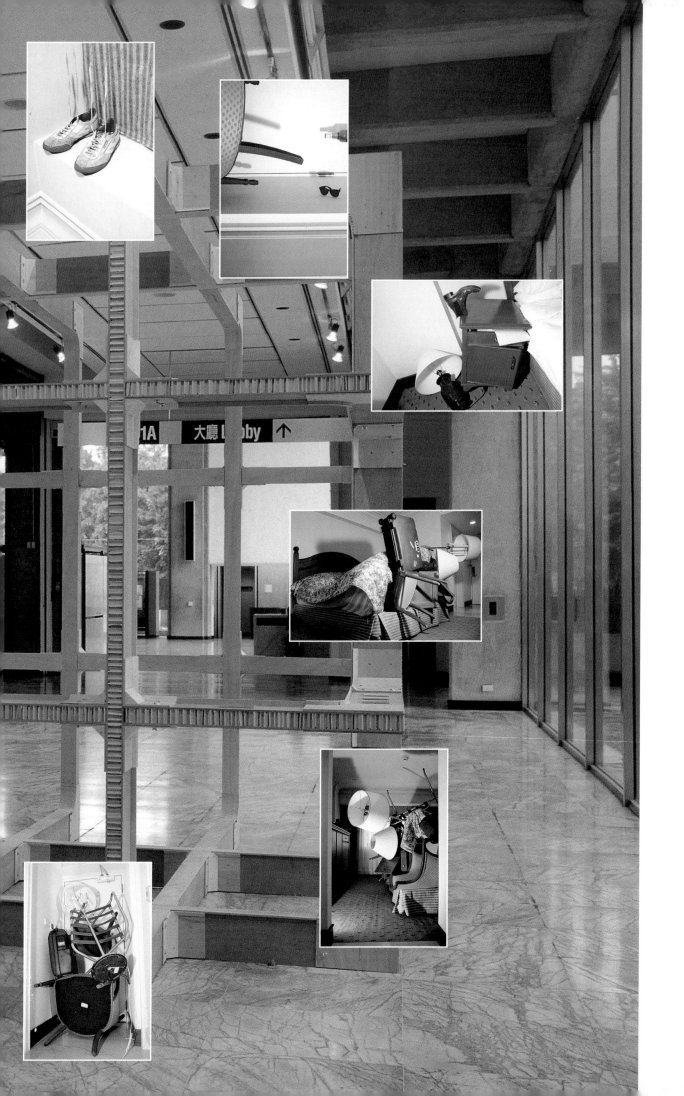

Turning the Place Over, 2000 (in development)
Curated by Simon Morrissey, London

The work will consist of a vast 10-metre-diameter pipe inserted into
the façade of a disused building at ground-floor level. The façade that
abuts the pipe will be carefully cut away and inserted flush into its
mouth. The mouth of the pipe will in turn be cut at a precise angle so
that it is ovoid in appearance. When the pipe is at rest the oval end
will sit flush with the façade of the building. The pipe, however, will
rotate, powered by a set of motorized industrial rollers. As the pipe
rotates, the façade will not only become completely inverted, but will
also oscillate into the building and out into the street, occupying its
original position at one point only during its rotation.

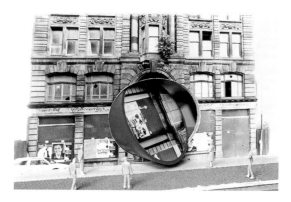 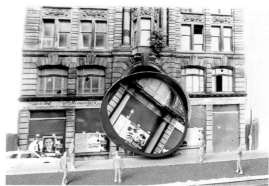 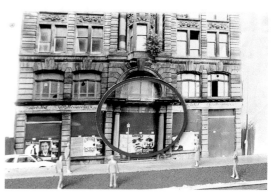

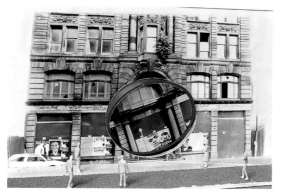 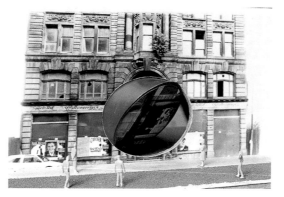 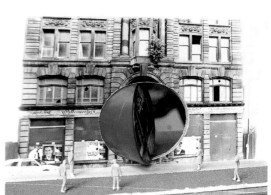

The layout of the works in the preceding illustrated section of this book, while roughly chronological, have been ordered by the artist. A strictly chronological checklist is set out below.

Richard Wilson
Born London 1953

1970–71
London College of Printing (foundation)

1971–74
Hornsey College of Art (Dip. AD)

1974–76
Reading University (MFA)

1983
Formed Bow Gamelan Ensemble with Anne Bean and Paul Burwell

1992–93
DAAD, Berlin

1975–81
Richard Wilson began exhibiting in 1975, while a postgraduate student. Between 1975 and 1981 he primarily concentrated on object-based work that explored the physical limits and elasticity of materials. The works were often ephemeral and affected by environmental conditions. Almost no work from this period survives.

Wilson's first one-man exhibition opened the Coracle Press Gallery, London, in 1976. He continued to have a strong relationship with Coracle during this period, participating in a number of exhibitions and producing limited-edition books with the press. Increasingly, Wilson's interests in the temporary manifestation of sculpture led him towards the idea of integrating his work with the space in which it was shown. By 1982 he was making works, such as *Big Dipper*, which enlisted the physical properties of the site as an integral part of the piece.

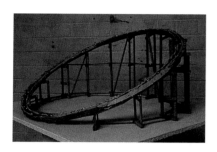

Big Dipper
June 1982
Wood, sand, aluminium
3 x 2.1 m
Chisenhale Works, London

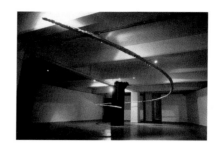

Heatwave
March 1986
Aluminium, soot, ash
Dimensions variable
Ikon Gallery, Birmingham
Curated by Andrew Nairne

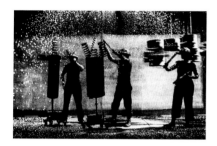

Bow Gamelan Ensemble
1983–91
Multimedia performance band
UK, Europe, USA, Far East
Collaborators: Anne Bean, Paul Burwell

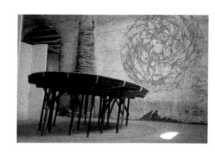

Halo
June 1986
Wood, thermal paper, lead
Dimensions variable
Aperto, June–September 1986, Venice
Biennale, Venice
Curated by Lynne Cooke

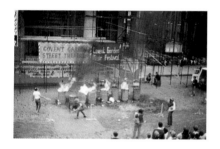

Chroronzon
September 1984
Transit van, oil drums, glass,
beer barrels, pyrotechnics
Dimensions variable
Covent Garden Music Festival, London
Curated by Alternative Arts
Collaborator: Paul Burwell

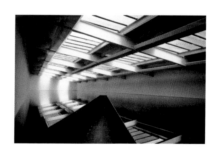

20:50
1987–96
Used sump oil, steel, wood,
valve tap
Dimensions variable
Matt's Gallery, London
Royal Scottish Academy, Edinburgh
Saatchi Gallery, London
Mito Art Tower, Mito, Japan
Museum of Contemporary Art, Los
Angeles
Australian National Gallery, Canberra
Curated by Robin Klassnik, Charles
Saatchi, Yuko Hasegawa, Paul Schimmel
and Desmond Patrick
Saatchi Collection, London

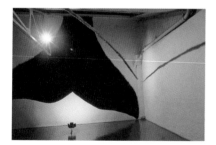

Sheer Fluke
January 1985
Aluminium, soot, blue light
Length 10.1 m
Matt's Gallery, London
Curated by Robin Klassnik

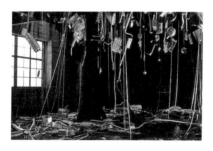

One Piece at a Time
May 1987
1200 car parts, string, motors,
steel, wood, sound, closed-
circuit television
29.3 x 12.2 x 9.1 m
Tele-South-West Arts 3D National
Exhibition, South Tower, Tyne Bridge,
Gateshead
Curated by Jonathan Harvey, James
Lingwood and Tony Foster
Collaborators: Jon Bewley and Simon
Herbert of Projects UK

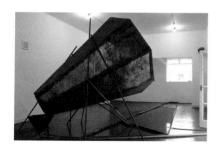

Hopperhead
September 1985
Pump, swimming-pool water,
steel, rubber hose, copper
tubing
Dimensions variable
Café Gallery, London
Curated by Ron Henocq

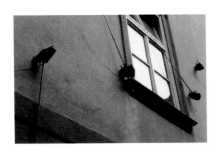

Up a Blind Alley
September 1987
Seven gilded blind person's
sticks, lead, motors
Dimensions variable
Trigon Biennale, Graz, Austria
Curated by Mark Francis

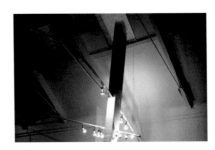

High-Tec
April 1989
Cast concrete, steel, wood,
museum lighting track
Approximate height 10 m
Museum of Modern Art, Oxford
Curated by David Elliot and Crissie
Issles

Hot, Live, Still
October 1987
Photograph, gas flame, thermal
paper
Dimensions variable
Plymouth Art Centre, Plymouth
Curated by Rose Garrard

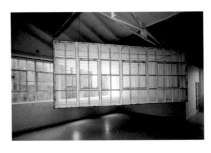

**She came in through the
bathroom window**
April 1989
Gallery window, steel,
softboard, PVC material,
tungsten-halogen floodlights
1.8 x 4.9 x 4.3 m
Matt's Gallery, London
Curated by Robin Klassnik
Weltkunst Foundation Collection, Dublin

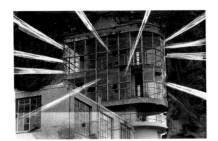

Luma Light Factory
1988 (unrealized)
Electric lighting, timers, cable
Dimensions variable
Luma Light Factory, Glasgow
Curated by Andrew Nairne

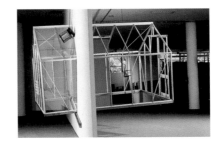

High Rise
October 1989–91
Glass greenhouse, wooden
wall, steel beams, two
insectocutor units
2.4 x 2.4 x 4.3 m
São Paulo Biennale, São Paulo, Brazil
UK/USSR, June–September 1990, The
House of Artists, Kiev and Moscow
Saatchi Gallery, London
Curated by Jill Headley (British Council),
David Thorp, Jonathan Watkins and
Charles Saatchi
Arts Council Collection, London

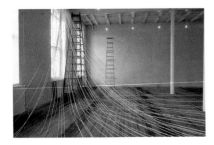

Leading Lights
February 1989
Eighty-four lightbulbs, electric
cable, fittings
19 x 22 m
Kunsthallen Brandts Klaederfabrik,
Odense, Denmark
Curated by Grethe Grathwol

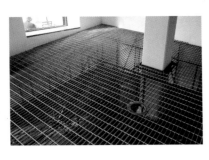

Sea Level
March 1989
Galvanized steel grille, steel,
gas-fired space heater
1.5 x 6.7 x 9.1 m
Arnolfini, Bristol
Curated by Stephen Snoddy

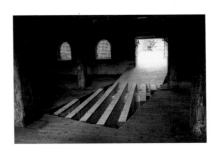

All Mod Cons
1990
Wood, steel tube, steel
Dimensions variable
Edge 90, Edge, Newcastle upon Tyne
Curated by Rob La Frenais

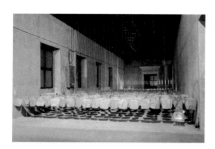

Takeaway
June 1990
1000 brown-paper carrier bags,
twine, rubble, projected slide,
halogen lamp
6 x 12 x 30 m
Centre for Contemporary Art, Warsaw
Curated by Milada Slizinska
Collaborators: Galerie Akumulatory 2
Collection of the Centre for
Contemporary Art, Warsaw

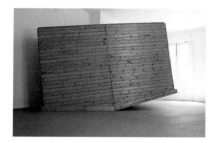

Face Lift
January 1991
Wood, steel, aluminium
3 x 2.4 x 5.5 m approximately
Saatchi Gallery, London
Commissioned by Charles Saatchi
Saatchi Collection, London

Lodger
May 1991
Wooden chalet, galvanized steel
Dimensions variable
Galleria Valeria Belvedere, Milan
Curated by Valeria Belvedere

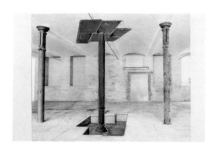

Bronze Column
1992–93 (unrealized)
Cast bronze column
Approximate height 2.7 m
Henry Moore Studio, Dean Clough
Gallery, Halifax, West Yorkshire
Curated by Robert Hopper

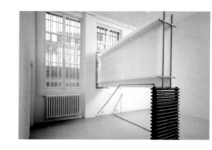

Return to Sender
February 1992
Radiator, copper piping, section
of window, twin-wall plastic
sheeting
Dimensions variable
Galerie de l'Ancienne Poste, Calais
Curated by Marie Thérèse Champesme

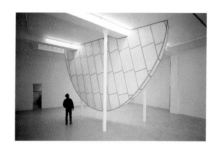

Swift Half
February 1992
Steel, polystyrene, yellow
corrugated plastic
4.3 x 0.07 x 4.9 m
Galerie de l'Ancienne Poste, Calais
Curated by Marie Thérèse Champesme

A Fresh Bunch of Flowers
June 1992
Multimedia floral arrangement
in ice
Dimensions variable
Heatwave Festival, Serpentine Gallery,
London
Curated by Katy Sender
Collaborators: Anne Bean, Paul Burwell

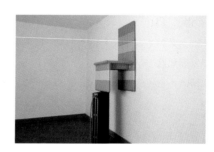

I've Started So I'll Finish
December 1992
Tiles, wood, radiator, copper
tubing, fittings
Dimensions variable
La Casa di Alice, October 1992 –
January 1993, Galleria Mazzocchi,
Parma, Italy
Curated by Maurizio Barberis, Federico
de Leonardis and Elio Grazioli
Private collection

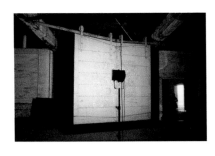

Not too clear on the viewfinder
December 1992
Steel fire doors, steel hawser,
engraved text, halogen lamp
3 x 4.3 m
The Boundary Rider, IXth Biennale of
Sydney, December 1992 – March 1993,
Bonded Warehouse, Sydney
Curated by Tony Bond

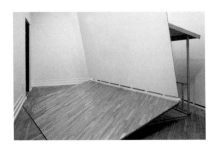

Elbow Room
1993
Wooden chalet, steel, wooden
flooring
Dimensions variable
On Siat, Museet for Samtidskunst, Oslo
Curated by the British Council
Collection of the Museet for
Samtidskunst, Oslo

GMS Frieden
1993; 2001
Framed text
Dimensions variable
Space without Art, Der Fernsehturm,
Berlin (1993)
Victoria and Albert Museum, London
(2001)
Curated by Klara Wallner and Colin
Painter
Collaborator: Captain Siegfried
Schauder

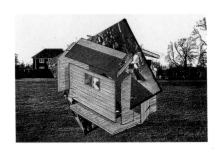

Hyde Park Concert 2
1993 (unrealized)
Cricket pavilion, metal cone
screen, film loop of Rolling
Stones concert
Dimensions variable
Serpentine Gallery, London
Curated by Julia Peyton Jones

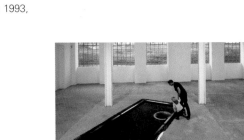

**14:20:18 Aug 11th 1993
Looking North: Right**
11 August 1993
Billboard
Collaborator: Stephen White
Commissioned by *Time Out* magazine

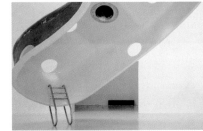

Watertable
March 1994
Full-size billiard table, concrete
pipe, ground water, electrics
3.7 x 2.1 x 4 m
Matt's Gallery, London
Curated by Robin Klassnik
Collaborators: Price & Myers Consulting
Engineers

Deep End
October 1994
Fibre-glass swimming-pool shell
with handrail and ladders,
aluminium pipe
18.9 x 4.3 x 10.1 m
Museum of Contemporary Art, Los
Angeles
Curated by Paul Schimmel

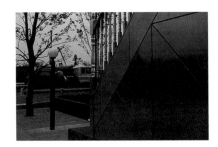

Entrance to the Utility Tunnel
October 1994
Aluminium and stainless steel
6.2 x 1.5 x 5.4 m
Faret Tachikawa Urban Renewal Project,
Tokyo
Curated by Fram Kitagawa, Art Front
Gallery, Tokyo
Collaborators: Levitt & Bernstein
Architects
Permanent commission

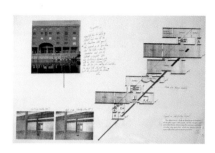

Bronze Pole of the North
1995 (unrealized)
Bronze pole
Dimensions unknown
Tate Gallery Liverpool

Pleasure Trip
April 1995
Cassette tape and player,
projected slide, two postcards
Dimensions variable
Coexistence: Construction in Process,
9–21 April, Mizpe Ramon, Israel
Curated by the Artists' Museum

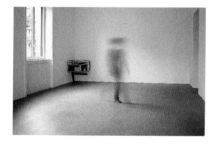

Corner
October 1995
Table-football machine
0.8 x 0.8 x 1 m
Galleria Valeria Belvedere, Milan
Curated by Valeria Belvedere
British Council Collection

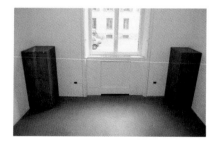

Cutting Corners
October 1995
Two sand-blasted filing cabinets
Dimensions variable
Galleria Valeria Belvedere, Milan
Curated by Valeria Belvedere

The Joint's Jumping
1996–99 (unrealized)
Neon tubing, north-facing wall
of the former Baltic Flour Mill
Dimensions variable
Baltic Centre for Contemporary Art,
Gateshead
Curated by Jon Bewley and Simon
Herbert of Locus +

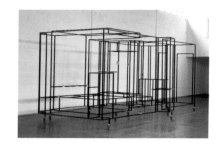

Hotel: Zimmer 27, Central Hotel
1996
Dexion speed-frame, wheels,
Polaroid photographs
2.5 x 3 x 5 m
Städtische Ausstellungshalle am
Hawerkamp, Münster, Germany
Curated by Dr Gail Kirkpatrick

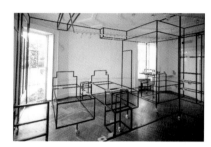

Hotel: Room 6, Channel View Hotel
May 1996
Dexion speed-frame, wheels,
postcard, photographs encased
in clear acrylic
2.9 x 3.9 x 5.8 m
Towner Art Gallery, Eastbourne
Curated by Penny Johnson

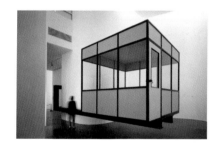

Doner
June 1996
Site cabin, hole in museum wall
and window, two steel L-beams
Dimensions variable
Mirades (Sobre el Museu),
June–September 1996, Museu d'Art
Contemporani, Barcelona
Curated by Antonia M. Perelló

Formative Processes
August 1996
Wood, Acro-props, artist's
preparatory works
2.7 x 24 m
Gimpel Fils Gallery, London
Curated by Tim Dawson

Jamming Gears
August 1996
Three site huts, one forklift
truck, excavated floor, cored
gallery interior, gallery window
Dimensions variable
Serpentine Gallery, London
Curated by Julia Peyton Jones and
Jonathan Watkins
Collaborators: Kilnbridge Construction;
Howard Associates

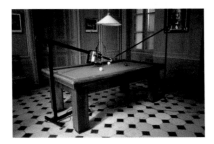

Ricochet (Going in/off)
July 1997
French billiard table, steel
stands, Super-8 projection,
mirror, three billiard balls
3 x 1.5 x 1.5 m
Château de Sacy, Picardie, France
Curated by Hermione Demoriane

Outsize
1998 (in development)
Multimedia
Collaborators: Mark Lucas and Jane
Thorburn of After Image Productions

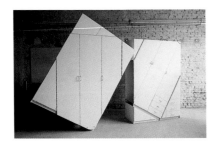

Hung, Drawn and Quartered
July 1998
Two steel filing cabinets, metal
shelving units, plastic boxes,
two wooden wardrobes
Dimensions variable
Städtisches Museum, Zwickau,
Germany
Curated by Petra Lewey
Contemporary Art Society purchase;
Ulster Museum Collection

Over Easy
January 1999
Steel, glass, electric motors,
render, PVC seals
Diameter 8 m
The Arc Trust, Stockton-on-Tees
Curated by David Metcalfe
Collaborators: Price & Myers Consulting
Engineers; W.S. Atkins Mechanical
Engineers; Renton Howard Wood Levin
Partnership (RHWL); Commercial
Systems International (CSI)
Permanent commission

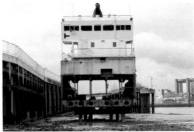

Turning the Place Over
2000 (in development)
Turning section of building
façade, rollers, steel
Curated by Simon Morrissey
Collaborators: Price & Myers Consulting
Engineers

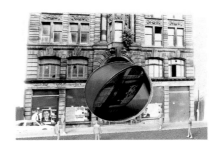

Slice of Reality
January 2000
Section of 600-ton sand dredger
on six piles in the River Thames,
Greenwich, London
21 x 9.75 x 7.9 m
New Millennium Experience Company
(NMEC), London
Curated by Andrea Schieker, North
Meadow Sculpture Project, London
Collaborators: NMEC; W.S. Atkins
Mechanical Engineers; English
Partnership; Molem Marine; River Tees
Engineering and Welding

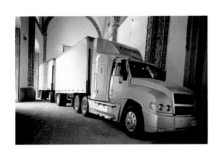

Give me forty acres and I'll turn this rig around
April 2000
Dina truck and two trailers, truck cab illuminations, cassette tape
Length 28 m
Structurally Sound, April 2000, Ex Convento de Santa Teresa, Mexico City
Curated by Frances Horn

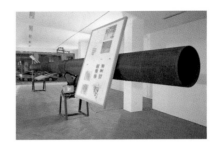

Set North for Japan (74° 33' 2") drawings
March 2001
Steel tube, drawings, model, Bode Sizzer rollers
2 x 14 m approximately
Gimpel Fils Gallery, London
Curated by René Gimpel and Jackie Halliday

Turbine Hall Swimming Pool
May 2000
Diesel generator, DVD player, amplifier speakers, wood, rockwall, steel fittings, bar-fire elements, lighting
Dimensions variable
Café Gallery Projects, London
Collaborator: Paul Burwell

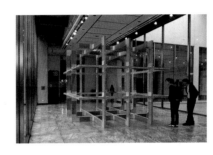

Hotel: Room 921, Empress Hotel
April 2001
Plywood-faced honeycomb boarding, photographs, acrylic
Dimensions variable
Field Day: Sculpture from Britain, April–June 2001, Taipei Fine Art Museum, Taipei, Taiwan
Curated by Fang-Wei Chang

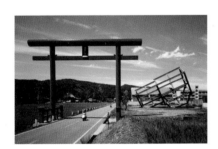

Set North for Japan (74° 33' 2")
July 2000
Painted steel, concrete base
8.8 x 4.6 x 14 m
Echigo-Tsumari Art Triennial 2000, Nakasato, Niigata Prefecture, Japan
Curated by Fram Kitagawa, Art Front Gallery, Tokyo
Collaborators: Price & Myers Consulting Engineers; Maeda Corporation
Permanent commission

Selected Bibliography

1978 *12 Pieces*, Coracle Press, London, edition of 150

1980 *Wind Instruments*, Coracle Press, London, edition of 200

1985 *Sheer Fluke*, exhib. cat., Matt's Gallery, London

1986 *Heatwave*, exhib. cat., Ikon Gallery, Birmingham

 The Elements, exhib. cat., Bookworks, London

1987 *TSWA 3D*, exhib. cat., Gateshead

 Trigon Biennale 1987, exhib. cat., Graz, Austria

1989 *Richard Wilson*, exhib. cat., Matt's Gallery, London; Arnolfini, Bristol; Museum of Modern Art, Oxford

 Art of Our Time: The Saatchi Collection, exhib. cat., Royal Scottish Academy, Edinburgh

1990 'Edge 90 (Art and Life in the Nineties)', *Mediamatic*, vol. 4 #4, summer 1990

 UK/USSR, exhib. cat., The Showroom, London

1992 *La Casa di Alice*, exhib. cat., Electa, Italy

1993 'On Siat: New British Sculpture', *Threshold*, no. 9, Museet for Samstidskunst, Oslo, January 1993

 Another World, exhib. cat., Mito Art Tower, Mito, Japan

 Richard Wilson, exhib. cat., DAAD, Berlin

 Space Without Art, exhib. cat., Der Fernsehturm, Berlin

1994 *Watertable*, 45 rpm record commissioned by Arts Council Collection and National Touring Exhibition, London, for Art Unlimited, edition of 1000

 Nicolas De Oliveira and others, *Installation Art*, Thames & Hudson, London

 Faret Tachikawa Art Project, exhib. cat., Genaikikakushitsu Publishers, Tokyo

1995 *Deep End*, exhib. cat., British Council and the Museum of Contemporary Art, Los Angeles

1996 *Mirades (Sobre el Museu)*, exhib. cat., Museu d'Art Contemporani, Barcelona

 Jamming Gears, exhib. cat., Serpentine Gallery, London

 Islands, exhib. cat., Australian National Gallery, Canberra

 Andrew Graham-Dixon, *A History of British Art*, BBC Books, London

1997 *You Are Here: Re-siting Installations*, exhib. cat., Royal College of Art, London

 The Turner Prize, exhib. cat., Tate Gallery, London

1998 *Hung, Drawn and Quartered*, exhib. cat., Städtisches Museum, Zwickau, Germany

1999 *Leeds Sculpture Collections: Works on Paper*, Henry Moore Sculpture Trust, Leeds

2000 *Turbine Hall Swimming Pool*, exhib. cat., Café Gallery, London

 Cultural Ties, exhib. cat. by Kapil Jariwala, Westzone, London

 The Saatchi Gift to the Arts Council Collection, Hayward Gallery Publishing, London

2001 *Field Day*, exhib. cat., Taipei Fine Arts Museum, Taipei, Taiwan

 Double Vision, exhib. cat., Galerie für Zeitgenossischekunst, Leipzig, Germany

 Echigo-Tsumari Art Triennial 2000, exhib. cat., Echigo-Tsumari Art Triennial 2000 Executive Committee, Japan